From Picasso to Pollock
CLASSICS OF MODERN ART

From Picasso to Pollock

CLASSICS OF MODERN ART

GuggenheimMUSEUM

Published on the occasion of the exhibition
From Picasso to Pollock: Classics of Modern Art
Solomon R. Guggenheim Museum, New York
July 4 –September 28, 2003
Organized by Lisa Dennison and Tracey Bashkoff

This exhibition is sponsored in part by

Additional support is provided by The Harry Frank Guggenheim Foundation.

Guggenheim Museum Publications
1071 Fifth Avenue
New York, New York 10128

ISBN 0-89207-298-9

Design: Eileen Boxer / BoxerDesign
Production: Melissa Secondino
Editorial: Meghan Dailey, Elizabeth Franzen, Edward Weisberger

Printed in Germany by GZD
Front and back covers: Fernand Léger, *The Great Parade* (detail), 1954 (page 136)

Contents

Preface and Acknowledgments

The history of the Guggenheim Museum is a collage of various stories that intertwine with the events of the twentieth century—for example, Solomon R. Guggenheim's collaboration with his art advisor, Hilla Rebay; her obsession with the philosophy of Rudolph Steiner and the aesthetics of Vasily Kandinsky; the pivotal careers and collections of the art dealers Karl Nierendorf and Justin K. Thannhauser; the Rebay-Guggenheim collaboration with Frank Lloyd Wright. The outcome of this history, which is outlined more fully in Lisa Dennison's introduction to this catalogue, is on display in *From Picasso to Pollock: Classics of Modern Art.* Honoring the Guggenheim's past tradition of showing collection exhibitions during the summer, this presentation features masterpieces that have come to be regarded as signature works of our collection.

The identity of a museum derives from the balance of objects that comprise its collection. While the Guggenheim collection cannot be "complete" in an encyclopedic sense, it includes a deep and broad assembly of masterpieces through which the attentive viewer may perceive the era of Modern art emerging in all of its diversity and complexity. The selection of works for *From Picasso to Pollock* highlights many of the major movements of art in the twentieth century, from Cubism to Abstract Expressionism.

Formulated by Pablo Picasso and his Parisian colleague Georges Braque, Cubism offered new possibilities for rendering three-dimensional objects on the two-dimensional picture plane. In addition to seminal Cubist works by Braque and Picasso, this exhibition features major paintings by Fernand Léger, Robert Delaunay, and František Kupka, who elaborated on the vocabulary of Cubism, tailoring it to their sensibilities.

From Picasso to Pollock encompasses diverse examples of the varied paths and radical approaches taken in painting and sculpture throughout the twentieth century. Constantin Brancusi, Marc Chagall, Vasily Kandinsky, Paul Klee, Franz Marc, and Piet Mondrian have been collected in depth by the Guggenheim and can be seen here for their pioneering roles in the course of Modernism. Examples of postwar abstraction as practiced by the avant-garde in Europe and America—including Willem de Kooning, Lucio Fontana, Mark Rothko, and Antoni

Tàpies—are juxtaposed. This presentation concludes with works by Jackson Pollock, who developed a style that was as original and influential to the art of the second half of the twentieth century as Picasso's had been to the first half.

An exhibition of this scope could not take place without the generous support of our corporate and foundation supporters. We would like to extend our thanks to *Business Week*, in particular to William Kupper, President and Publisher, Geoff Dodge, Associate Publisher, U.S. Sales Director, and Keith Fox, Senior Vice President for their media sponsorship of this exhibition. We remain deeply grateful to The Harry Frank Guggenheim Foundation, especially to Peter Lawson-Johnston, Chair, and James M. Hester, President, for their steadfast support of the Guggenheim Museum.

For their excellent and informed selection of works for this exhibition and catalogue, I would like to thank Lisa Dennison, Deputy Director and Chief Curator, and Tracey Bashkoff, Associate Curator for Collections and Exhibitions. I am grateful as well to Kara Vander Weg, Assistant Curator, for her consistent attention to detail and to Anna Nathorst-Westfelt, Curatorial Intern. I extend my appreciation to the authors who have contributed catalogue entries and artist biographies to this publication. We have also benefited from the expertise and participation of the following members of the curatorial staff: Nancy Spector, Curator of Contemporary Art; Susan Davidson, Curator; Vivien Greene, Associate Curator; Susan Cross, Associate Curator; and Maya Kramer, Administrative Curatorial Assistant.

My sincere thanks for the realization of this catalogue are extended to Graphic Designer Eileen Boxer, and the Guggenheim's Publications Department: Elizabeth Levy, Director of Publications; Elizabeth Franzen, Managing Editor; Edward Weisberger, Editor; and Melissa Secondino, Assistant Production Manager. David Heald, Chief Photographer, and Kimberly Bush, Manager of Photography and Permissions, have provided the reproductions for this catalogue.

I extend my gratitude to our registrarial staff for their constant care and concern for the museum's collections: Meryl Cohen; Director of Registration and Art Services; Marylouise Napier, Registrar; Kaia Black, Assistant Registrar; and Ted Mann, Assistant Registrar for Collections and Outgoing Loans. Special thanks go to all who expertly prepare our holdings and

the building for installation: Scott Wixon, Manager of Art Services and Preparations; David Bufano, Chief Preparator; Michael Sarff, Construction Manager; Jeffrey Clemens, Associate Preparator; Liza Martin, Art Handler; Derek DeLuco, Technical Specialist; Mary Ann Hoag, Lighting Designer; Elisabeth Jaff, Associate Preparator for Paper; Barry Hylton, Senior Exhibition Technician; Peter Read, Manager of Exhibition Fabrication and Design; Stephen Engelman, Technical Designer; Doug Hollingsworth and David Johnson, Fabricators.

Many thanks go to the Conservation Department, who continually look after the treasures of our collection, including Paul Schwarzbaum, Chief Conservator, Guggenheim Museums/Technical Director, International Projects; Gillian McMillan, Senior Conservator, Collections; Julie Barten, Conservator, Exhibitions and Administration; Eleonora Nagy, Conservator, Sculpture; and Mara Guglielmi, Paper Conservator. My great appreciation goes to Karen Meyerhoff, Managing Director for Exhibitions, Collections and Design; Marion Kahan, Exhibition Program Manager; Ana Luisa Leite, Manager of Exhibition Design; Dan Zuzanaga, Exhibition Design Assistant; and Marcia Fardella, Chief Graphic Designer. Marc Steglitz, Deputy Director, Finance and Operations, and Anthony Calnek, Deputy Director for Communications and Publishing have been of great assistance. Further I would like to acknowledge the individuals who by expertly managing diverse areas and programs have contributed to the success of this exhibition: Kim Kanatani, Gail Engelberg Director of Museum Education; Pablo Helguera, Senior Education Program Manager; David Bleecker, Education Program Coordinator; Ryan Hill, Education Program Manager; Reagan Kiser, Education Program Manager; Sharon Vatsky, Senior Education Program Manager; Kendall Hubert, Director of Corporate Development; Bruce Lineker, Director of Institutional Development; Helen Warwick, Director of Individual Giving and Membership; Betsy Ennis, Director of Public Affairs; Jennifer Russo, Public Affairs Coordinator; Laura Miller, Director of Marketing; Ellenor Emery, Marketing Coordinator; Stephanie King, Director of Visitor Services; Lynn Underwood, Director of Integrated Information and Management; Danielle Uchitelle, Information Technology; Tom Foley, Director of Security; Brij Anand, Director of Facilities; Michael Lavin; Technical Director; and Christina Kallergis, Senior Financial Analyst, Budgeting and Planning.

9

Introduction

From Picasso to Pollock: Classics of Modern Art highlights the history of the avant-garde from early Modernism through Abstract Expressionism by presenting works of singular importance from the collection of the Solomon R. Guggenheim Museum. In uniting the major artists and developments of the first half of the twentieth century, the exhibition also reflects the history of the Guggenheim's holdings and the visions of the individuals who shaped the institution from the 1930s through the 1970s. The story of the Guggenheim Museum and its metamorphosis from one man's private collection to a public museum is exemplified, for example, by four people whose lives intersected at various points during several decades: the philanthropist Solomon R. Guggenheim; his advisor Hilla Rebay; his flamboyant niece Peggy Guggenheim; the eminent gallery owner Justin K. Thannhauser; and the art dealer Karl Nierendorf. All had much to do with bringing to light some of the most significant artists of the twentieth century.

Solomon R. Guggenheim (1861–1949) was born in Philadelphia into a large, affluent family of Swiss origin. His grandfather, Simon Guggenheim, and his father, Meyer, had reached these shores in 1848, like many immigrants, dreaming of a new life of freedom and success. Beginning as door-to-door peddlers of household goods, the Guggenheims ultimately made their fortune in the American mining industry. Meyer and his wife Barbara had three daughters and seven sons, five of whom, including Solomon, participated in the lucrative family mining business. Like many of the prosperous industrialist families of their time, Solomon and his wife, Irene Rothschild, collected art. Originally, there was no defining focus to their collection, nor was there any great expertise guiding their choices. The walls of their suite at the Plaza Hotel were adorned with old master paintings, French Barbizon school canvases, American landscapes, and primitive art. There was a decreasing number of old master paintings on the market, and a fairly competitive market for their purchase, so Solomon found himself at a disadvantage with respect to his more senior peers such as Henry Clay Frick and J. P. Morgan.

But all this was to change when the Guggenheims made the acquaintance of a young German artist, Hilla Rebay (1890–1967), who was commissioned by Irene to paint Solomon's portrait in 1927. Rebay was born Baroness Hilla Rebay von Ehrenwiesen in Strasbourg, Alsace. She studied

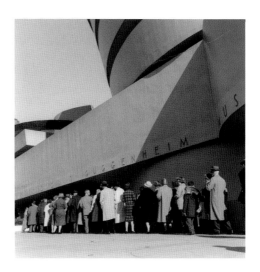

art and music in Cologne, Paris, Munich, and Berlin before moving to New York in 1927. One of her earliest mentors was the critic and art dealer Félix Fénéon, a close personal friend of Georges Seurat, and champion of the Neo-Impressionist group. The Dada artist Jean Arp was another important early influence on Rebay, and he introduced the young painter to the artistic circle associated with Der Sturm Gallery in Berlin. Der Sturm was owned by Herwarth Walden, who as early as 1912 exhibited simultaneously the French Cubists, Italian Futurists, and the German Die Brücke and Der Blaue Reiter groups, and who showed Rebay's work at his gallery in 1917.

Rebay was ardently committed—aesthetically and philosophically—to one particular vision in art: the "non-objective." This she described as an abstract art based not on nature or the empirical world, but on pure artistic invention stemming from the inner spirit and infused with mystical essence. The foundation for these beliefs drew heavily upon the quasi-religious/philosophical movement known as theosophy, popularized in the first quarter of the century by Rudolf Steiner, a teacher of Rebay when she was fourteen. She also followed the theories of artist Vasily Kandinsky (himself influenced by theosophy), whose 1911 treatise *On the Spiritual in Art*, set the stage for his move toward abstraction. It was his conviction that art was the embodiment of the spirit, and that the purpose of the highest art was to express an inner truth, which could only be achieved by abandoning the representation of the objective world. Rebay and Kandinsky were soul mates in their convictions.[1] She maintained that non-objective painting transcended boundaries of language, experience, and culture. As she wrote in 1937, "Non-objectivity will be the religion of the future. Very soon the nations on earth will turn to it in thought and feeling and develop such intuitive powers which lead them to harmony."[2]

When Rebay arrived in New York, her dream was to help patrons assemble collections of non-objective art. Drawing on her well-documented skills of passionate persuasion, she used the opportunity afforded by the portrait commission of Solomon Guggenheim to proselytize for the art in which she so profoundly believed. Rebay soon became his artistic advisor, and in 1929 took the Guggenheims on their first of many trips to Europe to visit the studios of artists including Kandinsky, Robert Delaunay, Albert Gleizes, Piet Mondrian, and László Moholy-Nagy. Guggenheim initially imagined that he would build a world-class collection and bequeath it to the Metropolitan Museum of Art in New York, but during the winter of 1930 he was drawn to the

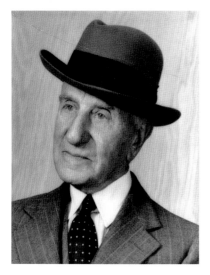
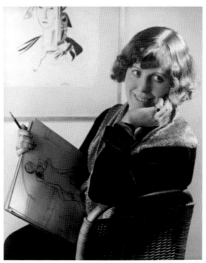

notion of founding his own museum, particularly since the collection soon outgrew the domestic setting of the Guggenheims' Plaza Hotel apartment.[3] In 1937, he established the Solomon R. Guggenheim Foundation for the "promotion and encouragement of art and education in art and the enlightenment of the public."[4] The decision to establish a museum was one of the central tenets of this foundation. Guggenheim would donate his collection to form the core of the museum, and Rebay would be its curator and director. Rebay was deeply drawn to the idea of making an important architectural statement in the design of the museum, something that would "set a standard by which to judge all future museums."[5]

In 1939, as an interim measure, the Museum of Non-Objective Painting was established in temporary quarters in a former automobile showroom on East Fifty-fourth Street. By this point in time, there were over 800 objects in the collection. By 1943, Rebay renewed her quest to build a permanent space for the thriving museum, and settled fairly quickly on the choice of American architect Frank Lloyd Wright, whose organic architecture and utopian ideals were closely aligned with her own sensibilities. She wrote to Wright, "Could you ever come to New York and discuss with me a building for our collection of Non-objective paintings. I feel that each of these great masterpieces should be organized into space and only you would test the possibilities to do so.... I want a temple of spirit—a monument, and your help to make it possible."[6] It took seventeen years to realize Wright's vision, due to design modifications, site alterations, and construction postponements spurred by the financial uncertainty of the war years, but throughout this period, the collection continued to grow.

An existing townhouse at 1071 Fifth Avenue, the future site of the museum, was home to the collection from 1947 until 1956, when the site was finally cleared for construction of the Wright building. Solomon died in 1949 before construction began, and his nephew, Harry Guggenheim, took over the reins of the Guggenheim Foundation. In 1952, the museum's name was officially changed to the Solomon R. Guggenheim Museum, to honor its benefactor, and Rebay herself was removed as director, under mounting criticism that her "non-objective" vision was too narrow and esoteric. The board selected James Johnson Sweeney, the former director of the Department of Painting and Sculpture at the Museum of Modern Art, New York, to succeed her. Wright himself died only six months before the museum opened to the public on October 21, 1959.

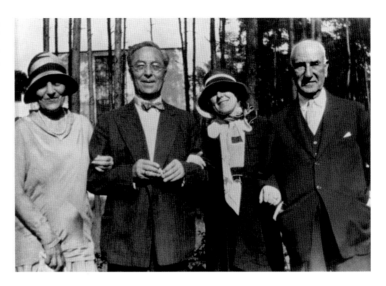

Solomon Guggenheim had depended on Rebay to guide him and admired the skills she possessed when negotiating for works of art. They preferred to buy directly from the artists whenever possible, to avoid paying what they considered to be "inflated dealer prices." There were, however, several artists who could or would not sell works except through their dealers. Pablo Picasso and Henri Matisse were the most notable of these, and while Rebay was able to locate several excellent Picassos for the collection, works by Matisse were not to be had.[7] Perhaps more than any other twentieth-century painter, Vasily Kandinsky has been closely linked to the history of the Guggenheim Museum. In 1929, Rebay took Guggenheim to Kandinsky's studio at the Bauhaus in Dessau, Germany, where he purchased the 1923 masterpiece of geometric form and color, *Composition 8*. In 1935, Kandinsky wrote to Rebay, "Perhaps Mr. G would find it possible to pay me a fixed amount per year, for which I would place my entire production at his disposal for his selection, at two-thirds of the price."[8] The artist would be helped on a less formal basis, and between August 1935 and July 1936, when he was living in Paris, seven more new works were acquired, some for Guggenheim and others for Rebay.[9] Over the course of his lifetime, Guggenheim acquired some 150 works by the great Russian master.

At the same time as Guggenheim was forming his collection of non-objective art, he was also purchasing paintings in a representational style, such as Amedeo Modigliani's *Jeanne Hébuterne with Yellow Sweater* (1918 – 19; p. 79). As a patron of the arts, he was sympathetic to the difficult financial climate of the 1930s. In order to provide assistance to Fénéon, who in 1930, at age seventy-one and retired, found himself in financial difficulty, Guggenheim purchased Modigliani's stylized portrait of his model and companion at Rebay's urging. As the depression worsened, others turned to Rebay and Guggenheim for assistance. In 1935, Marc Chagall wrote to Rebay in this vein, and the following year, during a visit to Paris, the Guggenheims purchased five canvases by the artist. Throughout the 1930s and 1940s, collection-building remained a priority. One of the remarkable acquisitions from this time was Robert Delaunay's *Eiffel Tower* (1911; p. 71), purchased from the artist. The Eiffel Tower was favorite theme of Robert Delaunay's, appearing consistently in his oeuvre from 1909 to 1914, to his last paintings of 1937. In 1909, he gave his first *Eiffel Tower* painting as an engagement gift to his Russian fiancée, Sonia Terk. The tower, which symbolized all that was modern about Paris, represented the discovery of shared

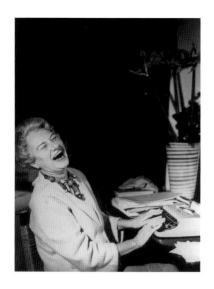

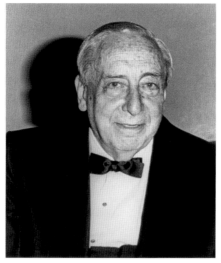

feelings and ideas between Terk and Delaunay, and united them, just as they saw it as a unifying symbol of the universe itself.

Another noteworthy expansion of the collection was the acquisition of the estate of the German art dealer Karl Nierendorf (1889 – 1947). Rebay's acquaintance with Nierendorf dated back to the 1920s in Berlin, where he had a gallery in partnership with J. B. Neumann. Nierendorf moved to New York in the 1930s, and his gallery became the best source for Kandinsky paintings. Sharing an affinity for the work of the abstract painter brought Nierendorf and Rebay closer together.[10] In 1948, when Nierendorf died, the Guggenheim Museum purchased his entire estate of some 730 objects, including works by Paul Klee (e.g., *Red Balloon*, 1922; p. 122), Kandinsky, Alexander Calder, Chagall, Picasso, and the German Expressionists (e.g., Oskar Kokoschka's *Knight Errant*, 1915; pp. 102 – 03). In that same year, Rebay was offered works from the collection of Nell Walden-Urech, former wife of Herwarth Walden, whose art gallery Der Sturm had played such a vital role at the outset of Rebay's career. Walden-Urech wrote to Hilla at the time, "The reason I have now made up my mind to part with them is that during my lifetime, I want to know where these 'children of mine' will go and I want them to be in museums only. I am certain that nowhere could they be better placed than in your museum."[11] Although she had been offered the entire collection, Rebay eventually bought five paintings for the museum, including Franz Marc's 1911 canvas *Yellow Cow* (pp. 98 – 99), a work that splendidly conveys the artist's pantheistic view of nature.

In the 1950s, the Guggenheim Museum's collection continued to grow under the aesthetic direction of James Johnson Sweeney, who abolished the restrictive boundaries of Rebay's focus on non-objective painting. Works were more often than not purchased from galleries, rather than from the artists themselves. In 1961, Thomas M. Messer took over as director, and acquisitions followed the same comprehensive trend established by Sweeney. During Messer's tenure, Harry F. Guggenheim commissioned Joan Miró and Josep Lloréns Artigas's site-specific mural *Alicia* (1965 – 67; pp. 138 – 39) for the museum, and two dramatic enrichments to the collection changed its tenor significantly: the 1976 bequest of the Peggy Guggenheim's collection, and the 1978 gift of Justin K. Thannhauser's collection.

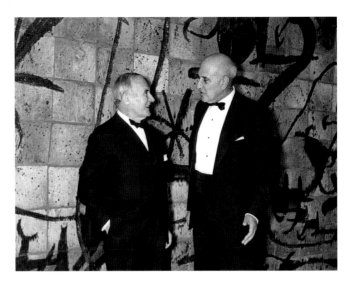

Solomon's niece, Peggy Guggenheim (1898–1979), was the second of three daughters born to Benjamin Guggenheim and Florette Seligman in New York. Peggy became part of the artistic and social life of Paris in the 1920s, and by 1938, established as a bona fide patron of the arts, she opened the Guggenheim Jeune gallery in London, a punning reference to her uncle Solomon's patronage of the arts and to Fénéon's now defunct Galerie Bernheim-Jeune in Paris. Rebay, who was not at all amused by what she saw as a parasitic gesture, protested loudly to "Miss Guggenheim Jeune" in one of her infamous letters, "It is extremely distasteful at this moment, when the name of Guggenheim stands for an ideal in art, to see it used for commerce."[12] It set the tone for an acrimonious relationship between the two women that was to last their lifetimes.

In 1939, on the recommendation of Duchamp, Peggy gave Kandinsky his first solo show in England, exhibiting thirty-eight works dating from 1909 to 1937, with a catalogue that included a preface by André Breton. At Kandinsky's insistence, Peggy wrote to Solomon offering to sell him an early work that he had apparently once desired. Solomon did not buy the Kandinsky from his niece, but later acquired *Dominant Curve* (1936; p. 135) from Nierendorf. Peggy herself had bought this painting from her show and sold it to Nierendorf during the war; she considered this sale to be one of the tragedies of her life as a collector, regretting in her autobiography that "I listened to people saying it was a Fascist picture. To my great sorrow I later found it in my uncle's collection in an exhibition in Rome."[13]

In 1939, Peggy closed Guggenheim Jeune and ultimately turned her attention to assembling a private collection of abstract and Surrealist art. Her motto was "buy a picture a day." As the European conflict escalated, Peggy and her family fled Europe for America, arriving in New York in July 1941. Once there, she and Max Ernst (whom she was soon to wed) went to see her uncle's Museum of Non-Objective Painting, as well as his personal collection. She was not impressed by the atrocious manner in which the collection was hung, nor did she appreciate the presence of Rudolf Bauer's works, which overshadowed the Kandinskys on view. But she did appreciate Solomon's personal holdings in the Plaza Hotel: "a really fine collection of modern paintings. . . . Aunt Irene lived there with my uncle surrounded by the most beautiful Picassos, Seurats, Braques, Klees, Kandinskys, Gleizeses, Delaunays, Chagalls, and a Lissitzky."[14]

In October 1942, Peggy opened the Art of This Century, a museum/gallery, on West Fifty-seventh Street. The rivalry between Rebay and Guggenheim intensified, with Rebay claiming that the name of Peggy's museum implied a direct challenge to Solomon's *Art of Tomorrow* exhibition, a 1939 show at the Museum of Non-Objective Painting.[15] It is important to note that Peggy's interest in certain stylistic currents that were disregarded by her uncle, namely Surrealism and the early painters of the New York School, is a distinguishing feature of her collection to this day. After the war, Peggy returned to Europe and eventually took up residence in Venice, where she purchased the eighteenth century Palazzo Venier dei Leoni on the Grand Canal. The palazzo enabled her to realize her dream of opening an art museum. She presided over the museum housing her acclaimed collection from 1949 until her death in 1979. Despite the earlier acrimony with her uncle's museum (she said the museum resembled a huge garage, and that Wright's ramp coiled like an evil serpent),[16] Peggy transferred her collection and the palazzo that houses it to the Guggenheim Foundation in 1976.[17]

The Thannhauser bequest is also an important chapter in Guggenheim history. Justin K. Thannhauser (1892–1976) was the son of renowned art dealer Heinrich Thannhauser, who founded the Galerie Moderne in Munich in 1909. The Thannhausers can be counted among a select circle of prominent dealers in the early twentieth century, including Daniel-Henry Kahnweiler, Ambroise Vollard, and Herwarth Walden, among others. From an early age, Justin was involved in the activities of the gallery, and with his father built an impressive program, presenting Impressionist and Post-Impressionists exhibitions, as well as the art of the contemporary French and German avant-gardes. Their commitment to important early exhibitions of such artists as Kandinsky, Marc, and Klee paralleled the collecting interests of Solomon Guggenheim. In 1911, the Thannhausers presented the first exhibition of Der Blaue Reiter at the Munich gallery. Included in this historic show was Marc's *Yellow Cow*, which was later brought into the collection by Rebay. Equally significant was the 1913 Picasso exhibition, which included seventy-six paintings, and thirty-eight drawings, watercolors, and etchings from the Blue Period through Cubism. This presentation marked the beginning of a close personal and professional relationship between Justin and Picasso, which lasted until the artist's death inn 1973. Of the seventy-three works now in the Guggenheim's Thannhauser Collection, thirty-two are by Picasso, including *Woman with Yellow Hair* (December 1931; p. 128).

In 1918, the newly married Justin Thannhauser moved his wife and newborn son to Switzerland because of the increasingly vexed political and economic situation in Germany. He opened a branch of the gallery in Lucerne inn 1919, took control of the Munich gallery on the occasion of his father's retirement, and eventually expanded the enterprise to Berlin in 1927. By this time, Berlin had emerged as the center of vanguard activity in postwar Germany. Thannhauser staged two extraordinary special exhibitions, one of masterpieces of French painting, and another featuring German art. Several works in the Thannhauser Collection today were in these exhibitions.

After a few years in Paris, with the onset of World War II, Thannhauser left for New York with his family, arriving in 1940. Some of his collection had made its way safely to the United States as well, although much was lost when his house in Paris was looted and the collection confiscated by the Nazis. In New York, Thannhauser worked at rebuilding the collection, and in 1963 decided

to give his holdings to the Guggenheim. To house the gift, a space on the second floor of the monitor building was created, and in 1965, the collection was placed on permanent view there. The collection was legally transferred to the Guggenheim Foundation in 1978, two years after Thannhauser's death. A bequest of ten additional works was received after the passing of his second wife, Hilde, in 1991, and the monitor building was renamed in honor of their legacy.

With the Thannhauser bequest, the museum had in a sense come full circle. As early as 1944, Rebay wrote to Wright of her intention to bring the "objective" paintings from Guggenheim's Plaza Hotel suite to the museum, and install them separately as historical precursors to the non-objective works. She argued for a separate wing, rather than placing them on the top floor, "like an old attic filled with remnants over one's head."[18] In today's museum, the Thannhauser Collection serves as an historic point of departure, fulfilling Rebay's wish, and subsequent museum directors have closed the chronological and stylistic gaps created by Rebay's inspired but idiosyncratic collecting.

Notes

This introduction is adapted from the author's "The Collective Collections of the Guggenheim Museums," which originally appeared in *Masterpieces and Master Collectors: Impressionist and Early Modern Paintings from the Hermitage and Guggenheim Museums* (New York: Guggenheim Museum, 2001), pp. 28 – 38.

1. It should be noted however that the two could not agree on the terminology of "abstract" versus "non-objective." See Joan M. Lukach, *Hilla Rebay: In Search of the Spirit in Art* (New York: George Braziller, 1983), for more on this subject. See also Thomas Krens, "The Genesis of a Museum: A History of the Guggenheim" in *Art of This Century: The Guggenheim Museum and its Collection* (New York: Guggenheim Museum, 1997), pp. 7 – 52.

2. Hilla Rebay, "The Beauty of Non-Objectivity," in *Second Enlarged Catalogue of the Solomon. R. Guggenheim Collection of Non-Objective Paintings* (New York: The Solomon R. Guggenheim Foundation, 1937), p. 13.

3. Lukach, p. 61.

4. Charter of Guggenheim Foundation, dated June 25, 1937.

5. Lukach, p. 62.

6. Ibid., p. 183.

7. Lukach, p. 95. It would be 1982 before the Guggenheim would acquire its first painting by Matisse, *Italian Woman* (1916), in exchange with The Museum of Modern Art, New York, for a Kandinsky painting.

8. Ibid., p. 94. Lukach writes that "Kandinsky's position at the focal point of the Guggenheim collection was prestigious, but he derived little financial benefit from it. Many of the Kandinsky acquisitions came through the intermediary of Rudolf Bauer."

9. Ibid., p. 95. Guggenheim would often buy works for Rebay's own collection after she helped him make his own selections. Her collection also grew through exchange of work with other artists, as well as gifts from friends to thank her for her assistance.

10. Lukach, p. 239. "Out of a shared passion for the art of Kandinsky a symbiotic relationship developed between Nierendorf and the Guggenheim's art advisor, Nierendorf being the best source of Kandinsky paintings and Rebay and Guggenheim the artist's most zealous collectors."

11. Ibid., p. 288.

12. Peggy Guggenheim, *Out of This Century: Confessions of an Art Addict* (New York: Universe Books, 1979), p. 171.

13. Ibid., p. 317.

14. Ibid., p. 251.

15. Lukach, p. 155.

16. Guggenheim, p. 361.

17. For a complete summary of how the Peggy Guggenheim Collection became part of the Solomon R. Guggenheim Foundation, see Thomas Messer, "The History of a Courtship," in Karole P. B. Vail, ed., *Peggy Guggenheim: A Celebration* (New York: Guggenheim Museum, 1998), pp. 127 – 51.

18. Lukach, p. 190.

Artists

Alexander Archipenko, Max Beckmann, Constantin Brancusi, Georges Braque, Alberto Burri, Alexander Calder, Marc Chagall, Eduardo Chillida, Willem de Kooning, Robert Delaunay, Jean Dubuffet, Max Ernst, Lucio Fontana, Naum Gabo, Juan Gris, Hans Hofmann, Vasily Kandinsky, Ernst Ludwig Kirchner, Paul Klee, Franz Kline, Oskar Kokoschka, František Kupka, Mikhail Larionov, Fernand Léger, Kazimir Malevich, Franz Marc, Henri Matisse, Joan Miró, Amedeo Modigliani, László Moholy-Nagy, Piet Mondrian, Robert Motherwell, Francis Picabia, Pablo Picasso, Jackson Pollock, Liubov Popova, Mark Rothko, Egon Schiele, Gino Severini, Antoni Tàpies

Alexander Archipenko was born May 30,

1887, in Kiev. In 1902, he entered the Kiev Art School, where he studied painting and sculpture until 1905. During this time, he was impressed by the Byzantine icons, frescoes, and mosaics of Kiev. After a sojourn in Moscow, Archipenko moved to Paris in 1908. He attended the Ecole des Beaux-Arts for a brief period and then continued to study independently at the Musée du Louvre, where he was drawn to Egyptian, Assyrian, archaic Greek, and early Gothic sculpture. In 1910, he began exhibiting at the Salon des Indépendants, Paris, and the following year showed for the first time at the Salon d'Automne.

In 1912, Archipenko was given his first solo show in Germany at the Folkwang Museum, Hagen. That same year, in Paris, he opened the first of his many art schools, joined the Section d'Or group, which included Marcel Duchamp and Fernand Léger, among others, and produced his first painted reliefs, the *Sculpto-Peintures*. In 1913, Archipenko exhibited at the Armory Show in New York and made his first prints, which were reproduced in the Italian Futurist publication *Lacerba* in 1914. He participated in the Salon des Indépendants in 1914 and the Venice Biennale in 1920. During the war years, the artist resided in Cimiez, a suburb of Nice. From 1919 to 1921, he traveled to Geneva, Zurich, Paris, London, Brussels, Athens, and other European cities to exhibit his work.

Archipenko's first solo show in the United States was held at the Société Anonyme, New York, in 1921. In 1923, he moved from Berlin to the United States, where over the years he opened art schools in New York City; Woodstock, New York; Los Angeles; and Chicago. In 1924, Archipenko invented his first kinetic work, *Archipentura*. For the next thirty years, he taught throughout the United States at art schools and universities, including the short-lived New Bauhaus in Chicago. He became a United States citizen in 1928. Most of Archipenko's work in German museums was confiscated by the Nazis in their purge of "degenerate art." In 1947, he produced the first of his sculptures that are illuminated from within. He accompanied an exhibition of his work through-out Germany in 1955, and at this time began his book *Archipenko: Fifty Creative Years 1908–1958*, published in 1960. Archipenko died February 25, 1964, in New York.

Max Beckmann was born February 12, 1884, in Leipzig,

Germany. He began to study art with Carl Frithjof Smith at the Grossherzogliche Kunstschule, Weimar, in 1900 and made his first visit to Paris in 1903 – 04. During this period, Beckmann began his lifelong practice of keeping a diary. In the fall of 1904, he settled in Berlin. In 1913, the artist's first solo show took place at the Galerie Paul Cassirer, Berlin. He was discharged for reasons of health from the medical corps of the German army in 1915 and settled in Frankfurt.

In 1925, Beckmann's work was included in the exhibition *New Objectivity* (*Die neue Sachlichkeit*) in Mannheim, and he was appointed professor at the Städelsches Kunstinstitut, Frankfurt. His first show in the United States took place at J. B. Neumann's New Art Circle, New York, in 1926. A large retrospective of his work was held at the Kunsthalle Mannheim in 1928. From 1929 to 1932, he continued to teach in Frankfurt but spent time in Paris during the winters. It was during these years that Beckmann began to use the triptych format. When the Nazis came to power in 1933, he lost his teaching position and moved to Berlin. In 1937, Beckmann was included in the Nazis' exhibition *Degenerate Art* (*Entartete Kunst*). The day after the show opened in July in Munich, the artist left Germany for Amsterdam, where he remained until 1947. In 1938, he had the first of numerous exhibitions at Curt Valentin's Buchholz Gallery, New York.

Beckmann traveled to Paris and the south of France in 1947 and later that year went to the United States to teach at the School of Fine Arts at Washington University, Saint Louis. The first Beckmann retrospective in the United States took place in 1948 at the City Art Museum, Saint Louis. The artist taught at the University of Colorado, Boulder, during the summer of 1949 and the following fall at the Brooklyn Museum Art School. That year, the artist was awarded first prize in the exhibition *Painting in the United States*, 1949 at the Carnegie Institute, Pittsburgh. He died December 27, 1950, in New York.

Constantin Brancusi was born February 19, 1876,

in Hobitza, Romania. He studied art at the Craiova School of Arts and Crafts from 1894 to 1898 and at the Bucharest School of Fine Arts from 1898 to 1901. Eager to continue his education in Paris, Brancusi moved there in 1904 and enrolled in the Ecole des Beaux-Arts in 1905. The following year, his sculpture was shown at the Salon d'Automne, where he met Auguste Rodin.

Soon after 1907, Brancusi's mature period began. The sculptor had settled in Paris but throughout these years returned frequently to Bucharest, where he exhibited almost every year. In Paris, his friends included Marcel Duchamp, Fernand Léger, Henri Matisse, Amedeo Modigliani, and Henri Rousseau. In 1913, five of Brancusi's sculptures were included in the Armory Show in New York. Alfred Stieglitz presented the first solo show of Brancusi's work at his gallery "291," New York, in 1914. Brancusi was never a member of any organized artistic movement, although he was associated with Francis Picabia, Tristan Tzara, and many other Dadaists in the early 1920s. In 1921, he was honored with a special issue of *The Little Review*. He traveled to the United States twice in 1926 to attend his solo shows at Wildenstein and at the Brummer Gallery in New York. The following year, a historic trial was initiated in the United States to determine whether Brancusi's *Bird in Space* was liable for duty as a manufactured object or as a work of art. The court decided in 1928 that the sculpture was a work of art.

Brancusi traveled extensively in the 1930s, visiting India and Egypt as well as European countries. He was commissioned to create a war memorial for a park in Turgu Jiu, Romania, in 1935, and designed a complex that included gates, tables, stools, and an *Endless Column*. After 1939, Brancusi continued to work in Paris. His last sculpture, a plaster *Grand Coq*, was completed in 1949. In 1952, Brancusi became a French citizen. He died March 16, 1957, in Paris.

Georges Braque was born May 13, 1882, in Argenteuil,

France. He grew up in Le Havre and studied evenings at the Ecole des Beaux-Arts there from about 1897 to 1899. He left for Paris to study under a master decorator to receive his craftsman certificate in 1901. From 1902 to 1904, he painted at the Académie Humbert in Paris, where he met Marie Laurencin and Francis Picabia. By 1906, Braque's work was no longer Impressionist but Fauve in style; after spending that summer in Antwerp with Othon Friesz, he showed his Fauve work in 1907 at the Salon des Indépendants in Paris. His first solo show was at Daniel-Henri Kahnweiler's gallery in 1908. From 1909, Pablo Picasso and Braque worked together in developing Cubism; by 1911, their styles were extremely similar. In 1912, they started to incorporate collage elements into their paintings and to experiment with the papier collé (pasted paper) technique. Their collaboration lasted until 1914. Braque served in the French army during World War I and was wounded; upon his recovery in 1917, he began a close friendship with Juan Gris.

After World War I, Braque's work became freer and less schematic. His fame grew in 1922 as a result of an exhibition at the Salon d'Automne in Paris. In the mid-1920s, Braque designed the decor for two Sergei Diaghilev ballets. By the end of the decade, he had returned to a more realistic interpretation of nature, although certain aspects of Cubism always remained present in his work. In 1931, Braque made his first engraved plasters and began to portray mythological subjects. His first important retrospective took place in 1933 at the Kunsthalle Basel. He won First Prize at the Carnegie International, Pittsburgh, in 1937.

During World War II, Braque remained in Paris. His paintings at that time, primarily still lifes and interiors, became more somber. In addition to paintings, the artist also made lithographs, engravings, and sculpture. From the late 1940s, Braque treated various recurring themes such as birds, ateliers, landscapes, and seascapes. In 1953, he designed stained-glass windows for the church of Varengeville. During the last few years of his life, Braque's ill health prevented him from undertaking further large-scale commissions, but he continued to paint, make lithographs, and design jewelry. He died August 31, 1963, in Paris.

Alberto Burri

was born March 12, 1915, in Città di Castello, Italy. He earned a medical degree in 1940 from the University of Perugia and served as a physician during World War II. He was interned in a prisoner-of-war camp in Hereford, Texas, in 1944, where he started to paint on the burlap that was at hand. After his release in 1946, Burri moved to Rome, where his first solo show was held at Galleria La Margherita in 1947. He turned to abstraction, becoming a proponent of Art Informel. Around 1949–50, Burri experimented with unorthodox materials, fabricating tactile collages with pumice, tar, and burlap. He also commenced the "mold" series and the "hunchback" series (humped canvases that broke with the two-dimensional plane). Burri helped start Gruppo Origine, founded by Italian artists in 1950 in opposition to the increasingly decorative nature of abstraction; Gruppo Origine exhibited in 1951 at Galleria dell'Obelisco, Rome. In 1953, Burri's work was included in the exhibition *Younger European Painters* at the Solomon R. Guggenheim Museum, New York, and was shown as well at the Frumkin Gallery, Chicago, and the Stable Gallery, New York. In the mid-1950s, he began burning his mediums, a technique he termed *combustione*; his charred wood and burlap works were first exhibited in 1957 at Galleria dell'Obelisco. In 1958, his welded iron sheets were shown at Galleria Blu, Milan, and he was awarded third prize in the Carnegie International, Pittsburgh. In 1959, he won the Premio dell'Ariete in Milan and the UNESCO Prize at the São Paulo Bienal.

Burri had a one-person show in 1960 at the Venice Biennale, where he was awarded the Critics' Prize. He started to burn plastic in the early 1960s and exhibited these works in 1962 at the Marlborough Galleria, Rome. His first retrospective in the United States was presented by the Museum of Fine Arts, Houston. His art was selected for the traveling *Premio Marzotto* exhibition of 1964–65, for which he won the prize in 1965, the same year in which he was awarded the Grand Prize at the São Paolo Bienal. In 1972, the Musée National d'Art Moderne, Paris, held a Burri retrospective. In the early 1970s, he embarked upon the "cracked" paintings series, creviced earthlike surfaces. A Burri retrospective opened at the University of California's Frederick S. Wight Gallery, Los Angeles, in 1977 and traveled to the Marion Koogler McNay Art Institute, San Antonio, and the Solomon R. Guggenheim Museum in 1978. Burri turned to another industrial material, Cellotex, in 1979, and used it throughout the 1980s and 1990s. In 1994, the Italian Order of Merit was bestowed upon Burri. The artist died February 15, 1995, in Nice.

Alexander Calder

was born July 22, 1898, in Lawnton, Pennsylvania, into a family of artists. In 1919, he received an engineering degree from Stevens Institute of Technology, Hoboken. Calder attended the Art Students League, New York, from 1923 to 1926, studying briefly with Thomas Hart Benton and John Sloan, among others. As a free-lance artist for the *National Police Gazette* in 1925 he spent two weeks sketching at the circus; his fascination with the subject dates from this time. He also made his first sculpture in 1925; the following year he made several constructions of animals and figures with wire and wood. Calder's first exhibition of paintings took place in 1926 at the Artist's Gallery, New York. Later that year, he went to Paris and attended the Académie de la Grande Chaumière. In Paris, he met Stanley William Hayter, exhibited at the 1926 Salon des Indépendants, and in 1927 began giving performances of his miniature circus. The first show of his wire animals and caricature portraits was held at the Weyhe Gallery, New York, in 1928. That same year, he met Joan Miró, who became his lifelong friend. Subsequently, Calder divided his time between France and the United States. In 1929, the Galerie Billiet gave him his first solo show in Paris. He met Frederick Kiesler, Fernand Léger, and Theo van Doesburg and visited Piet Mondrian's studio in 1930. Calder began to experiment with abstract sculpture at this time and in 1931 and 1932 introduced moving parts into his work. These moving sculptures were called "mobiles"; the stationary constructions were to be named "stabiles." He exhibited with the Abstraction-Création group in Paris in 1933. In 1943, the Museum of Modern Art, New York, gave him a solo exhibition.

During the 1950s, Calder traveled widely and executed *Towers* (wall mobiles) and *Gongs* (sound mobiles). He won First Prize for Sculpture at the 1952 Venice Biennale. Late in the decade, the artist worked extensively with gouache; from this period, he executed numerous major public commissions. In 1964 – 65, the Solomon R. Guggenheim Museum, New York, presented a Calder retrospective. He began the *Totems* in 1966 and the *Animobiles* in 1971; both are variations on the standing mobile. A Calder exhibition was held at the Whitney Museum of American Art, New York, in 1976. Calder died November 11, 1976, in New York.

Marc Chagall was born July 7, 1887, in Vitebsk, Russia. From 1906

to 1909, he studied in Saint Petersburg at the Imperial School for the Protection of the Arts and with Léon Bakst. In 1910, he moved to Paris, where he associated with Guillaume Apollinaire and Robert Delaunay and encountered Fauvism and Cubism. He participated in the Salon des Indépendants and the Salon d'Automne in 1912. His first solo show was held in 1914 at Der Sturm gallery in Berlin.

Chagall returned to Russia during World War I, settling in Vitebsk, where he was appointed Commissar for Art. He founded the Vitebsk Popular Art School and directed it until disagreements with the Suprematists resulted in his resignation in 1920. He moved to Moscow and executed his first stage designs for the Jewish Art Theater there. After a sojourn in Berlin, Chagall returned to Paris in 1923 and met critic and art dealer Ambroise Vollard. The artist's first retrospective took place in 1924 at the Galerie Barbazanges-Hodebert, Paris. During the 1930s, he traveled to Palestine, the Netherlands, Spain, Poland, and Italy. In 1933, the Kunsthalle Basel held a major retrospective of his work.

During World War II, Chagall fled to the United States. The Museum of Modern Art, New York, gave him a retrospective in 1946. He settled permanently in France in 1948 and exhibited in Paris, Amsterdam, and London. During 1951, he visited Israel and executed his first sculptures. The following year, the artist traveled in Greece and Italy. In 1962, he designed windows for the synagogue of the Hadassah Medical Center, near Jerusalem, and the cathedral at Metz. He designed a ceiling for the Opéra, Paris, in 1964 and murals for the Metropolitan Opera House, New York, in 1965. An exhibition of the artist's work from 1967 to 1977 was held at the Musée du Louvre, Paris, in 1977–78. Chagall died March 28, 1985, in Saint Paul de Vence, France.

Eduardo Chillida was born January 10, 1924, in San

Sebastián, Spain. From 1943 to 1947, he studied architecture at the University of Madrid while dedicating the rest of his time to drawing and sculpture. In 1948, he went to Paris, and exhibited at the Salon de Mai the following year. In 1951, Chillida returned to Spain and lived in Hernani until 1958. His first solo exhibition opened in 1954 at the Galeria Clan, Madrid. In 1955, the city of San Sebastián commissioned his first monumental outdoor sculpture, *Alexander Fleming*; many others followed from *Comb of the Wind IV* (1969) for the UNESCO building in Paris to *Gure Aitaren Etxea* (1988) in Guernica. Chillida's sculptures are characterized by their geometric and organic shapes made of stone, steel, or fired clay; his open-air work often occupies key public spaces and dramatizes the relation between people and nature.

In 1956, the Galerie Maeght, Paris, organized the first of many solo exhibitions. He traveled to the United States in 1958, returning in 1959 to settle permanently in San Sebastián. In 1966, the Museum of Fine Arts, Houston, mounted his first retrospective. Chillida's encounter with Martin Heidegger in 1968 resulted in his illustrating the philosopher's book *Die Kunst und der Raum*. He was invited by the Carpenter Center, Harvard University, Cambridge, Massachusetts, to be a visiting professor in 1971. In 1984, the artist created the Chillida Foundation in Hernani to house his work. During the late 1990s, Chillida proposed a controversial project on Fuerteventura, one of the Canary Islands; the idea was to produce a colossal artwork within the Tindaya mountain.

Notable among the many prizes the artist received were the Sculpture Prize of the 1958 Venice Biennale, the 1960 Kandinsky award, and the Andrew W. Mellon Prize shared in 1978 with Willem de Kooning. During the 1980s and 1990s, Chillida was also honored with the highest distinctions from England, France, Germany, Japan, and Spain. Retrospectives of his work were organized in 1980 by the Solomon R. Guggenheim Museum, New York, in 1990 by the Venice Biennale, in 1991 by the Martin-Gropius-Bau, Berlin, and in 1992 by the Royal Palace of Miramar, San Sebastián. Chillida died August 19, 2002, in San Sebastián.

Willem de Kooning

was born April 24, 1904, in Rotterdam, the Netherlands. From 1916 to 1925, he studied at night at the Academie voor Beeldende Kunsten en Technische Wetenschappen, Rotterdam, while apprenticed to a commercial art and decorating firm and later working for an art director. In 1924, he visited museums in Belgium and studied further in Brussels and Antwerp. De Kooning came to the United States in 1926 and settled briefly in Hoboken, New Jersey. He worked as a house painter before moving to New York in 1927, where he met Stuart Davis, Arshile Gorky, and John Graham. He took various commercial art and odd jobs until 1935 – 36, when he was employed in the mural and easel divisions of the WPA Federal Art Project. Thereafter, he painted full-time. In the late 1930s, his abstract as well as figurative work was primarily influenced by the Cubism and Surrealism of Pablo Picasso and also by Gorky, with whom he shared a studio.

In 1938, de Kooning started his first series of *Women*, which would become a major recurrent theme. During the 1940s, he participated in group shows with other artists who would form the New York School and become known as Abstract Expressionists. De Kooning's first solo show, which took place at the Egan Gallery, New York, in 1948, established his reputation as a major artist; it included a number of the allover black-and-white abstractions he had initiated in 1946. The *Women* of the early 1950s were followed by abstract urban landscapes, *Parkways*, rural landscapes, and, in the 1960s, a new group of *Women*.

In 1968, de Kooning visited the Netherlands for the first time since 1926, for the opening of his retrospective at the Stedelijk Museum, Amsterdam. In Rome in 1969, he executed his first sculptures—figures modeled in clay and later cast in bronze—and in 1970 – 71, he began a series of life-size figures. In 1974, the Walker Art Center, Minneapolis, organized a show of de Kooning's drawings and sculpture that traveled throughout the United States, and in 1978 the Solomon R. Guggenheim Museum, New York, mounted an exhibition of his recent work. In 1979, de Kooning and Eduardo Chillida received the Andrew W. Mellon Prize, which was accompanied by an exhibition at the Museum of Art, Carnegie Institute, Pittsburgh. De Kooning settled in the Springs, East Hampton, Long Island, in 1963. He was honored with a retrospective at the Museum of Modern Art, New York, in 1997. The artist died March 19, 1997, on Long Island.

Robert Delaunay was born April 12, 1885, in Paris. In 1902,

after secondary education, he apprenticed in a studio for theater sets in Belleville. In 1903, he started painting and by 1904 was exhibiting, that year and in 1906 at the Salon d'Automne and from 1904 until World War I at the Salon des Indépendants. Between 1905 and 1907, Delaunay became friendly with Henri Rousseau and Jean Metzinger and studied the color theories of Michel-Eugène Chevreul; he was then painting in a Neo-Impressionist manner. Paul Cézanne's work also influenced Delaunay around this time. From 1907–08, he served in the military in Laon, and upon returning to Paris he had contact with the Cubists. The period 1909–10 saw the emergence of Delaunay's personal style; he painted his first Eiffel Tower in 1909. In 1910, Delaunay married the painter Sonia Terk, who became his collaborator on many projects.

Delaunay's participation in exhibitions in Germany and association with advanced artists working there began in 1911, the year Vasily Kandinsky invited him to participate in the first Blaue Reiter exhibition in Munich. At this time, he became friendly with Guillaume Apollinaire, Albert Gleizes, and Henri Le Fauconnier. In 1912, Delaunay's first solo show took place at the Galerie Barbazanges, Paris, and he began his *Windows* pictures. Inspired by the *Windows*' lyricism of color, Apollinaire invented the term "Orphism," or "Orphic Cubism," to describe Delaunay's work. In 1913, Delaunay painted his *Circular Form*, or *Disc*, pictures.

From 1914 to 1920, Delaunay lived in Spain and Portugal and became friends with Sergei Diaghilev, Leonide Massine, Diego Rivera, and Igor Stravinsky. He designed decor for the Ballets Russes in 1918. By 1920, he had returned to Paris, where in 1922 an exhibition of his work was held at Galerie Paul Guillaume, and he began his second *Eiffel Tower* series. In 1924, he undertook his *Runner* paintings and in 1925 executed frescoes for the Palais de l'Ambassade de France at the *Exposition internationale des arts décoratifs* in Paris. In 1937, he completed murals for the Palais des Chemins de Fer and Palais de l'Air at the Paris World's Fair. His last works were decorations for the sculpture hall of the Salon des Tuileries in 1938. In 1939, he helped organize the exhibition *Réalités nouvelles*. Delaunay died October 25, 1941, in Montpellier, France.

Jean Dubuffet was born July 31, 1901, in Le Havre, France.

He attended art classes in his youth and in 1918 moved to Paris to study at the Académie Julian, which he left after six months. During this time, Dubuffet met Raoul Dufy, Max Jacob, Fernand Léger, and Suzanne Valadon and became fascinated with Hans Prinzhorn's book on psychopathic art. He traveled to Italy in 1923 and South America in 1924. Then, Dubuffet gave up painting for about ten years, working as an industrial draftsman and later in the family wine business. He committed himself to becoming an artist in 1942.

Dubuffet's first solo exhibition was held at the Galerie René Drouin, Paris, in 1944. During the 1940s, the artist associated with André Breton, Georges Limbour, Jean Paulhan, and Charles Ratton. His style and subject matter in this period owed a debt to Paul Klee. From 1945, he collected Art Brut, spontaneous, direct works by untutored individuals, such as mental patients. The Pierre Matisse Gallery gave him his first solo show in New York in 1947.

From 1951 to 1952, Dubuffet lived in New York. He then returned to Paris, where a retrospective of his work took place at the Cercle Volney in 1954. His first museum retrospective occurred in 1957 at the Schloss Morsbroich, Leverkusen. (Dubuffet exhibitions have since been held at the Musée des Arts Décoratifs, Paris, the Museum of Modern Art, New York, the Art Institute of Chicago, the Stedelijk Museum, Amsterdam, the Tate Gallery, London, and the Solomon R. Guggenheim Museum, New York.) His *L'Hourloupe*, a series of paintings begun in 1962, were exhibited at the Palazzo Grassi, Venice, in 1964. A collection of Dubuffet's writings, *Prospectus et tous écrits suivants*, was published in 1967, the same year he started his architectural structures. Soon thereafter, he began numerous commissions for monumental outdoor sculptures. In 1971 he produced his first theater props, the "practicables." A Dubuffet retrospective was presented at the Akademie der Künste, Berlin, the Museum Moderner Kunst, Vienna, and the Joseph-Haubrichkunsthalle, Cologne, in 1980 – 81. In 1981, the Solomon R. Guggenheim Museum observed the artist's eightieth birthday with an exhibition. Dubuffet died May 12, 1985, in Paris.

Max Ernst was born April 2, 1891, in Bruhl, Germany. He enrolled in the

University at Bonn in 1909 to study philosophy but soon abandoned this pursuit to concentrate on art. At this time, he was interested in psychology and the art of the mentally ill. In 1911, Ernst became a friend of August Macke and joined the Rheinische Expressionisten group in Bonn. Ernst showed for the first time in 1912 at the Galerie Feldman, Cologne. At the Sonderbund exhibition of that year in Cologne, he saw the work of Paul Cézanne, Edvard Munch, Pablo Picasso, and Vincent van Gogh. In 1913, he met Guillaume Apollinaire and Robert Delaunay and traveled to Paris. Ernst participated that same year in the *Erste deutsche Herbstsalon.* In 1914, he met Jean Arp, who was to become a lifelong friend.

Despite military service throughout World War I, Ernst was able to continue painting and to exhibit in Berlin at Der Sturm gallery in 1916. He returned to Cologne in 1918. The next year, he produced his first collages and founded the short-lived Cologne Dada movement with Johannes Theodor Baargeld; they were joined by Arp and others. In 1921, Ernst exhibited for the first time in Paris, at the Galerie Au Sans Pareil. He was involved in Surrealist activities in the early 1920s with Paul Eluard and André Breton. In 1925, Ernst executed his first frottages; a series of frottages was published in his book *Histoire naturelle* in 1926. He collaborated with Joan Miró on ballet designs for Sergei Diaghilev that same year. The first of his collage-novels, *La Femme 100 têtes*, was published in 1929. The following year, the artist collaborated with Luis Buñuel and Salvador Dalí on the film *L'Age d'or.*

Ernst's first American show was held at the Julien Levy Gallery, New York, in 1932. In 1936, he was represented in *Fantastic Art, Dada, Surrealism* at the Museum of Modern Art, New York. In 1939, he was interned in France as an enemy alien. Two years later, Ernst fled to the United States with Peggy Guggenheim, whom he married early in 1942. After their divorce, he married Dorothea Tanning and in 1953 resettled in France. Ernst received the Grand Prize for painting at the Venice Biennale in 1954. In 1975, the Solomon R. Guggenheim Museum, New York, gave him a retrospective, which traveled in modified form to the Musée National d'Art Moderne, Paris. He died April 1, 1976, in Paris.

Lucio Fontana was born February 19, 1899, in Rosario de Santa

Fé, Argentina. His father was Italian and his mother Argentinean. He lived in Milan from 1905 to 1922 and then moved back to Argentina, where he worked as a sculptor in his father's studio for several years before opening his own. In 1926, he participated in the first exhibition of Nexus, a group of young Argentinean artists working in Rosario de Santa Fé. Upon his return to Milan in 1928, Fontana enrolled at the Accademia di Belle Arti di Brera, which he attended for two years.

The Galleria Il Milione, Milan, organized Fontana's first solo exhibition in 1930. In 1934, he joined the group of abstract Italian sculptors associated with Galleria Il Milione. The artist traveled to Paris in 1935 and joined the Abstraction-Création group. The same year, he developed his skills in ceramics in Albisola, Italy, and later at the Sèvres factory, near Paris. In 1939, he joined the Corrente, a Milan group of expressionist artists. He also intensified his lifelong collaboration with architects during this period. In 1940, Fontana moved to Buenos Aires. With some of his students, he founded in 1946 the Academia de Altamira from which emerged the Manifiesto Blanco group. He moved back to Milan in 1947 and in collaboration with a group of writers and philosophers signed the "Primo manifesto dello spazialismo." He subsequently resumed his ceramic work in Albisola to explore these new ideas with his *Spatial Concepts* (*Concetti spaziali*).

The year 1949 marked a turning point: Fontana concurrently created the *Holes* (*Buchi*), his first series of paintings in which he punctured the canvas, and his first spatial environment, a combination of shapeless sculptures, fluorescent paintings, and black lights to be viewed in a dark room. The latter work led him to employ neon tubing in ceiling decoration. In the early 1950s, he participated in the Italian Art Informel exhibitions. During this decade, he explored various effects, such as slashing and perforating, in both painting and sculpture. The artist visited New York in 1961 during a show of his work at the Martha Jackson Gallery. In 1966, he designed opera sets and costumes for La Scala, Milan. In the last year of his career, Fontana became increasingly interested in the staging of his work in the many exhibitions that honored him worldwide, as well as in the idea of purity achieved in his last white canvases. These concerns were prominent at the 1966 Venice Biennale for which he designed the environment for his work, and at the 1968 Documenta in Kassel. Fontana died September 7, 1968, in Comabbio, Italy.

Naum Gabo

was born Naum Pevsner on August 5, 1890, in Briansk, Russia. From 1910 to 1911, he studied medicine, science, and art history at the University in Munich. In 1913 and 1914, he visited Paris, where he saw the work of Albert Gleizes, Jean Metzinger, Fernand Léger, and Robert Delaunay. During World War I, he lived in Oslo with his brother Antoine Pevsner. He executed his first construction in 1915 and signed it "Gabo."

In 1917, Gabo settled in Moscow; there he associated with Vladimir Tatlin, Kazimir Malevich, and Alexander Rodchenko. He and Pevsner published their "Realistic Manifesto" in 1920. In 1922, they participated in the *Erste Russische Kunstausstellung* at the Galerie van Diemen in Berlin. Gabo lived in Berlin for the next decade. The exhibition *Constructivistes russes: Gabo et Pevsner* was held at the Galerie Percier in Paris in 1924. Gabo was given his first one-man show in 1930 at the Kestner-Gesellschaft in Hannover. In 1932, the artist left Germany for Paris, where he became a leading member of the Abstraction-Création group. He moved to England in 1936 and the following year collaborated with Ben Nicholson and the architect Leslie Martin on the periodical *Circle: International Survey of Constructivist Art.*

Gabo visited the United States for the first time in 1938, when his sculpture was shown at the Wadsworth Atheneum, Hartford, Connecticut, the Julien Levy Gallery, New York and Vassar College, Poughkeepsie. In 1944, he worked with Herbert Read in London at the Design Research Unit, which promoted cooperation between artists and industry. Gabo moved to the United States in 1946 and two years later shared an exhibition with Pevsner at the Museum of Modern Art, New York. In 1952, he became a United States citizen and from 1953 to 1954 taught at the Harvard University Graduate School of Architecture. During the mid-1950s, the artist worked on commissions for the De Bijenkorf building in Rotterdam and for the United States Rubber Company at Rockefeller Center in New York. A retrospective of his work was shown in Amsterdam, Mannheim, Duisburg, Zurich, Stockholm, and London in 1965–66, and important Gabo exhibition toured Europe from 1970 to 1972. In 1973, he received a sculpture commission from the Nationalgalerie of Berlin. The Tate Gallery in London presented a major exhibition of his work in 1976. Gabo died on August 23, 1977, in Middlebury, Connecticut.

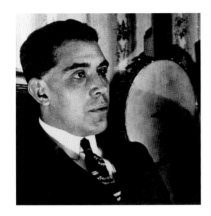

Juan Gris

was born March 23, 1887, as José Victoriano Carmelo Carlos González-Pérez, in Madrid. He studied mechanical drawing at the Escuela de Artes y Manufacturas in Madrid from 1902 to 1904, during which time he contributed drawings to local periodicals. From 1904 to 1905, he studied painting with the academic artist José Maria Carbonero. In 1906, he moved to Paris, where he lived for most of the remainder of his life. His friends in Paris included Georges Braque, Fernand Léger, and Pablo Picasso and the writers Guillaume Apollinaire, Max Jacob, and Maurice Raynal. Although he continued to submit humorous illustrations to journals such as *L'Assiette au beurre*, *Le Charivari*, and *Le Cri de Paris*, Gris began to paint seriously in 1910. By 1912, he had developed a personal Cubist style.

He exhibited for the first time in 1912: at the Salon des Indépendants, Paris, Galeries Dalmau, Barcelona, Der Sturm gallery, Berlin, the Salon de la Société Normande de Peinture Moderne, Rouen, and the Salon de la Section d'Or, Paris. That same year, Daniel-Henri Kahnweiler signed Gris to a contract that gave Kahnweiler exclusive rights to the artist's work. Gris became a good friend of Henri Matisse in 1914 and over the next several years formed close relationships with Jacques Lipchitz and Jean Metzinger. After Kahnweiler fled Paris at the outbreak of World War I, Gris signed a contract with Léonce Rosenberg in 1916. His first major solo show was held at Rosenberg's Galerie l'Effort Moderne, Paris, 1919. The following year, Kahnweiler returned and once again became Gris's dealer.

In 1922, the painter first designed ballet sets and costumes for Sergei Diaghilev. Gris articulated most of his aesthetic theories during 1924 and 1925. He delivered his definitive lecture, "Des possibilités de la peinture," at the Sorbonne in 1924. Gris exhibitions took place at the Galerie Simon, Paris, and the Galerie Flechtheim, Berlin, in 1923 and at the Galerie Flechtheim, Düsseldorf, in 1925. As his health declined, Gris made frequent visits to the south of France. Gris died May 11, 1927, in Boulogne-sur-Seine, France.

Hans Hofmann was born March 21, 1880, in Weissenburg,

Bavaria. He was raised in Munich, where in 1898 he began to study at various art schools. The patronage of Philip Freudenberg, a Berlin art collector, enabled Hofmann to live in Paris from 1904 to 1914. In Paris, he attended the Académie de la Grande Chaumière; he met Georges Braque, Pablo Picasso, and other Cubists and was a friend of Robert Delaunay, who stimulated his interest in color. In 1909, Hofmann exhibited with the Secession in Berlin, and in 1910 was given his first solo exhibition at Paul Cassirer's gallery there. During this period he painted in a Cubist style.

At the outbreak of World War I, Hofmann was in Munich; he remained there and in 1915 opened an art school, which became highly successful. The artist taught at the University of California at Berkeley during the summer of 1930. He returned to teach in California in 1931, and his first exhibition in the United States took place that summer at the California Palace of the Legion of Honor, San Francisco. In 1932, he closed his Munich school and decided to settle in the United States. His first school in New York opened in 1933 and was succeeded in 1934 by the Hans Hofmann School of Fine Arts; in 1935, he established a summer school in Provincetown, Massachusetts.

After an extended period devoted to drawing, Hofmann returned to painting in 1935, combining Cubist structure, vivid color, and emphatic gesture. He became a United States citizen in 1941. The artist's completely abstract works date from the 1940s. His first solo exhibition in New York took place at Peggy Guggenheim's gallery, Art of This Century, in 1944. Hofmann was an important influence upon younger artists. In 1958, he closed his schools to devote himself full time to painting. Hofmann died February 17, 1966, in New York.

Vasily Kandinsky was born December 4, 1866, in Moscow.

From 1886 to 1892, he studied law and economics at the University of Moscow, where he lectured after graduation. In 1896, he declined a teaching position in order to study art in Munich with Anton Azˇbe from 1897 to 1899 and at the Kunstakademie with Franz von Stuck in 1900. Kandinsky taught from 1901 to 1903 at the art school of the Phalanx, a group he had cofounded in Munich. One of his students, Gabriele Münter, would be his companion until 1914. In 1902, Kandinsky exhibited for the first time with the Berlin Secession and produced his first woodcuts. In 1903 and 1904, he began his travels in Italy, the Netherlands, and North Africa and visits to Russia. He showed at the Salon d'Automne in Paris from 1904.

In 1909, Kandinsky was elected president of the newly founded Neue Künstlervereinigung München (NKVM). The group's first show took place at Heinrich Thannhauser's Moderne Galerie in Munich in 1909. In 1911, Kandinsky and Franz Marc began to make plans for *Der Blaue Reiter Almanac*, although the publication would not appear until the following year. Kandinsky's *On the Spiritual in Art* was published in December 1911. He and Marc withdrew from the NKVM that month, and shortly thereafter the Blaue Reiter group's first exhibition was held at the Moderne Galerie. In 1912, the second Blaue Reiter show was held at the Galerie Hans Goltz, Munich. Kandinsky's first solo show was held at Der Sturm gallery in Berlin in 1912. In 1913, one of his works was included in both the Armory Show in New York and the *Erste deutsche Herbstsalon* at Der Sturm gallery in Berlin. Kandinsky lived in Russia from 1914 to 1921, principally in Moscow, where he held a position at the People's Commissariat of Education.

Kandinsky began teaching at the Bauhaus in Weimar in 1922. In 1923, he was given his first solo show in New York by the Société Anonyme, of which he became vice-president. Lyonel Feininger, Alexej Jawlensky, Kandinsky, and Paul Klee made up the Blaue Vier group, formed in 1924. He moved with the Bauhaus to Dessau in 1925 and became a German citizen in 1928. The Nazi government closed the Bauhaus in 1933, and later that year, Kandinsky settled in Neuilly-sur-Seine, near Paris. He acquired French citizenship in 1939. Fifty-seven of his works were confiscated by the Nazis in the 1937 purge of "degenerate art." Kandinsky died December 13, 1944, in Neuilly.

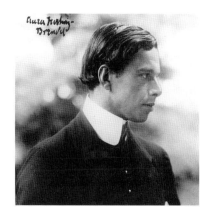

Ernst Ludwig Kirchner was born on May 6,

1880, in Aschaffenburg, Germany. After years of travel, his family settled in Chemnitz in 1890. From 1901 to 1905, he studied architecture at the Dresden Technische Hochschule and pictorial art in Munich at the Kunsthochschule and at an experimental art school established by Wilhelm von Debschitz and Hermann Obrist. While in Munich, he produced his first woodcuts; the graphic arts were to become as important to him as painting. At that time, he was drawn to Neo-Impressionism as well as to the Old Masters.

In 1905, Die Brücke (The Bridge) was founded in Dresden by Fritz Bleyl, Erich Heckel, Kirchner, and Karl Schmidt-Rottluff; later, Cuno Amiet, Otto Müller, Emil Nolde, and Max Pechstein joined the group. From 1905 to 1910, Dresden hosted exhibitions of Post-Impressionism, including the work of Vincent van Gogh, as well as shows featuring Gustav Klimt, Edvard Munch, and the Fauves, which deeply impressed Kirchner. Other important influences were Japanese prints, the Ajanta wall paintings, and African and Oceanic art. Kirchner moved to Berlin with Die Brücke in 1911. The following year, Franz Marc included works by Die Brücke artists in the second show of the Blaue Reiter (Blue Rider) in Munich, thus providing a link between the two groups. In 1913, Kirchner exhibited in the Armory Show in New York, Chicago, and Boston, and was given his first solo shows in Germany, at the Folkwang Museum, Hagen, and Galerie Gurlitt, Berlin. That year also marked the dissolution of Die Brücke.

During World War I, Kirchner was discharged from the army because of a nervous and physical collapse. He was treated at Dr. Kohnstamm's sanatorium in Königstein near Frankfurt, where he completed five wall frescoes in 1916. The artist was severely injured when struck by an automobile in 1917. The next year, he settled in Frauenkirch near Davos, Switzerland, where many young artists, particularly those of the Basel-based Rot-Blau group, sought him out for guidance. Solo shows of Kirchner's work were held throughout the 1930s in Basel, Bern, Hamburg, Munich, Detroit, and New York. However, physical deterioration and mental anxiety overtook him again in the middle of the decade. His inclusion in the 1937 Nazi-sponsored exhibition *Degenerate Art* (*Entartete Kunst*) in Munich caused him further distress. Kirchner died by his own hand on June 15, 1938, in Frauenkirch, Switzerland.

Paul Klee was born December 18, 1879, in Munchenbuchsee, Switzerland,

into a family of musicians. His childhood love of music was always to remain profoundly impor-
tant in his life and work. From 1898 to 1901, Klee studied in Munich, first with Heinrich Knirr,
then at the Akademie under Franz von Stuck. Upon completing his schooling, he traveled to Italy
in the first of the trips abroad that would nourish his visual sensibilities. He settled in Bern in
1902. A series of his satirical etchings was exhibited at the Munich Secession in 1906. That same
year, Klee married and moved to Munich. Here he gained exposure to Modern art. Klee's work
was shown at the Kunstmuseum Bern in 1910 and at Heinrich Thannhauser's Moderne Galerie,
Munich, in 1911.

Klee met Alexej Jawlensky, Vasily Kandinsky, August Macke, Franz Marc, and other avant-garde
figures in 1911. He participated in important shows of advanced art, including the second Blaue
Reiter exhibition in 1912, and the *Erste deutsche Herbstsalon* in 1913. In 1912, he visited Paris for
the second time, where he saw the work of Georges Braque and Pablo Picasso and met Robert
Delaunay. Klee helped found the Neue Münchner Secession in 1914. Color became central to his
art only after a revelatory trip to North Africa in 1914.

In 1920, a major Klee retrospective was held at the Galerie Hans Goltz, Munich; his *Schöpferische
Konfession* (*Creative Credo*) was published; he was also appointed to the faculty of the Bauhaus.
Klee taught at the Bauhaus in Weimar from 1921 to 1926 and in Dessau from 1926 to 1931. During
his tenure, he was in close contact with other Bauhaus masters such as Kandinsky and Lyonel
Feininger. In 1924 the Blaue Vier, consisting of Feininger, Jawlensky, Kandinsky, and Klee, was
founded. Among his notable exhibitions of this period were his first in the United States at the
Société Anonyme, New York, in 1924; his first major show in Paris the following year at the
Galerie Vavin-Raspail; and an exhibition at the Museum of Modern Art, New York, in 1930. Klee
went to Düsseldorf to teach at the Akademie in 1931, shortly before the Nazis closed the Bauhaus.
Forced by the Nazis to leave his position in Düsseldorf in 1933, Klee settled in Bern. Major Klee
exhibitions took place in Bern and Basel in 1935 and in Zurich in 1940. Klee died on June 29,
1940, in Muralto-Locarno, Switzerland.

Franz Kline was born May 23, 1910, in Wilkes-Barre, Pennsylvania.

While enrolled at Boston University, he took art classes at the Boston Art Students League from 1931 to 1935. In 1935, Kline went to London and attended Heatherley's Art School from 1936 to 1938. He settled permanently in New York in 1939. Kline was fortunate to have the financial support and friendship of two patrons, Dr. Theodore J. Edlich, Jr., and I. David Orr, who commissioned numerous portraits and bought many other works from him. During the late 1930s and 1940s, Kline painted cityscapes and landscapes of the coal-mining district where he was raised as well as commissioned murals and portraits. In this period he received awards in several National Academy of Design Annuals.

In 1943, Kline met Willem de Kooning at Conrad Marca-Relli's studio and within the next few years also met Jackson Pollock. Kline's interest in Japanese art began at this time. His mature abstract style, developed in the late 1940s, is characterized by bold gestural strokes of fast-drying black and white enamel. His first solo exhibition was held at the Egan Gallery, New York, in 1950. Soon after, he was recognized as a major figure in the emerging Abstract Expressionist movement. Although Kline was best-known for his black-and-white paintings, he also worked extensively in color, from the mid-1950s to the end of his life.

Kline spent a month in Europe in 1960 and traveled mostly in Italy. In the decade before his death, he was included in major international exhibitions, including the 1956 and 1960 Venice Biennales and the 1957 São Paulo Bienal, and he won a number of important prizes. Kline died May 13, 1962, in New York.

Oskar Kokoschka was born on March 1, 1886, in the

Austrian town of Pöchlarn. He spent most of his youth in Vienna, where he entered the Kunstgewerbeschule in 1904 or 1905. While still a student, he painted fans and postcards for the Wiener Werkstätte, which published his first book of poetry in 1908. That same year, Kokoschka was fiercely criticized for the works he exhibited in the Vienna Kunstschau and consequently was dismissed from the Kunstgewerbeschule. At this time, he attracted the attention of the architect Adolf Loos, who became his most vigorous supporter. In this early period, Kokoschka wrote plays that are considered among the first examples of Expressionist drama.

Kokoschka's first solo show was held at Paul Cassirer's gallery in Berlin in 1910, followed later that year by another at the Museum Folkwang in Essen. In 1910, he also began to contribute to Herwarth Walden's periodical *Der Sturm*. Kokoschka concentrated on portraiture at this time. In 1915, shortly after the outbreak of World War I, he volunteered to serve on the eastern front, where he was seriously wounded. Still recuperating in 1917, he settled in Dresden and in 1919 accepted a professorship at the art academy there. In 1918, Paul Westheim's comprehensive monograph on the artist was published.

Kokoschka traveled extensively during the 1920s and 1930s in Europe, North Africa, and the Middle East. In 1931, he returned to Vienna, but, as a result of the Nazis' growing power, he moved to Prague in 1935. He acquired Czechoslovak citizenship two years later. Kokoschka painted a portrait of Czechoslovakia's president Thomas Garrigue Masaryk in 1936, and the two became friends. In 1937, the Nazis condemned his work as "degenerate art" and removed it from public view. The artist fled to England in 1938, the year of his first solo show in the United States at the Buchholz Gallery in New York. In 1947, he became a British national. Two important traveling shows of Kokoschka's work originated in Boston and Munich in 1948 and 1950, respectively. In 1953, he settled in Villeneuve, near Geneva, and began teaching at the Internationale Sommer Akademie für bildende Kunst. Kokoschka's collected writings were published in 1956, and around this time he became involved in stage design. In 1962, he was honored with a retrospective at the Tate Gallery in London. Kokoschka died on February 22, 1980, in Montreux, Switzerland.

František Kupka was born September 23, 1871, in Opočno in

eastern Bohemia. From 1889 to 1892, he studied at the Prague art academy. At this time, he painted historical and patriotic themes. In 1892, Kupka enrolled at the Akademie der Bildenden Künste, Vienna, where he concentrated on symbolic and allegorical subjects. He exhibited at the Kunstverein, Vienna, in 1894. His involvement with theosophy and Eastern philosophy dates from this period. By spring 1896, Kupka had settled in Paris; there he briefly attended the Académie Julian and then studied with Jean-Pierre Laurens at the Ecole des Beaux-Arts.

Kupka worked as an illustrator of books and posters and, during his early years in Paris, became known for his satirical drawings for newspapers and magazines. In 1906, he settled in Puteaux, a suburb of Paris, and that same year exhibited for the first time at the Salon d'Automne. Kupka was deeply impressed by the first Futurist manifesto, published in 1909 in *Le Figaro*. His work became increasingly abstract around 1910 – 11, reflecting his theories of motion, color, and the relationship between music and painting. In 1911, he attended meetings of the Puteaux group. In 1912, he exhibited at the Salon des Indépendants in the Cubist room, although he did not wish to be identified with any movement.

Creation in the Plastic Arts, a book Kupka completed in 1913, was published in Prague in 1923. In 1921, his first solo show in Paris was held at Galerie Povolozky. In 1931, he was a founding member of Abstraction-Création together with Jean Arp, Albert Gleizes, Jean Hélion, Auguste Herbin, Theo van Doesburg, and Georges Vantongerloo. In 1936, his work was included in the exhibition *Cubism and Abstract Art* at the Museum of Modern Art, New York, and in an important show with Alphonse Mucha at the Jeu de Paume, Paris. A retrospective of his work took place at the Galerie S.V.U. Mánes in Prague in 1946. The same year, Kupka participated in the Salon des Réalités Nouvelles, Paris, where he continued to exhibit regularly until his death. During the early 1950s, he gained general recognition and had several solo shows in New York. Kupka died in Puteaux, France, on June 24, 1957.

Mikhail Larionov was born May 22, 1881, at Tiraspol in

Bessarabia, Russia. From 1898 to 1908, he studied at the Moscow School of Painting, Sculpture, and Architecture, where he met Natalia Goncharova; the two lived and worked together until her death in 1962. In 1906, he visited Paris with Sergei Diaghilev, who included Larionov's work in the exhibition of Russian artists at the Salon d'Automne of that year. In 1907, the artist abandoned the Impressionism of his previous work for a neoprimitive style inspired by Russian folk art. With the Burliuk brothers and others, he formed the Blue Rose group, under whose auspices the review *The Golden Fleece* was published. The first *Golden Fleece* exhibition of 1908 in Moscow introduced many Modern French masters to the Russian public. Larionov also organized the avant-garde *Link* and *Donkey's Tail* exhibitions of 1908 and 1912, respectively, and founded the Jack of Diamonds group in 1910.

In 1911, he developed a personal abstract style that would later be known as Rayism. An amalgam of Cubism and Italian Futurism, with an emphasis on dynamic, linear light rays, Rayism received its public debut at the *Target* exhibition of 1913. That same year, Larionov's Rayist manifesto was published in Moscow. The artist also participated in the *Erste deutsche Herbstsalon* at Der Sturm gallery, Berlin, in 1913, and the following year organized the exhibition *No. 4* in Moscow. In May 1914, Larionov and Goncharova accompanied Diaghilev's Ballets Russes to Paris; there Larionov associated with Guillaume Apollinaire. Larionov returned to Russia in July upon the outbreak of World War I and served at the front until his demobilization for health reasons. He then rejoined Diaghilev in Switzerland and devoted himself almost exclusively to designing sets and costumes for the Ballets Russes. After Diaghilev died in 1929, Larionov organized a retrospective of maquettes, costumes, and decor for his ballets at the Galerie Billiet in Paris in 1930, at which time he published *Les Ballets Russes de Diaghilev* with Goncharova and Pierre Vorms.

In 1938, Larionov became a French citizen. He and Goncharova were given a number of joint exhibitions throughout their careers, among them retrospectives in Paris at the Galerie des Deux-Iles in 1948, the Galerie de l'Institut in 1952, and the Musée National d'Art Moderne in 1963. A solo exhibition of Larionov's work was held in 1956 at the Galerie de l'Institut. Larionov died May 10, 1964, at Fontenay-aux-Roses, France.

Fernand Léger

was born February 4, 1881, in Argentan, France. After apprenticing with an architect in Caen from 1897 to 1899, Léger settled in Paris in 1900 and supported himself as an architectural draftsman. He was refused entrance to the Ecole des Beaux-Arts but nevertheless attended classes there beginning in 1903; he also studied at the Académie Julian. Léger's earliest known works, which date from 1905, were primarily influenced by Impressionism. The experience of seeing the Paul Cézanne retrospective at the Salon d'Automne in 1907 and his contact with the early Cubism of Pablo Picasso and Georges Braque had an extremely significant impact on the development of his personal style. From 1911 to 1914, Léger's work became increasingly abstract, and he began to limit his palette to primary colors and black and white. In 1912, he was given his first solo show at Galerie Kahnweiler, Paris.

Léger served in the military from 1914 to 1917. His "mechanical" period, in which figures and objects are characterized by tubular, machine-like forms, began in 1917. During the early 1920s, he collaborated with the writer Blaise Cendrars on films and designed sets and costumes for performances by Rolf de Maré's Ballets Suédois; in 1924, he completed his first nonnarrative film *Ballet mécanique*. Léger opened an atelier with Amédée Ozenfant in 1924 and in 1925 presented his first murals at Le Corbusier's Pavillon de l'Esprit Nouveau at the *Exposition internationale des arts décoratifs*. In 1931, he visited the United States for the first time. In 1935, the Museum of Modern Art, New York, and the Art Institute of Chicago presented an exhibition of his work.

Léger lived in the United States from 1940 to 1945 but returned to France after the war. In the decade before his death, Léger's wide-ranging projects included book illustrations, monumental figure paintings and murals, stained-glass windows, mosaics, polychrome ceramic sculptures, and set and costume designs. In 1955, he won the Grand Prize at the São Paulo Bienal. Léger died August 17 of that year, at his home in Gif-sur-Yvette, France.

Kazimir Malevich was born February 26, 1878, near Kiev.

He studied at the Moscow Institute of Painting, Sculpture, and Architecture in 1903. During the early years of his career, he experimented with various Modernist styles and participated in avant-garde exhibitions, such as those of the Moscow Artists' Association, which included Vasily Kandinsky and Mikhail Larionov, and the *Jack of Diamonds* exhibition of 1910 in Moscow. Malevich showed his neoprimitivist paintings of peasants at the exhibition *Donkey's Tail* in 1912. After this exhibition he broke with Larionov's group. In 1913, with composer Mikhail Matiushin and writer Alexei Kruchenykh, Malevich drafted a manifesto for the First Futurist Congress. That same year he designed the sets and costumes for the opera *Victory over the Sun* by Matiushin and Kruchenykh. Malevich showed at the Salon des Indépendants in Paris in 1914.

At the *0.10 The Last Futurist Exhibition of Pictures* in Petrograd in 1915, Malevich introduced his non-objective, geometric Suprematist paintings. In 1919, he began to explore the three-dimensional applications of Suprematism in architectural models. Following the Bolshevik Revolution in 1917, Malevich and other advanced artists were encouraged by the Soviet government and attained prominent administrative and teaching positions. Malevich began teaching at the Vitebsk Popular Art School in 1919; he soon became its director. In 1919–20, he was given a solo show at the *Sixteenth State Exhibition* in Moscow, which focused on Suprematism and other non-objective styles. Malevich and his students at Vitebsk formed the Suprematist group Unovis. From 1922 to 1927, he taught at the Institute of Artistic Culture in Petrograd, and between 1924 and 1926 he worked primarily on architectural models with his students.

In 1927, Malevich traveled with an exhibition of his paintings to Warsaw and also went to Berlin, where his work was shown at the *Grosse Berliner Kunstausstellung*. In Germany, he met Jean Arp, Naum Gabo, Le Corbusier, and Kurt Schwitters and visited the Bauhaus where he met Walter Gropius. The Tretiakov Gallery in Moscow gave Malevich a solo exhibition in 1929. Because of his connections with German artists he was arrested in 1930, and many of his manuscripts were destroyed. In his final period, he painted in a representational style. Malevich died May 15, 1935, in Leningrad.

Franz Marc

Franz Marc was born February 8, 1880, in Munich. The son of a landscape painter, he decided to become an artist after a year of military service interrupted his plans to study philology. From 1900 to 1902, he studied at the Kunstakademie in Munich with Gabriel Hackl and Wilhelm von Diez. The following year during a visit to France, he was introduced to Japanese woodcuts and the work of the Impressionists in Paris.

Marc suffered from severe depression between 1904 and 1907. In 1907, he went again to Paris, where he responded enthusiastically to the work of Paul Gauguin, Vincent van Gogh, the Cubists, and the Expressionists; later, he was impressed by the Henri Matisse exhibition in Munich in 1910. During this period, he received steady income from the animal-anatomy lessons he gave to artists.

In 1910, Marc's first solo show was held at Kunsthandlung Brackl, Munich, and he met August Macke and the collector Bernhard Koehler. He publicly defended the Neue Künstlervereinigung München (NKVM) and was formally welcomed into the group early in 1911, when he met Vasily Kandinsky. After internal dissension split the NKVM, he and Kandinsky formed Der Blaue Reiter, whose first exhibition took place in December 1911 at Heinrich Thannhauser's Moderne Galerie, Munich. Marc invited members of the Berlin Die Brücke group to participate in the second Blaue Reiter show two months later at the Galerie Hans Goltz, Munich. *Der Blaue Reiter Almanac* was published with lead articles by Marc in May 1912. When World War I broke out in August 1914, Marc immediately enlisted. He was deeply troubled by Macke's death in action shortly thereafter; during the war, he produced his *Sketchbook from the Field*. Marc died in the war on March 4, 1916, near Verdun-sur-Meuse, France.

Henri Matisse was born December 31, 1869, in Le Cateau-

Cambrésis, France. He grew up at Bohain-en-Vermandois and studied law in Paris from 1887 to 1888. By 1891, he had abandoned law and started to paint. In Paris, Matisse studied art briefly at the Académie Julian and then at the Ecole des Beaux-Arts with Gustave Moreau.

In 1901, Matisse exhibited at the Salon des Indépendants in Paris and met another future Fauve painter, Maurice de Vlaminck. His first solo show took place at the Galerie Vollard in 1904. Both Gertrude and Leo Stein, as well as Etta and Claribel Cone, began to collect Matisse's work at that time. Like many avant-garde artists in Paris, Matisse was receptive to a broad range of influences. He was one of the first painters to take an interest in "primitive" art. Matisse abandoned the palette of the Impressionists and established his characteristic style with its flat, brilliant color and fluid line. His subjects were primarily women, interiors, and still lifes. In 1913, his work was included in the Armory Show in New York. By 1923, two Russians, Sergei Shchukin and Ivan Morozov, had purchased nearly fifty of his paintings.

From the early 1920s until 1939, Matisse divided his time primarily between the south of France and Paris. During this period, he worked on paintings, sculptures, lithographs, and etchings, as well as on murals for the Barnes Foundation, Merion, Pennsylvania, designs for tapestries, and set and costume designs for Léonide Massine's ballet *Rouge et noir*. While recuperating from two major operations in 1941 and 1942, Matisse concentrated on a technique he had devised earlier: *papiers découpés* (paper cutouts). *Jazz*, written and illustrated by Matisse, was published in 1947. The plates are stencil reproductions of paper cutouts. In 1948, he began the design for the decoration of the Chapelle du Rosaire at Vence, which was completed and consecrated in 1951. The same year, a major retrospective of the artist's work was presented at the Museum of Modern Art, New York, and then traveled to Cleveland, Chicago, and San Francisco. The following year, the Musée Matisse was inaugurated at the artist's birthplace of Le Cateau-Cambrésis. Matisse continued to make his large paper cutouts, the last of which was a design for the rose window at Union Church of Pocantico Hills, New York. He died November 3, 1954, in Nice.

Joan Miró was born April 20, 1893, in Barcelona. At the age of fourteen, he went to business school in Barcelona and also attended La Lonja, the academy of fine arts in the same city. Upon completing three years of art studies, he took a position as a clerk. After suffering a nervous breakdown, he abandoned business and resumed his art studies, attending Francesc Galí's Escola d'Art in Barcelona from 1912 to 1915. Miró received early encouragement from the dealer José Dalmau, who gave him his first solo show at his gallery in Barcelona in 1918. In 1917, he met Francis Picabia.

In 1919, Miró made his first trip to Paris, where he met Pablo Picasso. From 1920, Miró divided his time between Paris and Montroig. In Paris he associated with the poets Max Jacob, Pierre Reverdy, and Tristan Tzara and participated in Dada activities. Dalmau organized Miró's first solo show in Paris, at the Galerie la Licorne in 1921. His work was included in the Salon d'Automne of 1923. In 1924, Miró joined the Surrealist group. His solo show at the Galerie Pierre, Paris, in 1925 was a major Surrealist event; Miró was included in the first Surrealist exhibition at the Galerie Pierre that same year. He visited the Netherlands in 1928 and began a series of paintings inspired by Dutch masters. This year he also executed his first papiers collés and collages. In 1929, he started his experiments in lithography, and his first etchings date from 1933. During the early 1930s, he made Surrealist sculptures incorporating painted stones and found objects. In 1936, Miró left Spain because of the civil war; he returned in 1941.

An important Miró retrospective was held at the Museum of Modern Art, New York, in 1941. That year, Miró began working in ceramics with Josep Lloréns Artigas and started to concentrate on prints; from 1954 to 1958, he worked almost exclusively in these two mediums. In 1958, Miró was given a Guggenheim International Award for murals for the UNESCO Building in Paris; the following year he resumed painting, initiating a series of mural-sized canvases. During the 1960s, he began to work intensively in sculpture. A major Miró retrospective took place at the Grand Palais in Paris in 1974. In 1978, the Musée National d'Art Moderne, Paris, exhibited over five hundred works in a major retrospective of his drawings. Miró died December 25, 1983, in Palma de Mallorca, Spain.

Amedeo Modigliani was born July 12, 1884, in

Livorno, Italy. The serious illnesses he suffered during his childhood persisted throughout his life. At age 14, he began to study painting. He first experimented with sculpture during the summer of 1902 and the following year attended the Reale Istituto di Belle Arti in Venice. Early in 1906, Modigliani went to Paris, where he settled in Montmartre and attended the Académie Colarossi. His early work was influenced by Paul Cézanne, Paul Gauguin, Théophile Alexandre Steinlen, and Henri de Toulouse-Lautrec. In the fall of 1907, he met his first patron, Dr. Paul Alexandre, who purchased works from him before World War I. Modigliani exhibited in the Salon d'Automne in 1907 and 1912 and in the Salon des Indépendants in 1908, 1910, and 1911.

In 1909, Modigliani met Constantin Brancusi when both artists were living in Montparnasse. From 1909 to 1914, he concentrated on sculpture, but he also drew and painted to a certain extent. However, the majority of his paintings date from 1916 to 1919. Modigliani's circle of friends first consisted of Max Jacob, Jacques Lipchitz, and the Portuguese sculptor Amedeo de Suza Cardoso; later, he associated with Tsugouharu Foujita, Moïse Kisling, Jules Pascin, the Sitwells, Chaim Soutine, and Maurice Utrillo. His dealers were Paul Guillaume (1914 – 16) and Leopold Zborowski (by 1917). The only solo show given the artist during his lifetime took place at the Galerie Berthe Weill in December 1917.

In March 1917, Modigliani met Jeanne Hébuterne, who became his companion and model. From March or April 1918 until May 31, 1919, they lived in the south of France, in both Nice and Cagnes. Modigliani died January 24, 1920, in Paris.

László Moholy-Nagy was born July 20, 1895

in Bacsbarsod, Hungary. In 1913, he began law studies at the University of Budapest, but inter-
rupted them the following year to serve in the Austro-Hungarian army. While recovering from a
wound in 1917, he founded the artists' group Ma (Today) with Ludwig Kassak and others in
Szeged, Hungary, and started a literary magazine called *The Present* (*Jelenkor*). After receiving
his law degree, Moholy-Nagy moved to Vienna in 1919, where he collaborated on the Ma period-
ical *Horizont*. He traveled to Berlin in 1920 and began making photograms and Dada collages.

During the early 1920s, Moholy-Nagy contributed to several important art periodicals and
coedited, with Kassak, *The Book of the New Artist* (*Das Buch neuer Künstler*), a volume of poetry
and essays on art. In 1921, he met El Lissitzky in Germany and traveled to Paris for the first time.
His first solo exhibition was organized by Herwarth Walden at the Der Sturm gallery in Berlin
in 1922. During this period, Moholy-Nagy was a seminal figure in the development of
Constructivism. While teaching at the Bauhaus in Weimar in 1923, he became involved in stage
and book design and edited and designed, with Walter Gropius, the Bauhausbücher series pub-
lished by the school. Moholy-Nagy moved with the Bauhaus to Dessau in 1925 and taught there
until 1928, when he returned to Berlin to concentrate on stage design and film.

In 1930, he participated in the *Internationale Werkbund Ausstellung* in Paris. The artist moved to
Amsterdam in 1934, the year a major retrospective of his work was held there, at the Stedelijk
Museum. In 1935, Moholy-Nagy fled to London from the growing Nazi threat; there, he worked
as a designer for various companies and on films and associated with Naum Gabo, Barbara
Hepworth, and Henry Moore. In 1937, he was appointed director of the New Bauhaus in Chicago,
which failed after less than a year because of financial problems. Moholy-Nagy established his
own School of Design in Chicago in 1938 and in 1940 gave his first summer classes in rural
Illinois. He joined the American Abstract Artists group in 1941 and in 1944 became a United
States citizen. His book *Vision in Motion* was published in 1947, after his death on November 24,
1946 in Chicago.

Piet Mondrian was born March 7, 1872, in Amersfoort, the

Netherlands. He studied at the Rijksakademie van Beeldende Kunsten, Amsterdam, from 1892 to 1897. Until 1908, when he began to take annual trips to Domburg in Zeeland, Mondrian's work was naturalistic—incorporating successive influences of academic landscape and still-life painting, Dutch Impressionism, and Symbolism. In 1909, a major exhibition of his work (with that of Jan Sluyters and Cornelis Spoor) was held at the Stedelijk Museum, Amsterdam. That same year, he joined the Theosophic Society. In 1909 and 1910, he experimented with Pointillism and by 1911 had begun to work in a Cubist mode. After seeing original Cubist works by Georges Braque and Pablo Picasso at the first Moderne Kunstkring exhibition in 1911 in Amsterdam, Mondrian decided to move to Paris. There, from 1912 to 1914, he began to develop an independent abstract style.

Mondrian was visiting the Netherlands when World War I broke out and prevented his return to Paris. During the war years in Holland, he further reduced his colors and geometric shapes and formulated his non-objective Neo-Plastic style. In 1917, Mondrian became one of the founders of De Stijl. This group, which included Theo van Doesburg and Georges Vantongerloo, extended its principles of abstraction and simplification beyond painting and sculpture to architecture and graphic and industrial design. Mondrian's essays on abstract art were published in the periodical *De Stijl*. In July 1919, he returned to Paris; there he exhibited with De Stijl in 1923, but withdrew from the group after van Doesburg reintroduced diagonal elements into his work around 1925. In 1930, Mondrian showed with Cercle et Carré and in 1931 joined Abstraction-Création.

World War II forced Mondrian to move to London in 1938 and then to settle in New York in October 1940. In New York, he joined American Abstract Artists and continued to publish texts on Neo-Plasticism. His late style evolved significantly in response to the city. In 1942, his first solo show took place at the Valentine Dudensing Gallery, New York. Mondrian died February 1, 1944, in New York.

Robert Motherwell was born January 4, 1915, in

Aberdeen, Washington. He was awarded a fellowship to the Otis Art Institute in Los Angeles at age eleven, and in 1932 studied painting briefly at the California School of Fine Arts in San Francisco. Motherwell received a bachelor of arts from Stanford University in 1937 and enrolled for graduate work later that year in the Department of Philosophy at Harvard University, Cambridge, Massachusetts. He traveled to Europe in 1938 for a year of study abroad. His first solo show was presented at the Raymond Duncan Gallery in Paris in 1939.

In September 1940, Motherwell settled in New York, where he entered Columbia University to study art history with Meyer Schapiro, who encouraged him to become a painter. In 1941, Motherwell traveled to Mexico with Roberto Matta for six months. After returning to New York, his circle came to include William Baziotes, Willem de Kooning, Hans Hofmann, and Jackson Pollock. In 1942, Motherwell was included in the exhibition *First Papers of Surrealism* at the Whitelaw Reid Mansion, New York. In 1944, Motherwell became editor of the *Documents of Modern Art* series of books, and he contributed frequently to the literature on Modern art from that time.

A solo exhibition of Motherwell's work was held at Peggy Guggenheim's Art of This Century gallery, New York, in 1944. In 1946, he began to associate with Herbert Ferber, Barnett Newman, and Mark Rothko, and spent his first summer in East Hampton, Long Island. This year, Motherwell was given solo exhibitions at the Arts Club of Chicago and the San Francisco Museum of Art, and he participated in *Fourteen Americans* at the Museum of Modern Art in New York. The artist subsequently taught and lectured throughout the United States, and continued to exhibit extensively in the United States and abroad. A Motherwell exhibition took place at the Kunsthalle Düsseldorf, the Museum des 20. Jahrhunderts, Vienna, and the Musée d'Art Moderne de la Ville de Paris in 1976 – 77. He was given important solo exhibitions at the Royal Academy, London, and the National Gallery of Art, Washington, D.C., in 1978. A retrospective of his works organized by the Albright-Knox Art Gallery, Buffalo, New York, traveled in the United States from 1983 to 1985. From 1971, the artist lived and worked in Greenwich, Connecticut. He died July 16, 1991, in Cape Cod, Massachusetts.

Francis Picabia was born on or about January 22, 1879, in

Paris, of a Spanish father and a French mother. He was enrolled at the Ecole des arts décoratifs in Paris from 1895 to 1897 and later studied with Fernand Cormon, Ferdinand Humbert, and Albert Charles Wallet. He began to paint in an Impressionist manner in the winter of 1902–03 and started to exhibit works in this style at the Salon d'Automne and the Salon des Indépendants of 1903. His first solo show was held at the Galerie Haussmann, Paris, in 1905. From 1908, elements of Fauvism and Neo-Impressionism as well as Cubism and other forms of abstraction appeared in his painting, and by 1912 he had evolved a personal amalgam of Cubism and Fauvism. Picabia worked in an abstract mode from this period until the early 1920s.

Picabia became a friend of Guillaume Apollinaire and Marcel Duchamp and associated with the Puteaux group in 1911 and 1912. He participated in the 1913 Armory Show, visiting New York on this occasion and frequenting avant-garde circles. Alfred Stieglitz gave him a solo exhibition at his gallery "291" that same year. In 1915, which marked the beginning of Picabia's machinist or mechanomorphic period, he and Duchamp, among others, instigated and participated in Dada manifestations in New York. Picabia lived in Barcelona in 1916 and 1917; in 1917 he published his first volume of poetry and the first issues of *391*, his magazine modeled after Stieglitz's periodical *291*. For the next few years Picabia remained involved with the Dadaists in Zurich and Paris, creating scandals at the Salon d'Automne, but finally denounced Dada in 1921 for no longer being "new." The following year, he moved to Tremblay-sur-Mauldre outside Paris, and returned to figurative art. In 1924, he attacked André Breton and the Surrealists in *391*.

Picabia moved to Mougins in 1925. During the 1930s, he became a close friend of Gertrude Stein. By the end of World War II, Picabia returned to Paris. He resumed painting in an abstract style and writing poetry. In March 1949, a retrospective of his work was held at the Galerie René Drouin in Paris. Picabia died November 30, 1953, in Paris.

Pablo Picasso was born October 25, 1881, in Málaga, Spain. The

son of an academic painter, José Ruiz Blanco, he began to draw at an early age. In 1895, the family moved to Barcelona, and Picasso studied there at La Lonja, the academy of fine arts. His visit to Horta de Ebro from 1898 to 1899 and his association with the group at the café Els Quatre Gats about 1899 were crucial to his early artistic development. In 1900, Picasso's first exhibition took place in Barcelona, and that fall he went to Paris for the first of several stays during the early years of the century. Picasso settled in Paris in April 1904, and soon his circle of friends included Guillaume Apollinaire, Max Jacob, Gertrude Stein and her brother Leo Stein, as well as the art dealers Ambroise Vollard and Berthe Weill.

Picasso's style developed from the Blue Period (1901–04) to the Rose Period (1905) to the pivotal work *Les Demoiselles d'Avignon* (1907), and the subsequent evolution of Cubism from an Analytic phase (ca. 1908–11), through its Synthetic phase (beginning in 1912–13). His collaboration on ballet and theatrical productions began in 1916. Soon thereafter his work was characterized by neoclassicism and a renewed interest in drawing and figural representation. In the 1920s, the artist and his first wife, Olga (whom he had married in 1918), continued to live in Paris, to travel frequently, and to spend their summers at the beach. From 1925 into the 1930s, Picasso was involved to a certain degree with the Surrealists, and from the fall of 1931 he was especially interested in making sculpture. With large exhibitions at the Galeries Georges Petit, Paris, and the Kunsthaus Zurich in 1932, and the publication of the first volume of Christian Zervos's catalogue raisonné the same year, Picasso's fame increased markedly.

By 1936, the Spanish Civil War had profoundly affected Picasso, the expression of which culminated in his painting *Guernica* (1937). His association with the Communist Party began in 1944. From the late 1940s, he lived in the south of France. Among the enormous number of Picasso exhibitions that were held during the artist's lifetime, those at the Museum of Modern Art, New York, in 1939 and the Musée des Arts Décoratifs, Paris, in 1955 were most significant. In 1961, the artist married Jacqueline Roque, and they moved to Mougins, near Cannes. There, Picasso continued his prolific work in painting, drawing, prints, ceramics, and sculpture until his death on April 8, 1973.

Jackson Pollock was born January 28, 1912, in Cody, Wyoming.

He grew up in Arizona and California and in 1928 began to study painting at the Manual Arts High School, Los Angeles. In the fall of 1930, Pollock came to New York and studied under Thomas Hart Benton at the Art Students League. Benton encouraged him throughout the succeeding decade. By the early 1930s, Pollock knew and admired the murals of José Clemente Orozco and Diego Rivera. Although he traveled widely throughout the United States during the 1930s, much of Pollock's time was spent in New York, where he settled permanently in 1935 and worked on the WPA Federal Art Project from 1935 to 1942. In 1936, he worked in David Alfaro Siqueiros's experimental workshop in New York.

Pollock's first solo show was held at Peggy Guggenheim's Art of This Century gallery, New York, in 1943. Guggenheim gave him a contract that lasted through 1947, permitting him to devote all his time to painting. Prior to 1947, Pollock's work reflected the influence of Pablo Picasso and Surrealism. During the early 1940s, he contributed paintings to several exhibitions of Surrealist and abstract art, including *Natural, Insane, Surrealist Art* at Art of This Century in 1943, and *Abstract and Surrealist Art in America*, organized by Sidney Janis at the Mortimer Brandt Gallery, New York, in 1944.

From the fall of 1945, when artist Lee Krasner and Pollock were married, they lived in the Springs, East Hampton, New York. In 1952, Pollock's first solo show in Paris opened at the Studio Paul Facchetti and his first retrospective was organized by Clement Greenberg at Bennington College, Bennington, Vermont. He was included in many group exhibitions, including the annuals at the Whitney Museum of American Art, New York, from 1946 and the Venice Biennale in 1950. Although his work was widely known and exhibited internationally, the artist never traveled outside the United States. He was killed in an automobile accident on August 11, 1956, in the Springs.

Liubov Popova

was born April 24, 1889, near Moscow. After graduating from high school in Yalta, she studied in Moscow at the Arsenieva Gymnasium in 1907–08 and at the same time attended the studios of Stanislav Zhukovsky and Konstantin Yuon. In the course of her travels in 1909–10, she saw Mikhail Vrubel's work in Kiev, ancient Russian churches in Pskov and Novgorod, and early Renaissance art in Italy. In 1912, Popova worked at The Tower, a Moscow studio, with Vladimir Tatlin and other artists. That winter, she visited Paris, where she worked in the studios of the Cubist painters Le Fauconnier and Jean Metzinger. In 1913, Popova returned to Russia, but the following year she journeyed again to France and to Italy, where she gained familiarity with Futurism.

In her work of 1912 to 1915, Popova was concerned with Cubist form and the representation of movement; after 1915 her nonrepresentational style revealed the influence of icon painting. She participated in many exhibitions of advanced art in Russia during this period: the *Jack of Diamonds* shows of 1914 and 1916 in Moscow; *Tramway V: First Futurist Exhibition of Paintings* and *0.10: The Last Futurist Exhibition*, both in 1915 in St. Petersburg; *The Store* in 1916, *Fifth State Exhibition: From Impressionism to Nonobjective Art* in 1918–19, and *Tenth State Exhibition: Nonobjective Creation and Suprematism* in 1919, all in Moscow. In 1916, Popova joined the Supremus group, which was organized by Kazimir Malevich. She taught at Svomas (Free State Art Studios) and Vkhutemas (Higher State Art-Technical Institute) from 1918 onward and was a member of Inkhuk (Institute of Painterly Culture) from 1920 to 1923.

The artist participated in the *5x5=25* exhibition in 1921 and in the *Erste russische Kunstausstellung*, held under the auspices of the Russian government in Berlin in 1922. In 1921, Popova turned away from studio painting to execute utilitarian Productivist art: she designed textiles, dresses, books, porcelain, costumes, and theater sets (the latter for Vsevolod Meierkhold's productions of Fernand Crommelynk's *The Magnanimous Cuckold*, 1922, and Serge Tretiakov's *Earth in Turmoil*, 1923). Popova died May 25, 1924, in Moscow.

ROTHKO 1903-1970

Mark Rothko was born September 25, 1903, in Dvinsk, Russia. In

1913, he left Russia and settled with the rest of his family in Portland, Oregon. Rothko attended Yale University, New Haven, on a scholarship from 1921 to 1923. That year, he left Yale without receiving a degree and moved to New York. In 1925, he studied under Max Weber at the Art Students League. He participated in his first group exhibition at the Opportunity Galleries, New York, in 1928. During the early 1930s, Rothko became a close friend of Milton Avery and Adolph Gottlieb. His first solo show took place at the Portland Art Museum in 1933.

Rothko's first solo exhibition in New York was held at the Contemporary Arts Gallery in 1933. In 1935, he was a founding member of the Ten, a group of artists sympathetic to abstraction and expressionism. He executed easel paintings for the WPA Federal Art Project from 1936 to 1937. By 1936, Rothko knew Barnett Newman. In the early 1940s, he worked closely with Gottlieb, developing a painting style with mythological content, simple flat shapes, and imagery inspired by primitive art. By mid-decade, his work incorporated Surrealist techniques and images. Peggy Guggenheim gave Rothko a solo show at Art of This Century in New York in 1945.

In 1947 and 1949, Rothko taught at the California School of Fine Arts, San Francisco, where Clyfford Still was a fellow instructor. With William Baziotes, David Hare, and Robert Motherwell, Rothko founded the short-lived Subjects of the Artist school in New York in 1948. The late 1940s and early 1950s saw the emergence of Rothko's mature style in which frontal, luminous rectangles seem to hover on the canvas surface. In 1958, the artist began his first commission, monumental paintings for the Four Seasons Restaurant in New York. The Museum of Modern Art, New York, gave Rothko an important solo exhibition in 1961. He completed murals for Harvard University in 1962 and accepted a mural commission for an interdenominational chapel in Houston in 1964. Rothko took his own life February 25, 1970, in his New York studio. A year later, the Rothko Chapel in Houston was dedicated.

Egon Schiele was born June 12, 1890, in Tulln, Austria. After attend-

ing school in Krems and Klosterneuburg, he enrolled in the Akademie der Bildenden Künste in
Vienna in 1906. Here he studied painting and drawing but was frustrated by the school's conser-
vatism. In 1907, he met Gustav Klimt, who encouraged him and influenced his work. Schiele left
the Akademie in 1909 and founded the Neukunstgruppe with other dissatisfied students. Upon
Klimt's invitation, Schiele exhibited at the 1909 Vienna Kunstschau, where he encountered the
work of Edvard Munch, Jan Toroop, Vincent van Gogh, and others. On the occasion of the first
exhibition of the Neukunstgruppe in 1909 at the Piska Salon, Vienna, Schiele met the art critic
and writer Arthur Roessler, who befriended him and wrote admiringly of his work. In 1910, he
began a long friendship with the collector Heinrich Benesch. By this time, Schiele had developed
a personal expressionist portrait and landscape style and was receiving a number of portrait
commissions from the Viennese intelligentsia.

Seeking isolation, Schiele left Vienna in 1911 to live in several small villages; he concentrated
increasingly on self-portraits and allegories of life, death, and sex and produced erotic water-
colors. In 1912, he was arrested for "immortality" and "seduction"; during his twenty-four-day
imprisonment, he executed a number of poignant watercolors and drawings. Schiele partici-
pated in various group exhibitions, including those of the Neukunstgruppe in Prague in 1910 and
Budapest in 1912; the Sonderbund, Cologne, in 1912; and several Secession shows in Munich,
beginning in 1911. In 1913, the Galerie Hans Goltz, Munich, mounted Schiele's first solo show. A
solo exhibition of his work took place in Paris in 1914. The following year, Schiele married Edith
Harms and was drafted into the Austrian army. He painted prolifically and continued to exhibit
during his military service. His solo show at the Vienna Secession of 1918 brought him critical
acclaim and financial success. He died several months later in Vienna, on October 31, 1918, a vic-
tim of influenza, which had claimed his wife three days earlier.

Gino Severini

was born April 7, 1883, in Cortona, Italy. He studied at the Scuola Tecnica in Cortona before moving to Rome in 1899. There he attended art classes at the Villa Medici and by 1901 met Umberto Boccioni, who had also recently arrived in Rome and later would be one of the theoreticians of Futurism. Together, Severini and Boccioni visited the studio of Giacomo Balla, where they were introduced to painting with "divided" rather than mixed color. After settling in Paris in November 1906, Severini studied Impressionist painting and met the Neo-Impressionist Paul Signac.

Severini soon came to know most of the Parisian avant-garde, including Georges Braque, Juan Gris, Amedeo Modigliani, and Pablo Picasso; Lugné-Poë and his theatrical circle; the poets Guillaume Apollinaire, Paul Fort, and Max Jacob; and author Jules Romains. After joining the Futurist movement at the invitation of Filippo Tommaso Marinetti and Boccioni, Severini signed the "Manifesto tecnico della pittura futurista" of April 1910, along with Balla, Boccioni, Carlo Carrà, and Luigi Russolo. However, Severini was less attracted to the subject of the machine than his fellow Futurists and frequently chose the form of the dancer to express Futurist theories of dynamism in art.

Severini helped organize the first Futurist exhibition at Galerie Bernheim-Jeune, Paris, in February 1912, and participated in subsequent Futurist shows in Europe and the United States. In 1913, he had solo exhibitions at the Marlborough Gallery, London, and Der Sturm, Berlin. During the Futurist period, Severini acted as an important link between artists in France and Italy. After his last truly Futurist works—a series of paintings on war themes—Severini painted in a Synthetic Cubist mode, and by 1920 he was applying theories of classical balance based on the Golden Section to figurative subjects from the traditional commedia dell'arte. He divided his time between Paris and Rome after 1920. He explored fresco and mosaic techniques and executed murals in various mediums in Switzerland, France, and Italy during the 1920s. In the 1950s, he returned to the subjects of his Futurist years: dancers, light, and movement. Throughout his career, Severini published important theoretical essays and books on art. He died February 26, 1966, in Paris.

Antoni Tàpies was born December 13, 1923, in Barcelona. He

began to study law in Barcelona in 1944 but decided instead within two years to devote himself exclusively to art. He was essentially self-taught as a painter; the few art classes he attended left little impression on him. Shortly after deciding to become an artist, he began attending clandestine meetings of the Blaus, an iconoclastic group of Catalan artists and writers who produced the review *Dau al Set*. Tàpies's early work was influenced by the art of Max Ernst, Paul Klee, Joan Miró, and Eastern philosophy. His art was exhibited for the first time in the controversial Salo d'Octubre of Barcelona in 1948. He soon began to develop a recognizable personal style related to *matière* painting, or Art Informel, a movement that focused on the materials of art-making. Tàpies freely adopted bits of detritus, earth, and stone—mediums that evoke solidity and mass—in his large-scale works.

In 1950, Tàpies's first solo show was held at the Galeries Laietanes, Barcelona, and he was included in the Carnegie International in Pittsburgh. That same year, the French government awarded him a scholarship that enabled him to spend a year in Paris. His first solo show in New York was presented in 1953 at the Martha Jackson Gallery. During the 1950s and 1960s, Tàpies exhibited in museums and galleries throughout the United States, Europe, Japan, and South America. In 1966, he began his collection of writings, *La practica de l'art*. In 1969, he and the poet Joan Brossa published their book, *Frègoli*; a second collaborative effort, *Nocturn Matinal*, appeared the following year. Tàpies received the Rubens Prize of Siegen, Germany, in 1972.

Tàpies was given retrospectives at the Musée National d'Art Moderne, Paris, in 1973 and at the Albright-Knox Art Gallery, Buffalo, in 1977. The following year, he published his prize-winning autobiography, *Memòria personal*. In the early 1980s, he produced his first ceramic sculptures and designed sets for Jacques Dupin's play *L'Eboulement*. In 1993, he and Cristina Iglesias represented Spain at the forty-fifth Venice Biennale, where he shared the award for painting with Richard Hamilton. A retrospective exhibition was organized by the Jeu de Paume in Paris, the Fundació Antoni Tàpies, and the Solomon R. Guggenheim Museum, New York, which was on view at the Guggenheim SoHo in 1995. Tàpies lives and works in Barcelona.

Catalogue

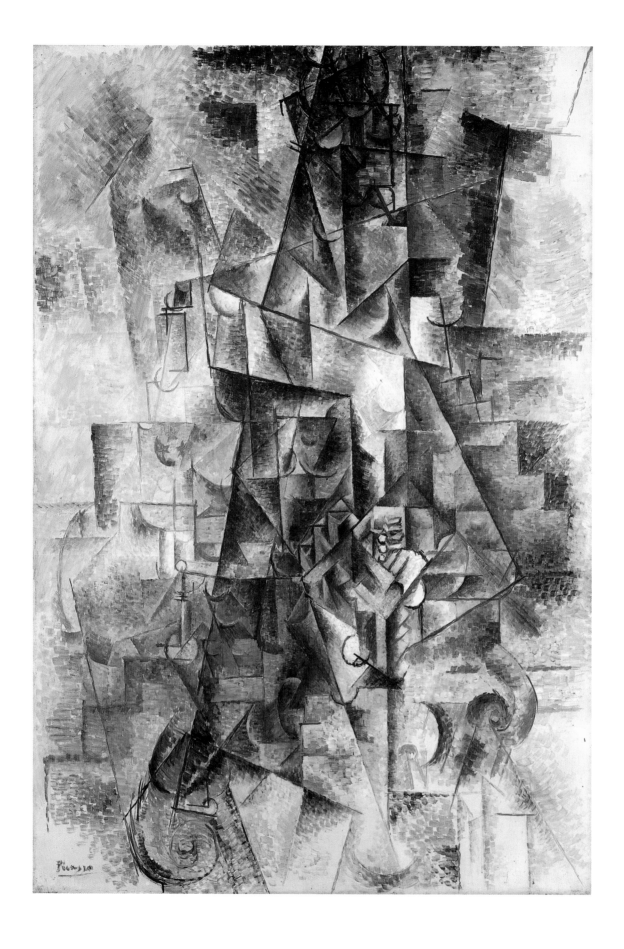

A decisive moment in the development of Cubism occurred during the summer of 1911, when Pablo Picasso and Georges Braque painted side by side in Céret, in the French Pyrenees. In Picasso's *Accordionist*, made during this time, the traditional relationship between figure and ground has been destroyed and replaced by a unified pictorial configuration. The extreme degree of fragmentation; flat, shaded planes; nondescriptive regularized brushstrokes; mono-chromatic color; and shallow space are all characteristic of the first, "Analytic" phase of Cubism.

With diligence, one can distinguish the general outlines of the seated accordionist, the centrally located folds of the accordion and its keys, and, in the lower portion of the canvas, the volutes of an armchair. But Picasso's elusive references to recognizable forms and objects cannot always be precisely identified and, as New York's Museum of Modern Art's founding director Alfred H. Barr, Jr. observed, "The mysterious tension between painted image and 'reality' remains."
—SRGM

GEORGES BRAQUE

When Georges Braque abandoned a bright Fauve palette and traditional perspective in 1908, it was the inspiration of Paul Cézanne's geometrized compositions that led him to simplified faceted forms, flattened spatial planes, and muted colors. By the end of that year, Braque and Pablo Picasso, who first met in 1907, began to compare the results of their techniques and it became obvious to both artists that they had simultaneously and independently invented a revolutionary style of painting, later dubbed "Cubism" by Guillaume Apollinaire. During the next few years the new style blossomed with stunning rapidity from its initial formative stage to high Analytic Cubism. The hallmarks of this advanced phase, named for its "breaking down" or "analysis" of form and space, are seen in an extraordinary pair of pendant works, *Violin and Palette* and *Piano and Mandola.*

Objects are still recognizable in the paintings, but are fractured into multiple facets, as is the surrounding space with which they merge. The compositions are set into motion as the eye moves from one faceted plane to the next, seeking to differentiate forms and to accommodate shifting sources of light and orientation. In *Violin and Palette*, the segmented parts of the violin, the sheets of music, and the artist's palette are vertically arranged, heightening their correspondence to the two-dimensional surface. Ironically, Braque depicted the nail at the top of the canvas in an illusionistic manner, down to the very shadow it casts, thus emphasizing the contrast between traditional and Cubist modes of representation. The same applies to the naturalistic candle in *Piano and Mandola*, which serves as a beacon of stability in an otherwise energized composition of exploding crystalline forms: the black-and-white piano keys all but disembodied; the sheets of music virtually disintegrated; the mandola essentially decomposed.

"When fragmented objects appeared in my painting around 1909," Braque later explained, "it was a way for me to get as close as possible to the object as painting allowed." If the appeal of still life was its implied tactile qualities, as Braque noted, then musical instruments held even more significance in that they are animated by one's touch. Like the rhythms and harmonies that are the life of musical instruments, dynamic spatial movement is the essence of Braque's lyrical Cubist paintings.—J.A.

VIOLIN AND PALETTE (VIOLON ET PALETTE), AUTUMN 1909
OIL ON CANVAS
36⅛ × 16⅞ INCHES
54.1412

PIANO AND MANDOLA (PIANO ET MANDORE), WINTER 1909–10
OIL ON CANVAS
36⅛ × 16⅞ INCHES
54.1411

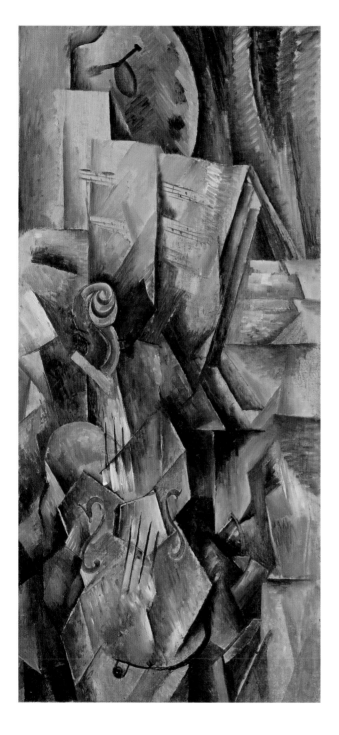

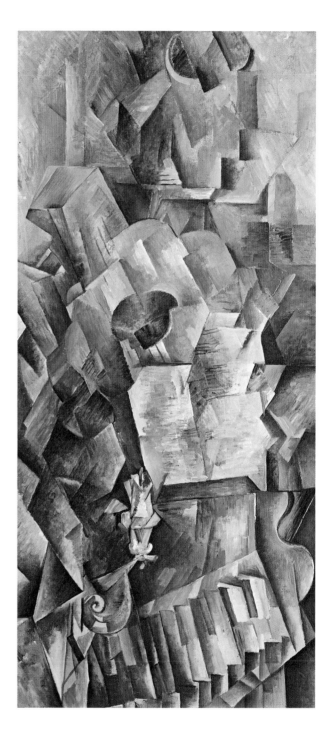

FERNAND LÉGER

In 1912 and 1913, Fernand Léger executed a series of drawings of standing, reclining, bending, and seated nudes. As seen in *Nude Model in the Studio*, he would sometimes abandon color to study shapes and volumes more systematically in preparation for paintings on this theme. These works mark a transition between the *Smokers* series of 1912 and the development of the famous *Contrasts of Form* series begun in 1913, and they manifest the principle of "contrast" that guides Léger's entire oeuvre. He wrote, "In seeking the state of plastic intensity, I apply the law of contrasts, which is eternal, as a means of equivalence in life. I organize the opposition of values, lines and contrasting colors."

While Léger preserves a few references to reality, he applies these principles with a rigor that verges on abstraction: the black lines form a network of repeated cylindrical or conical shapes, while only pure color is used: blue, green, and red alternate with white. The Cubist canvases of Georges Braque and Pablo Picasso regularly exhibited by Daniel-Henri Kahnweiler could not have left Léger indifferent, but his attempts at abstraction never led him to abandon totally either color or subject.—SRGM

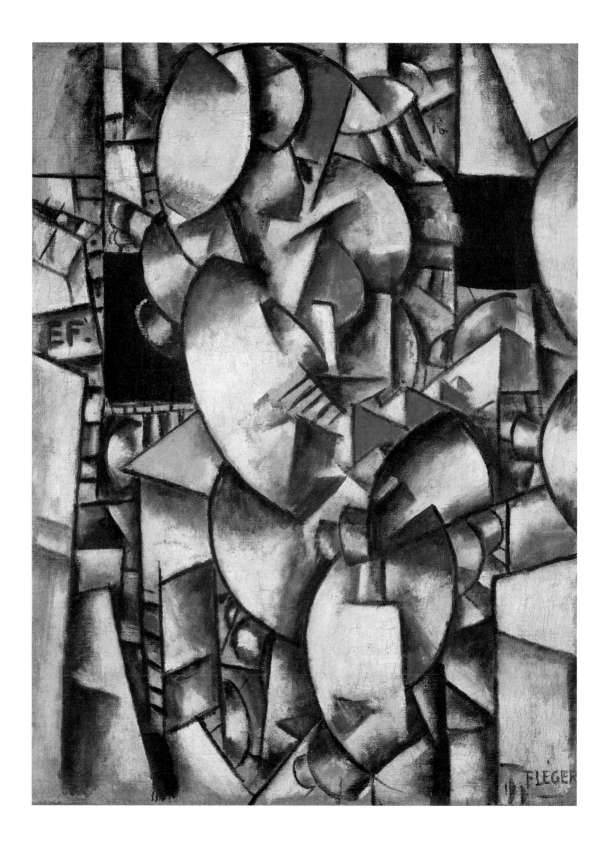

JUAN GRIS

An urban landscape, *Houses in Paris* dates from 1911, when Juan Gris lived in Montmartre. Soon after his arrival there from Madrid in 1906, he settled at 12, Rue Ravignan, in the building called the Bateau-Lavoir, where his compatriot Pablo Picasso also lived. Although Georges Braque and Picasso were his friends, Gris was by no means their follower. His stylistic development evolved toward Cubism in an individual manner and revealed the influence of Paul Cézanne. He painted his first oils in 1911. At that time, Gris had his studio on the first floor of the Bateau-Lavoir, over-looking Place Ravignan (now Place Emile Goudeau), and as Angelica Zander Rudenstine first observed, *Houses in Paris* may well represent the surrounding area.

The Guggenheim picture reflects this early moment in Gris's Cubism in the slight flattening of the building, the tilted angle at which architectural elements are presented, the emphasis on line as an integral part of the design, and the gray tonality, which incorporates subtle shades of blue, green, and pink. Related works showing buildings in Paris include an oil, *Houses in Paris*, in the Sprengel Collection, Hannover, and a drawing in the Museum of Modern Art, New York, Joan and Lester Avnet Collection.—V.E.B.

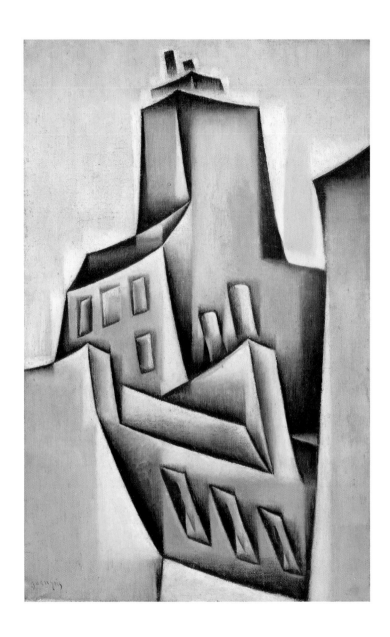

ROBERT DELAUNAY

Constructed in 1889 as a symbol of technological advancement, the Eiffel Tower captured the attention of painters and poets attempting to define the essence of modernity in their work. Robert Delaunay's obsession with the tower resulted in at least thirty completed paintings representing the radical yet graceful iron edifice. According to the poet Blaise Cendrars, Delaunay made fifty-one attempts to depict the tower in 1911 before arriving at an acceptable solution. "Delaunay," explained Cendrars, "wanted to interpret [the tower] plastically. He succeeded at last with his world-famous picture. He disarticulated the tower in order to get inside its structure. He truncated it and tilted it in order to disclose all of its three hundred dizzying meters of height."

The pictorial vocabulary with which Delaunay rendered the Eiffel Tower from simultaneous perspectives is essentially Cubist. In *Eiffel Tower*, the shifting, fragmented forms of the tower and the buildings surrounding it implode, as it were, to create an allover pattern of interconnected planes. However, the emphasis in this painting is not entirely on the interplay of various architectural constructions viewed from multiple vantage points but also on the effect of atmospheric light upon the city of Paris. Delaunay's *Eiffel Tower* series marks the beginning of a transition from his semimimetic representations of the urban environment to abstractions based on color-spectrum analysis. According to Guillaume Apollinaire, these latter works belonged to a new aesthetic category, which he called Orphism.—N.S.

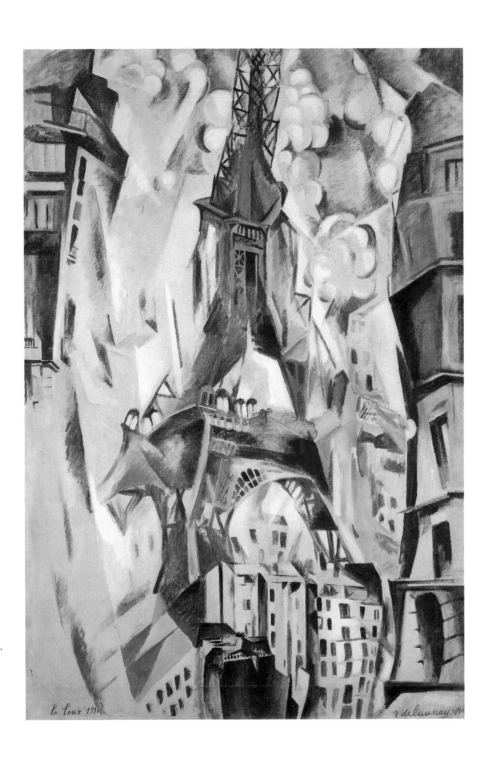

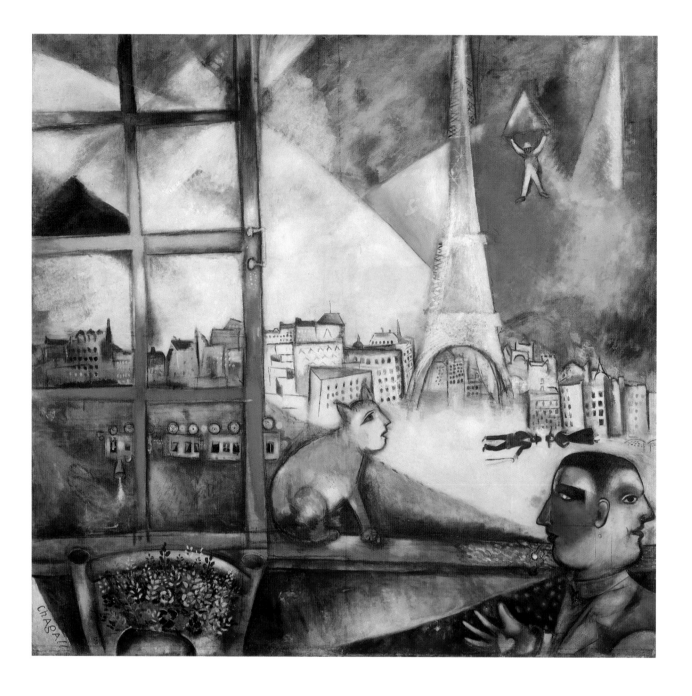

PARIS THROUGH THE WINDOW (PARIS PAR LA FENÊTRE), 1913
OIL ON CANVAS
53¹/₂ × 55³/₄ INCHES
GIFT, SOLOMON R. GUGGENHEIM 37.438

In 1910, Marc Chagall, like many of his peers, traveled to Paris to experience firsthand the art capital of the world. With a monthly stipend from his patron, Max Vinaver, the young Russian painter set off from St. Petersburg to "find the meaning of art." On his first day in his new city, Chagall went straight to the Salon des Indépendants to see the contemporary French paintings. He immersed himself in the art of Paul Gauguin, Henri Matisse, and Vincent van Gogh, as well as older masterpieces in the Louvre. Shortly after his arrival, Chagall moved to "La Ruche," a beehive-like series of Montmartre studios inhabited by Fernand Léger, Amedeo Modigliani, Chaim Soutine, and other artists, and visited by the poets Guillaume Apollinaire and Blaise Cendrars. While fellow painters inspired Chagall to engage in formal experimentation in his work, his more literary compatriots responded passionately to the dreamworld of the artist's imagination and reveries of home.

Chagall was introduced to Robert Delaunay, the leading proponent of what Apollinaire had termed Orphic Cubism or Orphism, which emphasized the exploration of color and light. Delaunay's work exploded with a prismatic rainbow; his interest in light as a unifying force and the key to perception was perhaps shared by Chagall who spoke of the "lumière liberté"—the freedom light—of Paris. This dazzling luminosity, suggesting the spiritual and the physical, bathes the city in Chagall's *Paris Through the Window*. In both subject and treatment, this work (the last he would make before returning to Russia in 1914) is clearly indebted to the influence of Delaunay's many paintings of the city. The view Chagall paints, however, is very much his own.

While the Cubists may have represented their subjects from various angles, Chagall expresses a simultaneous inner and outer view, both literally and metaphorically; we are shown what is inside the room as well as what lies beyond. More significantly, we glimpse the artist's fantastic vision of the city, mingling an old world and the new. Paris appears like a circus of amazing sights. A man parachutes from the sky, while a Russian peasant couple sails sideways above the street. There is a train floating by upside down, and a yellow cat with a human head crouches on the window ledge, while a two-headed Janus figure sits just inside. Suited in red and green, the man gazing both east and west has been read as the artist looking toward his home in Russia, and at Paris, which he called his "second Vitebsk." His heart is in his outstretched hand, an offer of love for a city and colleagues he later remembered as such: "With you I spring into the depths of Montjoie. As if dazzling lights flashed around you. As if a flight of white seagulls, or flakes of snowy spots, in single file, rose toward the sky. There, another flame, light and clear-toned, Blaise, my friend Cendrars [who titled this painting as well as others by Chagall]. A chrome smock, socks each of a different color. Waves of sunshine, poverty, and rhymes. Thread of colors. Of liquid, flaming art."—S.C.

FRANTIŠEK KUPKA

Although he moved to Paris at a young age, František Kupka's Bohemian origins, mysticism, and eccentric personality kept him at a distance from the avant-garde circles of the artistic capital. An individualist, he rejected association with any stylistic school or trend, but his paintings' aggressive palette and dependence on color as a means of faceting form and conveying meaning show undeniable affinities with Fauvism and the work of Henri Matisse, as well as with Orphism, Robert Delaunay's color-based brand of Cubism. A devoted mystic, Kupka spent his life in search of a transcendental other reality, or "fourth dimension." One of the first nonobjective artists, he extended his clairvoyant practice to his art as well, by uniting a metaphysical investigation of the human body and nature with daring color and abstract form.

Theosophy—a synthesis of philosophy, religion, and science—guided Kupka's holistic approach to art. His paintings draw on a variety of sources, including ancient myths, color theory, and contemporary scientific developments. The invention of radiography at the turn of the twentieth century was especially significant for Kupka, whose search for an alternative dimension through a kind of painterly X-ray vision is captured in his monumental *Planes by Colors, Large Nude*. He produced at least eighteen preliminary sketches for the work and probably six others after its completion; by 1906, he had almost certainly executed an initial large-scale oil study of the composition. In the Guggenheim's work, the highly finished quality of the background suggests that Kupka may well have completed it after the rest of the canvas. It also seems that he added the 1909 date and signature much later. Considering an exhibition label written in the artist's handwriting on the reverse, which notes the years 1905 – 10 (a span that indicates initial conceptualization to completion), the final date of the work is most likely 1910.

Over the course of the painting's development Kupka was fortunate to work with one model as his subject: his wife, Eugénie. The artist rendered her form in vivid shades of purple, green, yellow, and blue and devised an innovative modeling technique based on color, rather than line or shade, to render her body as sections of colored planes in such a way that her "inner form" is made visible, a technique that is closely related to that of his *Family Portrait* (National Gallery, Prague), completed around the same time. By revealing interior states through color, Kupka achieved a painterly solution to his spiritual quest for a fourth dimension. This unveiling of the unseen is crucial for Kupka, who believed that it is only through the senses, through physical experience, that we can reach an extrasensory, metaphysical dimension and thereafter achieve an intuitive understanding of the universal scheme underlying existence.—SRGM

PLANES BY COLORS, LARGE NUDE (PLANS PAR COULEURS, GRAND NU), 1909–10
OIL ON CANVAS
59¹⁄₈ × 71¹⁄₈ INCHES
GIFT, MRS. ANDREW P. FULLER 68.1860

THE ITALIAN WOMAN (L'ITALIENNE), 1916
OIL ON CANVAS
45^{15}/$_{16}$ × 35^{1}/$_{4}$ INCHES
BY EXCHANGE 82.2946

After an early, spontaneous sketch revealed itself to be a portrait of his mother rather than just a casual drawing, the young Henri Matisse had what he called a "revelation." He began to focus his attention on the role of memory in uncovering the essential attributes of his subjects and to the reduced image, which allowed emotions "fermenting under the surface" to come forth. This distilled quality would become the hallmark of his work: "The essential expression of a [portrait]," Matisse wrote years later, "depends almost entirely on the projection of the feeling of the artist in relation to his model, rather than organic accuracy." Given this sentiment, it is not surprising that one of the most abstract and experimental periods in his career was also characterized by an emphasis on portraiture.

A 1916 photograph of the artist in his studio shows him surrounded by a group of strikingly abstracted portraits, including *The Italian Woman* in an early state. The photograph allows us to see the beginning stages of the painting and to glimpse a moment in the artist's working process, which included multiple sittings with his model that inspired the gradual progression from initial observation to penetration of the subject's inner character while simultaneously moving away from direct representation to abstraction. The fleshy figure that is rendered with soft features in the more conservative, early version was by the final rendering transformed into a linear, almost iconic conception of a woman.

The Italian Woman is believed to be the first of Matisse's nearly fifty depictions of Laurette, a professional Italian model. Her face appears masklike, yet we are still able to recognize the distinctive essence of the model who would remain a favorite subject of the artist's for nearly two years. While the figure's rounded shoulders and volumetric blouse retain a sense of solidity, the overall effect is schematic. The unifying device of a monochromatic background, also used in works such as *The Red Studio* (1911, Museum of Modern Art, New York), is utilized to suggest limitless space while remaining faithful to the flatness of the picture plane. The image is notable for its unusual manipulation of figure and ground: "For me, the subject of a painting and its background have the same value." The ocher of the model's skirt, for example, is hardly distinguishable from the underpainting, constantly shifting between tangible object and impalpable atmosphere, and the upper-left ground is extended over the model's still-visible right arm. Thus the space around the figure becomes as material as her body, and she becomes as flat as the background. Matisse's rendering of this fluid space between object and atmosphere has been attributed to the influence of Cubism. The unusually austere palette of *The Italian Woman* also recalls the muted tones of Cubist paintings, although the "almost funereal" hues of this period, as historian Pierre Schneider described them, have also been discussed as a somber reaction to the devastation of World War I.–S.C.

AMEDEO MODIGLIANI

Amedeo Modigliani met Jeanne Hébuterne in 1917, when she was nineteen and a student at the Académie Colarossi in Paris, where Modigliani had studied eleven years earlier. They moved to a studio at 8, rue de la Grande-Chaumière in July 1917 and remained together until their deaths in January 1920, Hébuterne committing suicide the day after Modigliani died of tuberculosis. This biographical information is important in the discussion of *Jeanne Hébuterne with Yellow Sweater*, not only because the painting depicts Modigliani's companion, but also because the artist's biographers have often used details from his life to interpret his works, portraying him as the quintessential peripatetic accursed painter. In his memoir of the artist, André Salmon recalled that Modigliani's admirers called him "The Painter of Sorrows," whereas Salmon himself preferred to call him "The Painter of Purification." He noted that Modigliani was a passionate devotee of Dante and constantly dreamed of a new life based on the great Italian writer's famous narrative work of prose and poems in honor of Beatrice. His admiration for the author of the *Inferno* only enhanced the myth of Modigliani as a *peintre maudit* peregrinating through his own hell.

Hébuterne was the subject of more than twenty undated portraits made between 1917 and 1920. Modigliani liked to work from the model: "To do any work, I must have a living person," he explained to the artist Léopold Survage. "I must be able to see him opposite me." *Jeanne Hébuterne with Yellow Sweater* was painted while the artist lived in the South of France, where he and Hébuterne moved when his health began to fail in 1918 (the couple returned to Paris in the end of June 1919). The painting is executed in Modigliani's signature style, with a dramatically elongated figure, almond-shaped eyes, and sensual but firmly closed lips. Hébuterne is shown sitting on a chair, dressed in a yellow sweater and a dark blue skirt. The thinly applied colors are vivid and arranged in blocks. Similar hues recur throughout the picture—for example, in the sitter's hair, the chair, and the floor. Hébuterne looks straight ahead, but her eyes are empty, as if she were in reverie. The intense blue of her eyes is repeated on the wall behind her, which shimmers with light-filled tonalities of yellow, green, and purple, augmenting the painting's dreamy, sensual qualities. Hébuterne's composed and stoic presence stands in clear contrast to the restless and chaotic life for which Modigliani was known.

Modigliani looked at the human figure abstractly, reducing it to essentials clearly influenced by African art and the early Sienese masters, Duccio in particular. The primitivized style of the work of his friend Constantin Brancusi—derived from, among other things, the ethnographic motifs of the artist's native Romania—was also an influence. Modigliani himself was an accomplished sculptor, and his paintings share some of the volumetric qualities of his sculptures.—M.B.

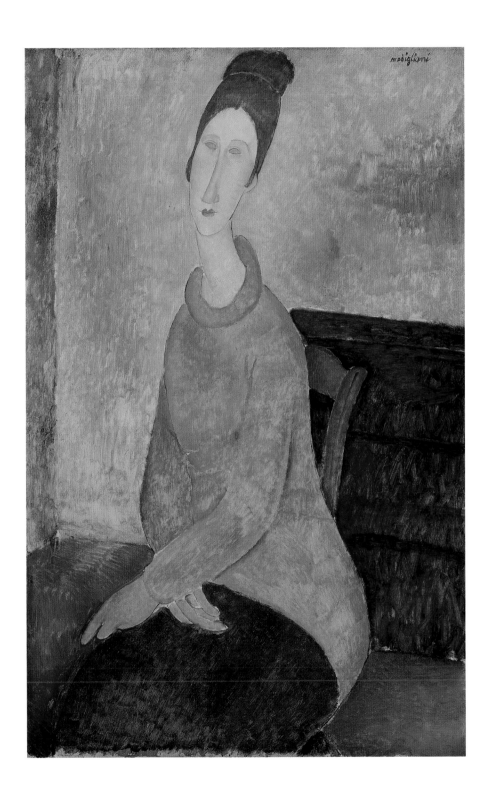

CONSTANTIN BRANCUSI

Though initially drawn to Auguste Rodin's sculptural transgressions of nineteenth-century aesthetic convention, Constantin Brancusi eventually rejected the French master's emphasis on theatricality and accumulation of detail in favor of radical simplification and abbreviation. Brancusi felt he was vindicated in his pursuit of sculptural immediacy when he saw Paul Gauguin's primitivist carvings at the Salon d'Automne in 1906. The practice of *taille directe*, or direct carving, adopted by Brancusi—as well as by Georges Braque, André Derain, and Pablo Picasso—after Gauguin's example, fostered an engagement with the material, eliminated working from a model, and promoted an abstract sensibility. In early sculptures executed through direct carving, such as *The Kiss*, Brancusi suppressed all decorative detail in an effort to create pure and resonant forms. His goal was to capture the essence of his subject and to render it visible with minimal formal means.

While Brancusi's sculptures reflect empirical reality, they also explore inner states of being. The human head, one of his favorite motifs, is often depicted separate from the body, as a unitary ovoid shape. When placed on its side, it evokes images of sleep. Other streamlined oval heads such as *Prometheus* and *The Newborn* (Musée National d'Art Moderne, Paris)—whose shapes recall Indian fertility sculptures—suggest the miracle of creation.

Brancusi's marble *The Muse* is a subtle monument to the aesthetic act and to the myth of Woman as its inspiration. The finely chiseled head—executed in a highly refined version of Brancusi's direct carving technique—is poised atop a sinuous neck, the rightward curve of which is counterbalanced by a fragmentary arm pressed against the cheek. The facial features, although barely articulated, embody classical beauty. As in the sculptor's *Mlle Pogany*, also of 1912, the subject's hair is coiffed in a bun at the base of the neck. While *Mlle Pogany* is the image of a particular woman, *The Muse*, although linked to portraiture, is the embodiment of an idea.
—N.S.

THE MUSE (LA MUSE), 1912
MARBLE
17³/₄ × 9 × 6³/₄ INCHES
85.3317

SHOWN ON OAK BASE, 1920
OAK
38³/₈ × 18⁵/₈ × 18¹/₂ INCHES
58.1516

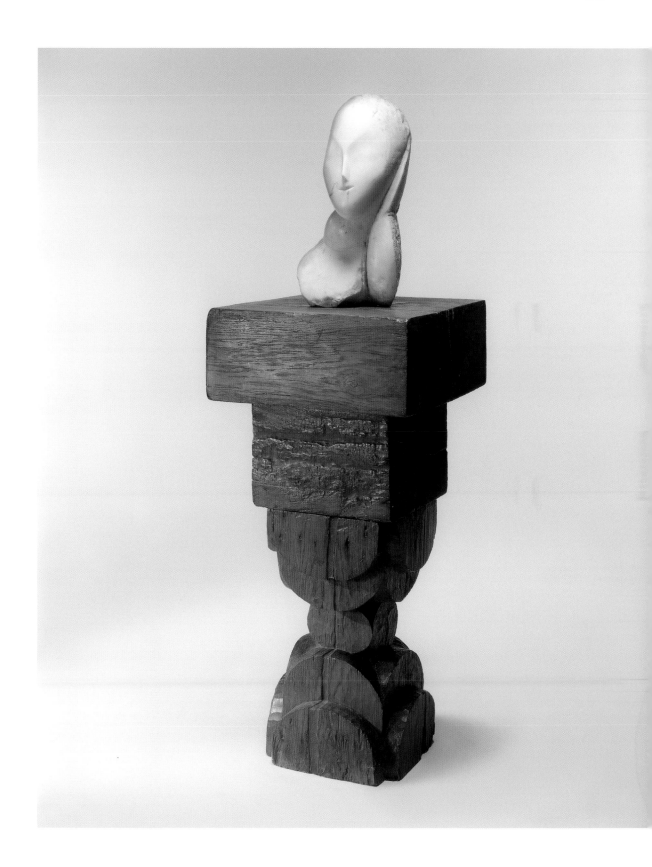

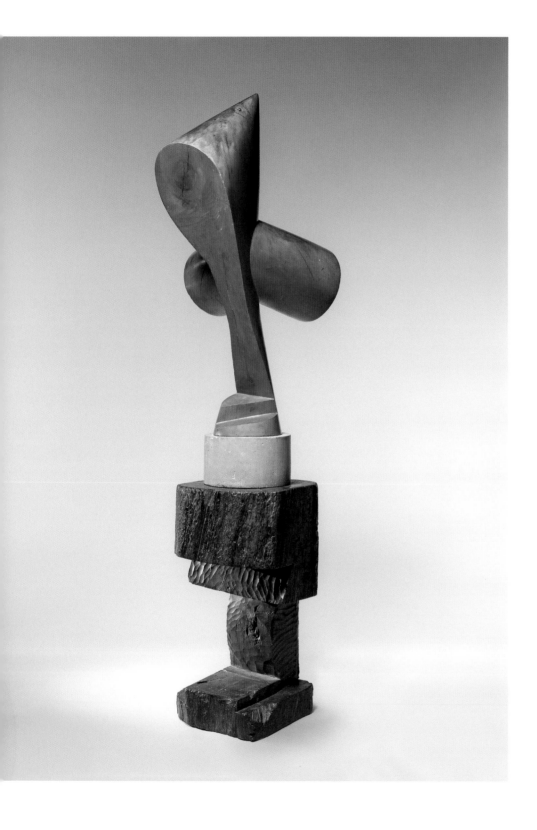

THE SORCERESS (LA SORCIÈRE), 1916–24
WALNUT, ON LIMESTONE BASE
44⁷/₈ × 19 × 24 INCHES
56.1448

SHOWN ON GUARD DOG (CHIEN DE GARDE), 1916
OAK
29¹/₈ × 15¹/₄ × 14¹/₄ INCHES
58.1503

Although *The Sorceress* bears the date 1916, it appears unfinished in photographs of Constantin Brancusi's studio for several years thereafter. He typically worked on his sculptures for extended periods of time, often for five years or more. As the face emerges from the grain of the wood, the pointed headdress and clothing are seen flying behind the sorceress — perhaps Brancusi had Romanian and French folktales about witches in mind as he created this form. Art historian Friedrich Teja Bach has suggested that the figure's source is in a drawing entitled *Witches' Bath* (1911–2) by Portuguese artist Amadeo de Souza-Cardoso. In this interpretation, the two cylinders often referred to as the sorceress' cloak, are instead the breasts of the bathing witch.

The Sorceress retains the integrity of the piece of wood that Brancusi selected and carved to exploit the way the branches grew from the tree trunk. The complex, asymmetrical arrangement of masses stands on a slender leg and maintains perfect equilibrium. This light form above is directly opposed by its massive rusticated support. As is often the case with Brancusi's sculpture, the upper "figure" and lower "base" complement each other through their contrasting textures, materials, and massing.

Guard Dog, Brancusi's title for the base on which *Sorceress* rests, retains a figurative quality. Separated from *Sorceress* by a flat stone cylinder, the base resembles the form of a canine sitting or standing erect. Brancusi photographed *Guard Dog* atop another base, attesting to its semiautonomy as a sculpture. Yet thematically linked to the sculpture, this watchdog can be seen as companion and support to the riding witch.—SRGM

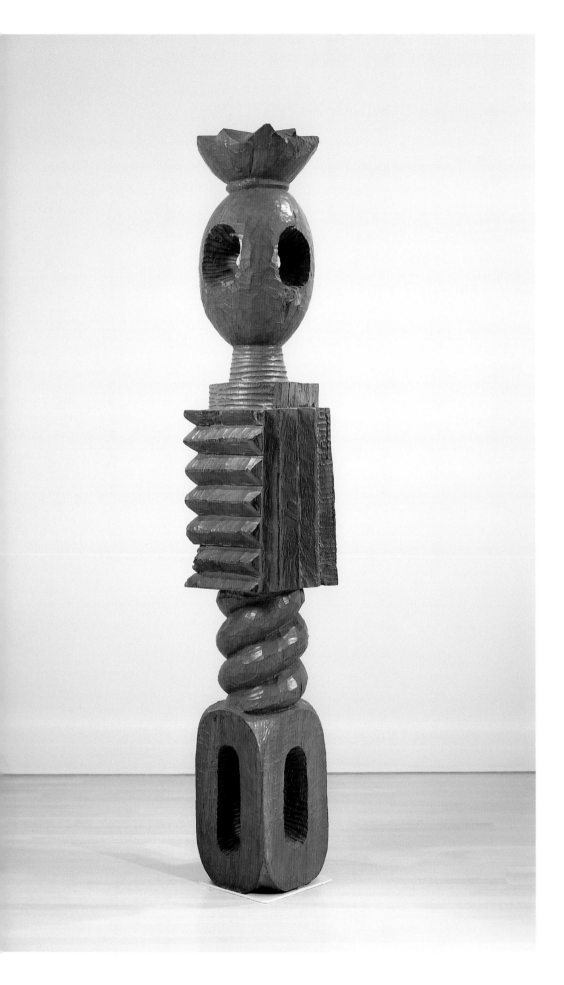

The monumental oak *King of Kings* was originally intended to stand in Constantin Brancusi's *Temple of Meditation*, a private sanctuary commissioned in 1933 by the Maharaja Yeshwant Rao Holkar of Indore. Although never realized, the temple—conceived as a windowless chamber (save for a ceiling aperture) with interior reflecting pool, frescoes of birds, and an underground entrance—would have embodied the concerns most essential to Brancusi's art: the idealization of aesthetic form; the integration of architecture, sculpture, and furniture; and the poetic evocation of spiritual thought.

Wood elicited from Brancusi a tendency toward expressionism, resulting in unique carved objects. *King of Kings* may be interpreted as Brancusi's attempt to translate the power of Eastern religion into sculptural form. The work's original title was *Spirit of Buddha*, and Brancusi is known to have been familiar with Buddhism through the writings of the Tibetan philosopher Milarepa.

Although the extent to which Brancusi's work was inspired by African sculpture and Romanian folk carvings has been widely debated among scholars, it is clear that he was acutely responsive to "primitivizing" influences early in his career. Paul Gauguin's technique of direct carving to emulate the raw quality of native Tahitian art inspired Brancusi to experiment with more daring approaches to sculpture than his academic training had previously allowed.

Sculptural sources from Brancusi's native country are also abundant: prototypes for the sequential designs of *King of Kings* have been found in Romanian vernacular architecture, such as wooden gate posts and chiseled ornamental pillars. Brancusi never clarified the visual sources for his designs, preferring that an air of mystery surround the origins of his vision.—N.S.

MIKHAIL LARIONOV

Mikhail Larionov was not only a painter but also an organizer of exhibitions, a stylistic innovator, and the author of the Rayist manifesto. Rayism was a short-lived movement invented by Larionov, who along with his companion Natalie Goncharova, were its primary practitioners. *Glass* and other Rayist works first appeared in the exhibition *World of Art*, which opened in Moscow in November 1912. In 1913, Larionov published a pamphlet entitled "Rayist Painting" in which he outlines his theories—based on ideas about vision and perception—for painting "the sum of rays reflected from the object." In his conceptualization, Rayist painting, by capturing the play of light on its subject, mimics the act of seeing: "Rayism erases the barriers that exist between the picture's surface and nature." Translating light rays into echoing lines of color, Rayism shares Cubism's analysis of form, Futurism's emphasis on dynamism, and Orphism's exploration of optic principles.

Larionov considered *Glass* to have been his first fully Rayist work. The 1909 date inscribed on the surface of this canvas is thought to have been added by the artist in 1914 when the work was brought to Paris for exhibition. The work depicts five tumblers, a goblet, and two bottles so that their essential forms are retained, and lines and vectors of color represent light refracted by the surface of these vessels. The Russian title, *Steklo* (glass) refers to the substance glass, rather than to glass as an individual object made from it. As early as 1913, a reviewer of Larionov's and Goncharova's work observed that Larionov was not painting a still life but "simply 'glass' as a universal condition of glass with all its manifestations and properties—fragility, ease in breaking, sharpness, transparency, brittleness, ability to make sounds, i.e., the sum of all the sensations, obtainable from glass."—SRGM

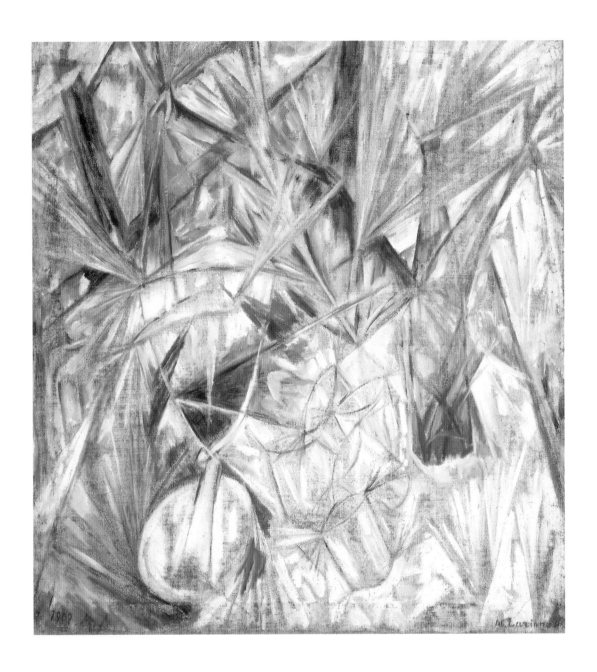

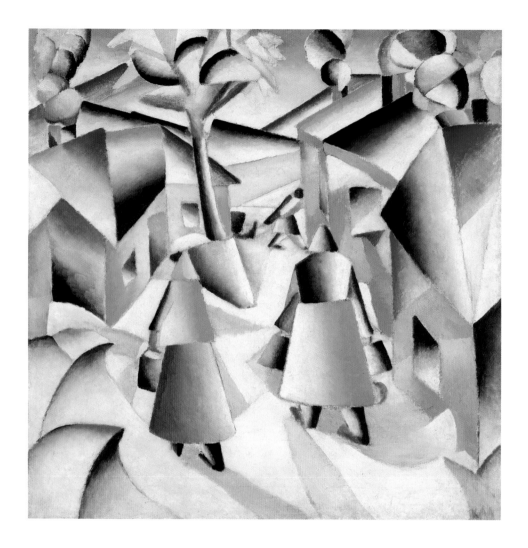

The paintings of the Russian avant-garde have, in general, elicited two types of interpretation: one focuses on issues of technique and style; the other concentrates on social and political issues. The former method is usually applied to Kazimir Malevich's early paintings, grounded as they are in the forms of Cubism, Futurism, and other contemporaneous art movements; the latter largely avoids Malevich in favor of more politically engaged artists such as El Lissitzky, Alexander Rodchenko, and Vladimir Tatlin.

From the formalist's standpoint, *Morning in the Village after Snowstorm* is, in its mastery of complex arrangements of colors and shapes, a perfect example of the newly created Russian style of Cubo-Futurism. The figures have been called a continuation of the genre types Malevich portrayed in his Neo-primitive paintings, their depiction seemingly reliant on aspects of Fernand Léger's work, which Malevich could have known from an exhibition in Moscow in February 1912 or through reproductions. This phase in Malevich's career has been seen as his formidable stopover on his journey toward abstraction and the development of Suprematism.

But to ignore the political and social dimensions of Malevich's art would be a disservice. Malevich came from humble circumstances and it is clear in autobiographical accounts that vivid memories of his country childhood compensated for his lack of a formal art education. *Morning in the Village after Snowstorm* demonstrates that his hard-won skills as a sophisticated painter were rooted in an unmistakably Russian experience. If art can be said to augur the future, then Malevich's repeated decision—on the brink of the October Revolution—to depict peasants cannot have been merely coincidental.—C.L.

ALEXANDER ARCHIPENKO

No doubt it was a sense of pride and more than an inkling of historical place that prompted the young Alexander Archipenko to inscribe this work with his name and "1913 Paris." Soon after arriving in Paris at the age of twenty, the Ukrainian artist could claim membership in the prestigious Section d'Or group, putting him in the company of Guillaume Apollinaire, the Duchamp brothers (Marcel Duchamp, Raymond Duchamp-Villon, and Jacques Villon), and Pablo Picasso. *Médrano II* is a souvenir of this heady time.

It is probably the only remaining work from his pioneering experiments with diverse, incongruous materials in 1912 and 1913. To create *Médrano I* (1912; now destroyed), he combined wood, glass, sheet metal, and found objects to represent an abstracted juggler; *Médrano II*, made of similar components, instead represents a female figure, perhaps a dancer. The volumes are organized along a slightly tipped, vertical axis, defining the figure by means of projecting planes. Archipenko has placed her, theatrically, in front of a flat background, thereby controlling the spectator's vantage point of the sculpture. While this highly experimental assemblage bears comparison to Cubist works of the same period, it also relates to Archipenko's native traditions—to his interest in the integrated materials of icons, and to his knowledge of the concept of *faktura* (a Russian term meaning "materials" or "texture"), which focused on the ways in which specific materials generate specific kinds of form. Accordingly, and perhaps with *Médrano I* and *II* in mind, Archipenko later wrote, "a sheet of bent metal has only two possible geometric bendings—cylindrical or conical."

None of Archipenko's colleagues could have missed the allusions in these works to the vogue for puppetry, to the jesters in Picasso's paintings, or to the Cirque Médrano, the famous Parisian circus frequented by many artists.—SRGM

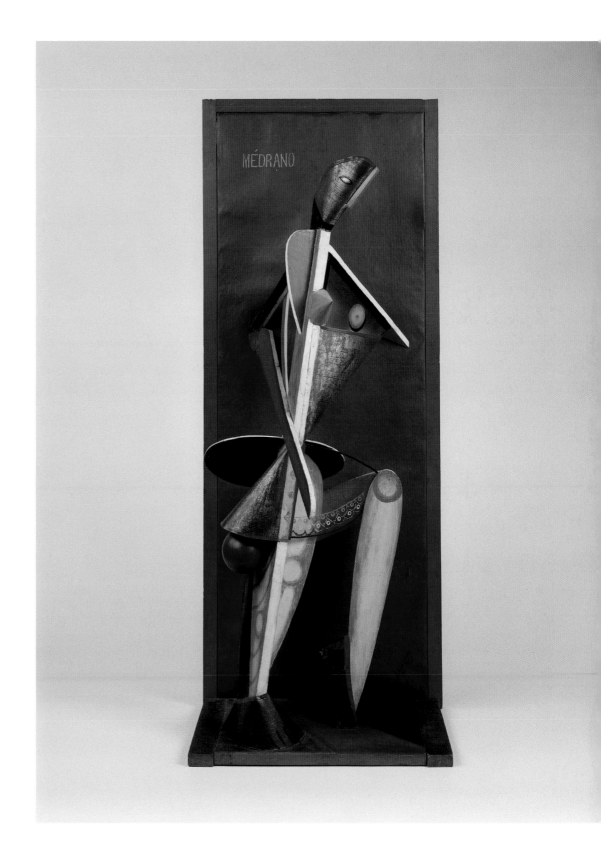

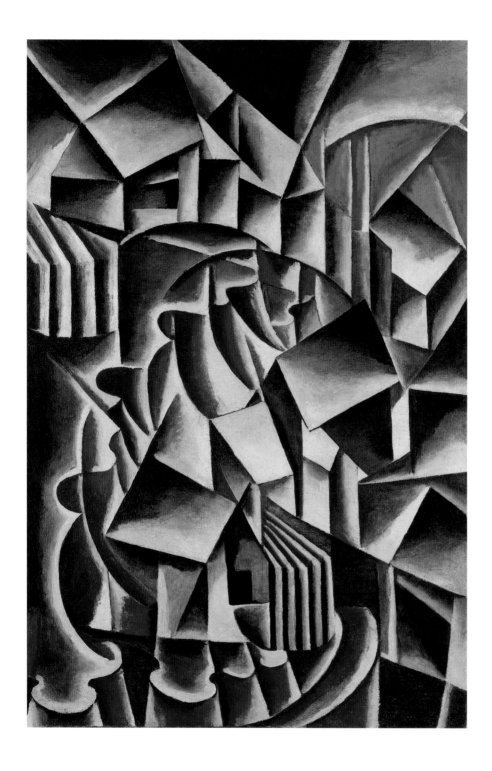

BIRSK, 1916
OIL ON CANVAS
41$\frac{3}{4}$ × 27$\frac{3}{8}$ INCHES
GIFT, GEORGE COSTAKIS 81.2822.R

Women formed an essential part of the Russian avant-garde, changing the face—and gender—of art in the process. Chief among them was Liubov Popova, the well-heeled daughter of a textile merchant. Popova's skill lay in her mastery of Parisian Cubism and Milanese Futurism, all the while maintaining her roots in a Russian artistic idiom. This is especially apparent in the commanding view of Birsk, a small town near the Urals, painted in 1916. Popova began this painting on the occasion of a summer visit to her former governess, who lived in Birsk.

Popova turned to a style that was already anachronistic in 1916; the houses are fragmented and depicted in sliding planes of color that seem a cross between those favored by Umberto Boccioni, Georges Braque, and Juan Gris. These shades, however, are too intense to be characteristic of her Western mentors. They evoke paintings on glass, or the brilliance of Russian folk costumes. At this time, Popova was still undecided as to her theoretical position. *Birsk* satisfied both the fragmentation of space so dear to the Cubists and the problem of luminous and shifting forms taken up by the Futurists. Like some of the works that Kazimir Malevich painted a few years earlier, it is an example of Russian Cubo-Futurism. *Birsk* was one of the last Western-oriented works that Popova painted before turning her attention to the artistic needs dictated by the October Revolution. By 1917, she adopted the theoretical implications of non-objective painting fully and began making Productivist art—art with a practical social function. In part this involved designing bold textile patterns that are anticipated in the cascading cliffs of *Birsk*.

It is ironic that Popova chose a frankly Western style to paint this work. Birsk is a city in Bashkir; its historical culture is Islamic and, until 1929, its writing system was Arabic. There, Popova may have gathered information for her later embarkation into textile design. Birsk has a strong local tradition of weaving and counted-thread embroidery, with geometric designs, diamonds, and cross-shaped figures providing an interesting parallel to the geometric solids of Popova's designs of the early 1920s.—C.L.

GINO SEVERINI

After moving from Rome to Paris in 1906, Gino Severini came into close contact with Georges Braque, Pablo Picasso, and the other leading artists of the avant-garde capital, while staying in touch with his compatriots who remained in Italy. In 1910 he signed the "Futurist Painting: Technical Manifesto" with four other Italian artists, Giacomo Balla, Umberto Boccioni, Carlo Carrà, and Luigi Russolo, who wanted their paintings to express the energy and speed of modern life.

In *Red Cross Train Passing a Village*, Severini split the landscape in order to impart a sense of the momentary fractured images that characterize our perception of a speeding object. The clash of intense contrasting colors suggests the noise and power of the train, which the Futurists admired as an emblem of vitality and potency.

Severini's paintings—like Futurist work in general—are informed by the legacy of Cubism, building on the Cubists' deconstruction of the motif, their collage technique, and their incorporation of graphic signs. But the Futurists' interest in depicting motion, use of bright expressive color, and politically inspired dedication to bridging the gap between art and life departed decisively from Cubist aesthetic practice, which focused on the rarefied world of the studio, investigating formal issues through often-somber portraits and still lifes.

Severini painted this canvas in the midst of World War I while living in Igny, outside Paris. Years later he recalled the circumstances: "Next to our hovel, trains were passing day and night, full of war matériel, or soldiers, and wounded." During 1915 he created many canvases in which he attempted to evoke war in paint, culminating in his January 1916 *First Futurist Exhibition of Plastic Art of the War*. This exhibition, held in Paris, included *Red Cross Train Passing a Village*.—J.B.

VASILY KANDINSKY

In 1911, Vasily Kandinsky wrote his influential treatise *On the Spiritual in Art*, which elucidated his belief that art would play a significant role in ushering in a new spiritual age. Influenced by a variety of sources, including the pantheistic doctrine of theosophy, the simplicity of folk art, and the nonnaturalistic, mystical expressions of the Symbolists, Kandinsky began constituting his own vocabulary of abstracted forms, which he maintained conveyed universal, transcendental truths. Wary of leaving the natural world behind too quickly, however, the artist developed a methodical approach that would gradually lead viewers into abstraction, and which avoided what he considered to be the dangers of a purely decorative art. By veiling familiar imagery, the artist provided narrative keys to understanding the spiritual emanations that he would soon invoke solely by the force of color and form.

In 1909, Kandinsky had introduced religious motifs in his work. Through 1913, he focused on the popularly interpreted version of the revelation of St. John the Divine and, in particular, on images of the Apocalypse and the Last Judgment, which he related to his own vision of contemporary social upheaval and eventual awakening and transformation. Although Kandinsky frequently adopted biblical titles during this period, he also used musical terminology, such as "impression," "improvisation," and "composition" to refer to his works. The *Impressions* he described as direct sensations of "external nature," and the *Improvisations* are noted as "expressions of the processes of the inner character, usually produced unconsciously." The *Compositions*, the most abstract of these works, Kandinksy defined as calculated, conscious expressions of "a slowly formed inner feeling." In applying this terminology, Kandinsky thus compared painting to the universal language of music, which is able to summon deep emotion without relying on narrative. Yet within these works, including *Improvisation 28 (second version)*, hidden images may be deciphered.

Like other related works, *Improvisation 28 (second version)*, can be divided into two parts with signs of the apocalyptic deluge on the left and Paradise on the right—a thematic succession signifying the struggle inherent in the development of the human soul. A boat with oars tossing about in waves is visible in the center above a serpent or fish, while below what has been interpreted as a cannon or a trumpet heralds the prophetic message of approaching cataclysm and salvation. A phalanx of candles and two long, vertical forms introduce the signs of hope pictured in the right side of the work, where a walled city sits peacefully atop a hill and a couple embraces under a shining sun. Such interpretations of Paradise and the Garden of Love as well as the exuberant palette of this and other works of the period were influenced by the Fauves and an encounter with Henri Matisse's painting *Bonheur de vivre* (1905 – 06, Barnes Foundation, Merion, Pennsylvania) during Kandinsky's stay in Paris in 1906.—S.C.

FRANZ MARC

Franz Marc's painting of a robust yellow cow leaping lightly across the brilliantly colored landscape of blue mountains and red and green earth is devoid of the Impressionist naturalism characteristic of the artist's earlier works. By this time, Marc had developed a chromatic symbolism reminiscent of the work of Paul Gauguin and other Post-Impressionists. "Blue is the male principle, severe, bitter, spiritual, and intellectual," he explained in a letter to August Macke in December 1910. "Yellow is the female principle, gentle, cheerful, and sensual. Red is matter, brutal and heavy."

Yellow Cow was produced around the time of Marc's second marriage to Maria Franck, and the painting has been interpreted by Mark Rosenthal as a wedding picture celebrating a happy moment in the artist's private life, the yellow cow representing the artist's bride and the blue mountains in the background representing the artist himself. The painting's bold forms suggest affinities with folk art, which inspired many German Expressionists, but it is not as abstract as Marc's later works would become. It is a superb example of the mature, pre-abstract style that he developed before World War I as an idiom that would be accessible to the untrained viewer. Nothing clearly identifiable in the painting suggests the upcoming war—which took the artist's life in 1916—nor contradicts the hope for a new age of spiritual "awakening" anticipated by the artists of Der Blaue Reiter, the group founded by Marc and Vasily Kandinsky in the year Marc painted *Yellow Cow*. The group's devotion to the expression of inner states extended in Marc's work to the inner lives of animals. "How does a horse see the world, how does an eagle, a doe, or a dog?" he asked. His answer was simple and esoteric at the same time: "It is a poverty-stricken convention to place animals into landscapes as seen by men; instead, we should contemplate the soul of the animal to divine its way of sight."

There is an oil sketch for *Yellow Cow* (1911, private collection, Germany), and an almost identical cow appears in *Cows Red, Green, Yellow* (1912, Städtische Galerie im Lenbachhaus, Munich). *The Little Yellow Horses* (1912, Staatsgalerie Stuttgart), which repeats the composition of Marc's famous *The Large Blue Horses* (1911, Walker Art Center, Minneapolis) is similar to *Yellow Cow* in that Marc used both the size of the animals and the color yellow to achieve that "gentle" and "sensual" effect of female presence he had mentioned in his letter to Macke. Yellow overpaint is also dominant in a rare example of a human presence in his art after 1907: *Yellow Seated Female Nude* (Kupferstichkabinett—Sammlung der Zeichnungen und Druckgraphik, Berlin), hand-painted in india ink and watercolor on a postcard that Marc sent to the Expressionist poet Else Lasker-Schüler on January 22, 1913.—M.B.

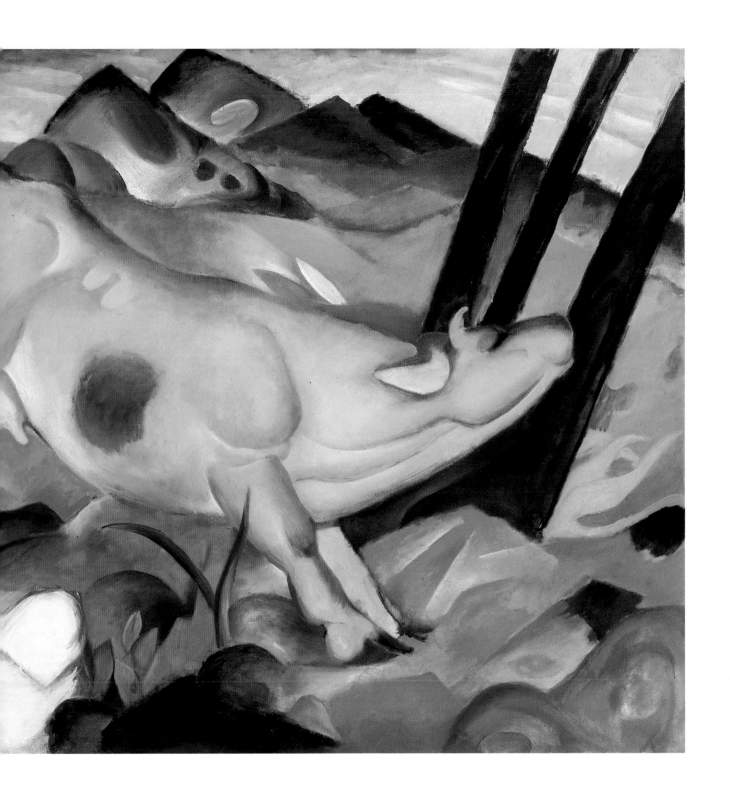

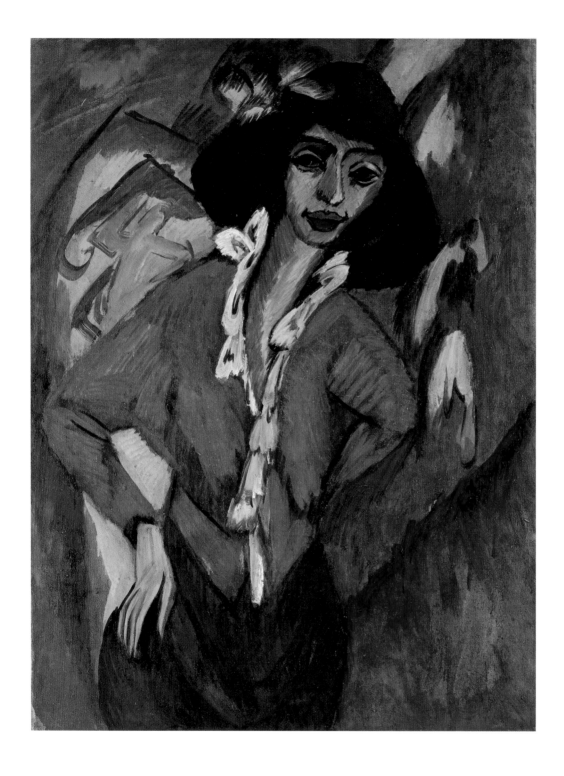

GERDA, HALF-LENGTH PORTRAIT (FRAUENKOPF, GERDA), 1914
OIL ON CANVAS
39 × 29⁵/₈ INCHES
PARTIAL GIFT, MR. AND MRS. MORTIMER M. DENKER 78.2421

In Dresden in 1905, Ernst Ludwig Kirchner banded together with Erich Heckel, Karl Schmidt-Rottluff, and others to form Die Brücke (The Bridge), a group devoted to the cause of shaking German art to its academic roots and transforming it into something contemporary and revolutionary. In their manifesto, they declared: "We wish to establish our freedom of action and life against well-established older forces." Taking their cue from the French Post-Impressionists and Fauves, they chose their subjects from the world around them, depicting city life, friends, landscapes, and music halls. Disparaging the studied classicism of academic painting, they filled their art with emotional energy rendered in acrid colors and with frenzied brushstrokes, thus defining the signature style of German Expressionism.

Gerda, Half-Length Portrait was painted after Kirchner had moved to Berlin and Die Brücke had disbanded. The stylized pose and angularity of the figure set within a radically foreshortened background are typical of the artist's mature style. The rough-hewn features of her face also call to mind Kirchner's interest in African masks. The intensity of the composition, the combined result of a harsh palette and sketch-like drawing, is made more dynamic by the highly abstract space surrounding the figure. The seductive, confrontational pose of the subject, the dancer Gerda Schilling (who was the older sister of the artist's future common-law wife), has an affinity with Kirchner's psychologically charged Berlin streetscapes of prostitutes and bourgeois life.

After World War I, Kirchner suffered from medical problems that occasioned his resettlement to the Swiss countryside. There, living in relative seclusion, he shifted to painting landscapes and other nature scenes invested with a mystical aura. In 1938 (the year after the Nazis included his work in the *Entartete Kunst* [*Degenerate Art*] exhibition), despondent and in failing health, Kirchner took his own life.—M.D.

OSKAR KOKOSCHKA

In the Vienna of 1914, a woman having an abortion was cause for scandal, even within the confines of the relatively open-minded art world. When such a woman was the widow of a famous composer, unwed, and carrying on two love affairs simultaneously, her decision would alarm even the most sympathetic souls. Thus it is that the agonized knight errant of Oskar Kokoschka's painting is to this day read as an expression of the artist's pain over the death of an unborn child and the crumbling of his relationship with the fascinating, and quite unrepentant, Alma Mahler.

The central figure appears to be a self-portrait of Kokoschka, clad in the armor of a medieval knight. He lies errant, or lost, in a stormy landscape, his two attributes—a winged bird-man and a sphinxlike woman—in close proximity. The bird-man has been interpreted either as the figure of death or another self-portrait, while the sphinx-woman has been seen as a stand-in for Mahler. A funereal sky bears the letters "E S," which probably refer to Christ's lament, "Eloi, Eloi, lama sabachthani" ("My God, my God, why hast Thou forsaken me?"). As if the self-equivalence with chivalry and the martyred Christ were not enough, the agitated brushwork and disturbing composition convince us of Kokoschka's spiritual discomfort.

If we look at *Knight Errant* within the context of Austrian art and compare it to the measured and ornate works of Hans Makart or even Gustav Klimt, Kokoschka's radicality emerges clearly. In what was still fin-de-siècle Vienna, *Knight Errant* was a notable exception for the immediacy of its imagery, which seemed to come more from the realm of psychoanalysis than from contemporary artistic trends. Indeed, Alma Mahler's first husband, Gustav, had consulted Sigmund Freud about his marriage, and the famous couple was apparently versed in psychoanalytic principles. But perhaps Kokoschka was equally influenced by his admiration for Baroque allegorical and literary motifs. Whatever their source, his emotion-charged images stem from a turbulently personal interpretation of Expressionism.—C.L.

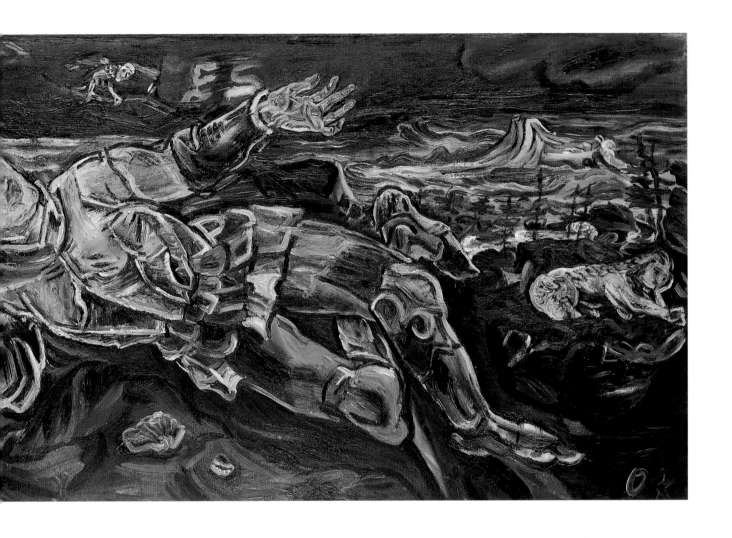

EGON SCHIELE

The subject of Egon Schiele's portrait is Johann Harms, his father-in-law. The painting demonstrates Schiele's sympathy for the seventy-three-year-old man, a retired machinist with the Austrian railway. Although a family portrait, it conveys a somber monumentality. With a stateliness that transcends its subject, the painting is reminiscent of papal portraits by Raphael or Titian. The work is known as the first in a series of "painterly portraits," as opposed to earlier canvases that Schiele executed in a more graphic style.

Schiele designed the chair in the painting for his studio and used it several times for portraits. As a prop, it allowed the artist to push his subjects toward the picture plane, flattening and enlarging the contours of their bodies. The chair also recalls the furniture in Vincent van Gogh's paintings of his own bedroom; its handcrafted style reminds us of the importance of the decorative arts in Vienna at this time.

Schiele painted the portrait two years before his death from influenza. It is an example of his mature style and goes far in abolishing fixed notions of Austrian Expressionism as only an art of angst. It also demonstrates that Schiele could successfully depart from his well-known fascination with the physical and psychic dimensions of sexuality. In 1916, after initial difficulties in his marriage to Edith Harms, Schiele was beginning to enjoy a sense of domestic happiness that would lead to other intimate family portraits. Schiele's fondness for Johann Harms carried beyond this portrait—after the old man's death in 1917, Schiele made a death mask of his father-in-law.—C.L.

PORTRAIT OF JOHANN HARMS, 1916
OIL WITH WAX ON CANVAS
54½ × 42½ INCHES
PARTIAL GIFT, DR. AND MRS. OTTO KALLIR 69.1884

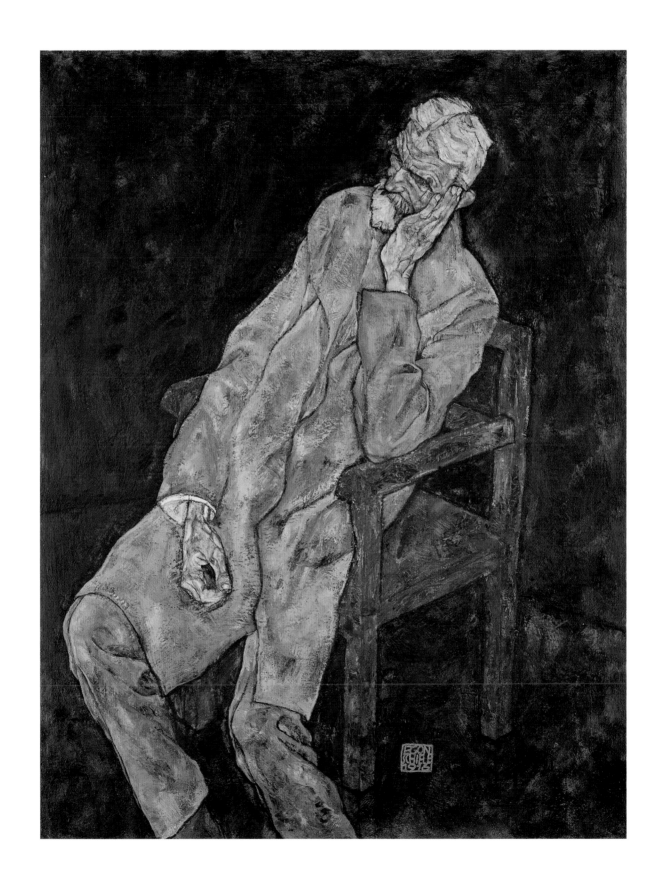

NAUM GABO

While studying medicine and science in Munich, Naum Gabo read works by philosopher Henri Bergson and attended lectures by art historian and theorist Heinrich Wölfflin. In 1914, at the outbreak of war, he moved to Norway, where he began to make sculptural reliefs of heads constructed from flat planes, in a manner similar to that of Italian Futurist Umberto Boccioni's work of the same period. Born Naum Pevsner, he changed his name to distinguish himself from his brother before returning to Russia with him in 1917 in order to support the Revolution. Gabo became an active member of the Russian avant-garde, and soon made the transition to pure abstraction. His approach was more closely aligned with Kazimir Malevich's relentless commitment to the transcendent power of art than to Vladimir Tatlin's Constructivist stance, yet he shared with Tatlin a belief in the idealistic power of architectural form.

Gabo left Russia for Germany in 1922, and it was there that he made many of his Constructivist sculptures. In works like *Column*, Gabo saw the potential of his sculptural forms being translated into an architectural language of public monuments. Gabo eschewed traditional sculpture's solid, massed forms, using interlocking vertical and horizontal planes to demarcate space and imply volume. The transparent planes expose the work's core and allow its overall structure to be seen from any vantage point. This visual clarity mirrors the work's formal clarity, which derives from a unifying mathematical system that determined the radius of the bases in relation to the dimensions of the vertical element.

In *Column*, Gabo came closest to a goal he established early in his career: to fuse the architectural with the sculptural. In "The Realistic Manifesto" of 1920 which he wrote with his brother, Antoine Pevsner, Gabo proclaimed: "The realization of our perceptions of the world in the forms of space and time is the only aim of our pictorial and plastic art. . . . We construct our work as the universe constructs its own, as the engineer constructs his bridges, as the mathematician his formula of the orbits."—I.B.

AXL II, 1927
OIL ON CANVAS
37 × 29⅛ INCHES
GIFT, MRS. ANDREW P. FULLER 64.1754

László Moholy-Nagy's utopian view that the transformative powers of art could be harnessed for collective social reform—a tenet embedded in much Modernist theory—reflected his early association with the leftist Hungarian group MA (Today), a coalition of artists devoted to the fusion of art and political activism. It was also tied to his long-standing affiliation with the Bauhaus, the German artistic and educational community founded by Walter Gropius and dedicated to the development of a universally accessible design vocabulary. With his Bauhaus colleagues, who included Josef Albers, Vasily Kandinsky, Paul Klee, and Oskar Schlemmer, he strove to define an objective science of essential forms, colors, and materials, the use of which would promote a more unified social environment.

Moholy-Nagy firmly believed that the art of the present must parallel contemporary reality in order to successfully communicate meaning to a public surrounded by new technological advancements. Hence, he considered traditional, mimetic painting and sculpture obsolete and turned to pure geometric abstraction filtered through the stylistic influence of Russian Constructivism. Inspired by the structural and formal capacities of modern, synthetic materials, Moholy-Nagy experimented with transparent and opaque plastics, particularly Celluloid, Bakelite, Trolitan, and Plexiglas. In 1923 he created his first painting on clear plastic, giving physical form to his profound interest in the effects of light, which would later be manifest in film and photography as well as in transparent sculptures.

AXL II illustrates how Moholy-Nagy translated his efforts to manipulate light "as a new plastic medium" onto the painted canvas. The intersecting transparent forms read as converging beams of light. A sense of layered space, echoing the artist's three-dimensional plastic "paintings" constructed with clear, projecting planes, is achieved. The contrived play of shadow and illumination on this canvas underscores the artist's conviction that light could be harnessed as an effective aesthetic medium, "just as color in painting and tone in music."—N.S.

In 1918, Piet Mondrian created his first "losangique" paintings, such as *Composition No. I* (also known as *Composition 1A*), by tilting a square canvas forty-five degrees. There are sixteen such canvases still extant, ranging in date from 1918 to 1944. A large number of these diamond-shaped works were created in 1925 and 1926, following Mondrian's break with the De Stijl group over Theo van Doesburg's introduction of the diagonal. Mondrian felt that in so doing van Doesburg had betrayed the movement's fundamental principles, thus forfeiting the static immutability achieved through stable verticals and horizontals. Mondrian asserted, however, that his own rotated canvases maintained the desired equilibrium of the grid, while the forty-five-degree turn allowed for longer lines.

From 1930 to 1933, Mondrian began to eliminate color in many of his canvases, producing in works like *Composition No. I* paintings of the utmost simplicity, in which the placement and varying thickness of lines determine the painting's rhythm. *Composition No. I* is the earlier of only two paintings by Mondrian in which none of the verticals and horizontals intersect within the confines of the canvas: two of them touch at the center of the lower right edge, but their intersection continues beyond the picture plane (suggesting that the work is taken from a larger whole). Art historian Rosalind Krauss notes that this exemplifies a centrifugal disposition of the grid, while works whose lines stop short of the picture's edge (implying that it is a self-contained unit) evince a centripetal tendency. Krauss argues that these dual and conflicting readings of the grid embody the central conflict of Mondrian's ambition: to represent properties of materials or perception while also responding to a higher spiritual call.—J.B.

COMPOSITION NO. 1, 1930
OIL ON CANVAS
29⅝ × 29⅝ INCHES; VERTICAL AXIS: 41³/₈ INCHES
HILLA REBAY COLLECTION 71.1936.R96

Francis Picabia abandoned his successful career as a painter of coloristic, amorphous abstraction to devote himself, for a time, to the international Dada movement. A self-styled "congenial anarchist," Picabia, along with his colleague Marcel Duchamp, brought Dada to the New York art world in 1915, the same year he began making his enigmatic machinist portraits, such as *The Child Carburetor*, which had an immediate and lasting effect on American art. *The Child Carburetor* is based on an engineer's diagram of a "Racing Claudel" carburetor, but the descriptive labels that identify its various mechanical elements establish a correspondence between machines and human bodies; the composition suggests two sets of male and female genitals.

Considered within the context created by Duchamp's contemporaneous work *The Bride Stripped Bare by Her Bachelors, Even* (1915 – 23; also known as *The Large Glass*), as art historian William Camfield has observed, *The Child Carburetor*, with its "bride" that is a kind of "motor" operated by "love gasoline," also becomes a love machine. Its forms and inscriptions abound in sexual analogies, but because the mechanical elements are nonoperative or "impotent," the sexual act is not consummated. Whether the implication can be drawn that procreation is an incidental consequence of sexual pleasure, or simply that this "child" machine has not yet sufficiently matured to its full potential, remains unclear.

Picabia stressed the psychological possibilities of machines as metaphors for human sexuality, but he refused to explicate them. Beneath the humor of his witty pictograms and comic references to copulating anthropomorphic machines lies the suggestion of a critique—always formulated in a punning fashion—directed against the infallibility of science and the certainty of technological progress. *The Child Carburetor* and his other quirky, though beautifully painted, little machines (which he continued to make until 1922) are indeed fallible. If they are amusingly naive as science fictions or erotic machines, they are also entirely earnest in placing man at the center of Picabia's universe, albeit a mechanical one.—J.A.

MAX ERNST

Max Ernst came to artistic maturity during one of the most fractious periods in European history. Both politically and culturally, the second decade of the twentieth century was a tumultuous period which brought major change to Europe: World War I broke out, the Russian empire collapsed, and avant-garde organizations proliferated in the arts. In Germany, where Ernst was born to an amateur painter and his wife in 1891, the journal *Der Sturm* began publication in 1910, and Der Blaue Reiter (The Blue Rider) group was formed in Munich in 1911. These and many other manifestations of the avant-garde provided the impetus for Ernst's rejection of the academic tradition represented by his father's paintings.

Ernst was conscripted into the military as an artillery engineer during World War I and was twice wounded, yet managed to pursue his artistic interests throughout the course of the war, exhibiting in Berlin at the Der Sturm gallery in 1916. The following year, he published "The Evolution of Color," an article that paid tribute to Marc Chagall, Robert Delaunay, and Vasily Kandinsky, reflecting Ernst's aesthetic interests at the time. *Landscape* similarly represents a synthesis of artistic idioms gleaned from his peers: the pictorial logic invokes a Cubist idiom, while the palette and animal forms recall the paintings of Heinrich Campendonk and Franz Marc.

While *Landscape* predates Ernst's involvement with Cologne Dada in the late 1910s and the Surrealist movement in the 1920s, the startling juxtapositions and fantastic imagery foreshadow this later work. Active among the Surrealists, who plumbed the recesses of the mind the world of dreams for their imagery, Ernst would develop his own highly personal iconography, including the bowler-hatted man and the bird seen in this painting. The former has been interpreted as a reference to his father, while the latter evolved into the artist's alter ego Loplop and appeared frequently throughout Ernst's oeuvre. The prominent eyes—presaging the Surrealist fascination with vision—compound the ambiguity of the canvas: they appear frontally in the profiles of the animals in the foreground and are partially obscured in the landscape below the bowler-hatted figure. Resistant to ready interpretation, this painting is perhaps best understood in terms of Louis Aragon's comment that "the place to catch the thoughts of Max Ernst is the place where, with a little color, a line of pencil, he ventures to acclimate the phantom which he has just precipitated into a foreign landscape."—J.F.R.

JOAN MIRÓ

In 1927, Joan Miró painted a series of landscapes on his family's farm in Montroig, Catalonia, where he went to recuperate from his bohemian life in Paris. These landscapes, with their whimsical animal figures and deep, earthy tones, show Miró returning to nature and responding to his immediate surroundings. (By contrast, the "dream landscapes" he painted in Paris during the same period are more hallucinatory and ethereal, without a ground plane or horizon line to anchor the composition.) In *Landscape (The Hare)*, a line of multicolored dots swirls into a solar spiral, melding a blank orange sky with a bare expanse of burgundy earth below. This surreal terrain is empty of life except for the hare, which seems mesmerized by the spiral form; its turning movement is reflected in the kaleidoscopic discs outlining the animal's dilated pupils. The artist later told Margit Rowell the source of the motif: one evening in Montroig, he was watching the sun set across an unplanted brown field when he saw a hare streak across the scene. According to him, the dotted spiral is meant to suggest the sun, but its yellow tail and swirling pattern also evoke a falling comet. In the earlier *Lady Strolling on the Rambla in Barcelona* (1925, New Orleans Museum of Art), a very similar form represents the sensuality of the female body. Rosalind Krauss and Rowell have speculated that the spiral has sexual connotations in *Landscape (The Hare)* as well, as a spellbinding force entrancing the animal, the artist, and the viewer.

Influenced by medieval Catalan fresco painting, Miró's landscapes from this period eliminate naturalistic perspective, instead using horizontal chromatic partitions of the picture plane to symbolize depth. The painting's structure is deceptively simple: intensely contrasting colors divide the canvas equally into earth and sky, which are united by the expanding rays of the setting sun. The hare's organic form and suspended stance are sweetly affecting; its outrageous color composition and devilish head and tail add a dash of humor to the scene. The figure looks more like a Surrealist paper collage than the animal it represents. By reimagining local landscape traditions in avant-garde form, Miró reconciled Modernism with Catalan culture.

Always remaining deeply attached to his ethnic heritage, Miró nonetheless looked to Paris for exposure to Europe's Modernist avant-garde. From his first trip there in 1920, he immersed himself in the literary and artistic culture of the city. In particular, he associated with the Surrealists, whose automatic techniques, intended to tap the unconscious mind, produced fantastically unconventional poetry and art. Miró's interest in poetry and the cultivation of an unfettered artistic imagination led him to develop his own startlingly original aesthetic, which combined calligraphic line, intense color, and stylized biomorphic form. Seeking to capture the essential structure and spirit of nature like his idols Paul Cézanne and Pablo Picasso, Miró simplified elements of the natural world into an evocative system of signs. According to the artist, "Poetry, plastically expressed, speaks its own language."—B.A.

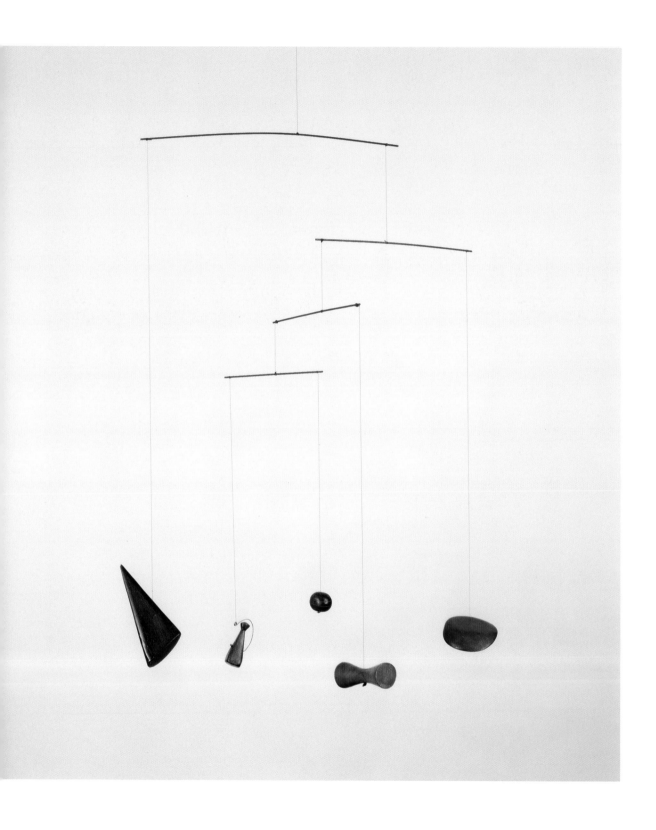

The kinetic potential of art was of primary interest to Alexander Calder throughout his career: "Why must art be static? You look at an abstraction, sculptured or painted, an entirely exciting arrangement of planes, spheres, nuclei, entirely without meaning. It would be perfect but it is always still. The next step in sculpture is motion." Employing the language of abstraction, Calder captured movement through a range of structures—including mobiles, stabiles, constellations, towers, and gongs—that offered radical alternatives to the prevailing notions of sculpture and had a profound impact on the history of twentieth-century art.

While the extraordinary breadth of Calder's production makes it impossible to characterize his work according to any particular style or technique, he is perhaps best known as the inventor of the mobile. Calder's first mobiles, kinetic works propelled only by air circulating its balanced components, date from the early 1930s, when he lived in Paris. It was Marcel Duchamp who devised the term for these suspended sculptures; as Calder recalled, "I asked him what sort of a name I could give these things and he at once produced 'mobile.' In addition to something that moves, in French it also means motive."

Calder, a fastidious craftsman, cut, bent, punctured, and twisted his materials entirely by hand, the manual emphasis contributing to the sculptures' evocation of natural form. Shape, size, color, space, and movement combine and recombine in shifting, balanced relationships that provide a visual equivalent to the harmonious but unpredictable activity of nature. In *Untitled*, simple wooden shapes—most of them unpainted—are suspended from metal rods. Responding to air currents, the mobile's ever shifting profile moves spontaneously and unpredictably, different elements traveling in different directions at varying rates of speed. Along with a second wood mobile in the Guggenheim collection, this work was previously owned by renowned collector of Surrealist art, Mary Reynolds. According to the artist, Reynolds dubbed the two pieces "Pas Nobles Mobiles" (the undignified mobiles) since they had been turned down for inclusion in one of Calder's early gallery shows.—SRGM/L.F.

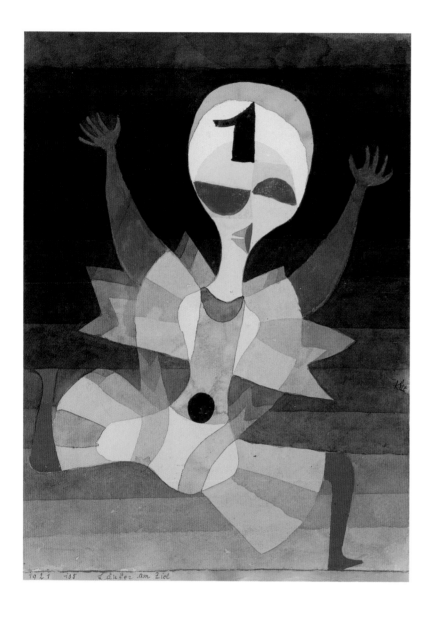

Paul Klee's persistent shifts in style, technique, and subject matter indicate a deliberate and highly playful evasion of aesthetic categorization. Nevertheless, it is virtually impossible to confuse a work by Klee with one by any other artist, even though many have emulated his idiosyncratic, enigmatic art. So accepted was his work that Klee was embraced over the years by the Blue Rider group, the European Dada contingent, the Surrealists, and the Bauhaus faculty, with whom he taught for a decade in Weimar and Dessau.

As part of the early twentieth-century avant-garde, Klee formulated a personal abstract pictorial language. His vocabulary, which oscillates freely between the figurative and the nonrepresentational communicates through a unique symbology that is more expressive than descriptive. Klee conveyed his meaning through an often whimsical fusion of form and text, frequently writing the title to his works on the mats upon which they are mounted. Although much of Klee's work is figurative, compositional design nearly always preceded narrative association. The artist often transformed his experiments in tonal value and line to visual anecdotes.

Klee arrived at the Weimar Bauhaus in 1921. In his courses, as in his work, he was particularly interested in the dynamism of things and beings and the way it could be expressed. This same year, Klee executed a series of works in which his passion for music is revealed. Based on Johann Sebastian Bach's fugues, the chromatic variations of a single shape resemble the harmonic variations of a single melodic line of music. Klee's diaries note his developing theories of simultaneity alongside the numerous entries that record the concerts he attended and pieces he heard: "Yesterday and tomorrow as simultaneous. In music, polyphony helped to some extent to satisfy this need. . . . Mozart and Bach are more modern than the nineteenth century. . . . Polyphonic painting is superior to music in that, here, the time element becomes a spatial element. The notion of simultaneity stands out even more richly." *Runner at the Goal* is an essay in simultaneity; overlapping and partially translucent bars of color illustrate the consecutive gestures of a figure in motion. The flailing arms and sprinting legs add a comic touch to this figure, on whose forehead the number "one" promises a winning finish.—SRGM

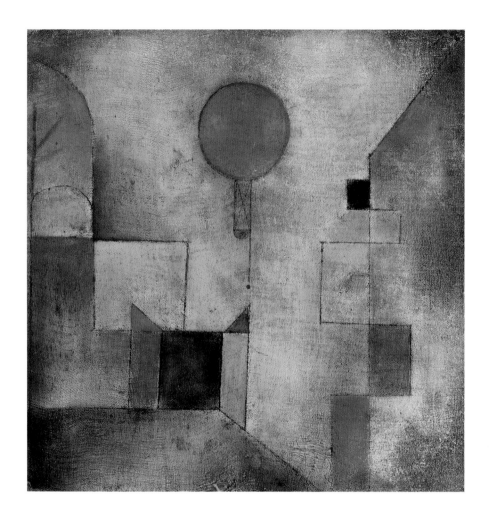

RED BALLOON (ROTER BALLON), 1922
OIL (AND OIL TRANSFER DRAWING?) ON CHALK-PRIMED GAUZE, MOUNTED ON BOARD
12½ × 12¼ INCHES
48.1172X524

This ethereal scene, half-abstract, half-representational, was made just one year before Paul Klee ventured into creating purely abstract compositions of colored rectangles. He was enjoying great success as a teacher at the Bauhaus during one of the most fertile periods in his career. With delicate pastel hues and a sensation of forms floating in space, Klee makes only the slightest references to doorways, walls, windows and rooftops in a scene that is simultaneously fantastic and intelligible.

In *Red Balloon*, Klee, a technical innovator, may have employed a special oil transfer drawing technique he developed in an effort to create the misty, atmospheric texture of his lithographs, in painting. He brushed a thinned oil paint onto one side of a piece of paper, then like making a carbon copy, he drew on the back of the painted sheet with a pen or stylus. The resulting lines have a feathered, smudged quality, as the artist stated, "saving transfer of my fundamental graphic talent into the domain of painting." Devised during Klee's Bauhaus years, the oil transfer method was used for watercolors and oil paintings that are among the artist's most idiosyncratically playful images.

United overall by a consistently soft, dark line that was transferred from a preparatory drawing to the surface of this canvas, and by warm touches of red distributed throughout the composition, *Red Balloon* shows Klee in the midst of experimentation with his technical and compositional practices. Poised above this charming cityscape, a red balloon is detached from the rest of the composition, extending the overall visual sensation of drifting lightness and freedom of movement.—SRGM

VASILY KANDINSKY

A believer in art's ability to transform self and society, Vasily Kandinsky was an ideal candidate to teach at the Bauhaus in Weimar. Established in 1919 by Walter Gropius, this uniquely utopian school educated students in both the theory and practice of art and architecture. Kandinsky began by teaching mural painting, which was in the early years of the school the only acceptable form of the medium because of its essential relationship to architecture. In 1925, however, as the scope of the Bauhaus changed, he taught courses in easel painting and aesthetic theory with Paul Klee, a fellow artist committed to creating work that suggested something beyond the material world.

During the Bauhaus years, the circle became Kandinsky's primary motif. He presented a mathematical and scientific categorization of various pictorial elements in his book *Point and Line to Plane* (1926). Based on his lectures and conceived as a guide to be used by future artists, the text also contains discussions of spirituality that were so crucial to his thinking about art and offers cosmic interpretations of basic geometric forms. Kandinsky's approach to the circle resembles a formal or metaphysical problem that he might have assigned his Bauhaus students to solve: Examine the emotional and psychological effects of color and form using only one of the primary forms. Evidence of his fascination with the psychological effects of these forms and their corresponding "spiritual vibrations" may be found not only in his writings of this period but also in his paintings.

Several Circles exemplifies the equilibrium Kandinsky sought in his work and life as an artist and theoretician, proving that it is possible to understand both the mathematical and spiritual aspects of a given form. In 1926, the artist completed an ink drawing and oil study for *Several Circles* as well as the final version of the painting. Brightly colored overlapping circles of varying sizes change color at their points of intersection as they float on the dark, mottled background. As the artist reworked the placement of the small orange circle below the largest orb to achieve a sense of stability, the proportion and scale of the work changed significantly.

In all versions of *Several Circles*, Kandinsky used another primary form, the square in the shape of the canvas itself, to anchor the composition and provide additional symmetry and order. Further, the nearly perfect circles in this composition, like those in similar works from Kandinsky's Bauhaus period, appear to have been created with a compass. Consequently, they are more rigid than the freehand forms of earlier paintings, but the central blue orb and some others are softened by pastel halos, which suggest religious connotations. Although *Several Circles* has been read as a depiction of a meteor shower or constellation, Kandinsky himself eschewed such literal interpretations and argued that circles are indeed "links with the cosmic."
—E.B.

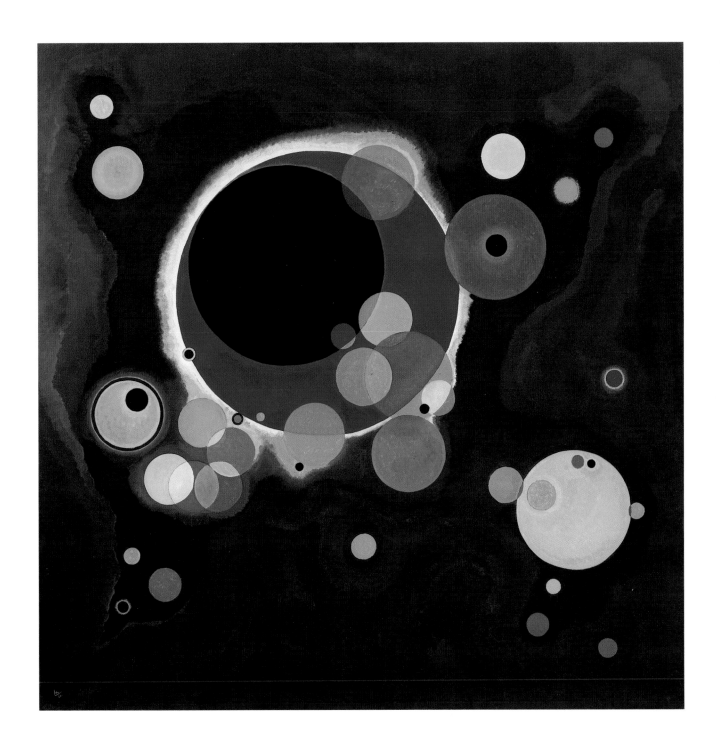

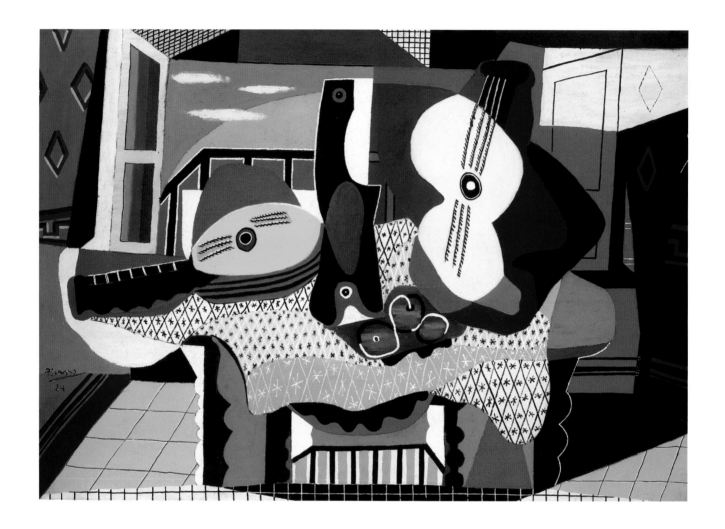

MANDOLIN AND GUITAR (MANDOLINE ET GUITARE), 1924
OIL WITH SAND ON CANVAS
55³/₈ × 78⁷/₈ INCHES
53.1358

One year before Pablo Picasso painted the monumental still life *Mandolin and Guitar*, Cubism's demise was announced during a Dada soiree in Paris by an audience member who shouted that "Picasso [was] dead on the field of battle"; the evening ended in a riot, which could be quelled only by the arrival of the police. Picasso's subsequent series of nine vibrantly colored still lifes (1924–25), executed in a bold Synthetic Cubist style of overlapping and contiguous forms, discredited such a judgment and asserted the enduring value of the technique. But the artist was not simply resuscitating his previous discoveries in creating this new work; the rounded, organic shapes and saturated hues attest to his appreciation of contemporary developments in Surrealist painting, particularly as evinced in the work of André Masson and Joan Miró. The undulating lines, ornamental patterns, and broad chromatic elements of *Mandolin and Guitar* foretell the emergence of a fully evolved, sensual, biomorphic style in Picasso's art.—N.S.

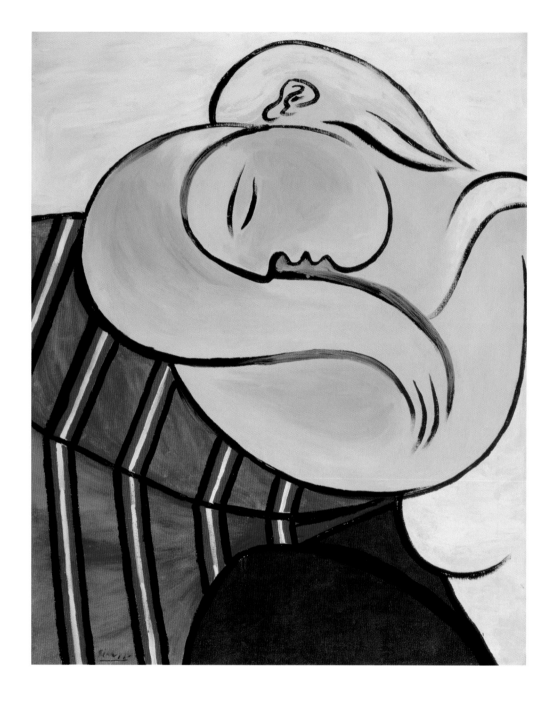

WOMAN WITH YELLOW HAIR (FEMME AUX CHEVEUX JAUNES), DECEMBER 1931
OIL ON CANVAS
39³/₈ × 31⁷/₈ INCHES
THANNHAUSER COLLECTION, GIFT, JUSTIN K. THANNHAUSER 78.2514.59

When Pablo Picasso met Marie-Thérèse Walter on January 11, 1927, in front of Galeries Lafayette, Paris, she was seventeen years old. As he was married at the time and she only a teenager, they were compelled to conceal their intense love affair. While their illicit liaison was hidden from public view, its earliest years are documented, albeit covertly, in Picasso's work. Five still lifes painted during 1927—incorporating the monograms "MT" and "MTP" as part of their compositions—cryptically announce the entry of Marie-Thérèse into the artist's life.

By 1931, explicit references to Marie-Thérèse's fecund, supple body and blond tresses appear in harmonious, voluptuous images such as *Woman with Yellow Hair*. She became a constant theme; she was portrayed reading, gazing into a mirror, and, most often, sleeping, which for Picasso was the most intimate of depictions. The abbreviated delineation of her profile—a continuous, arched line from forehead to nose—became Picasso's emblem for his subject, and appears in numerous sculptures, prints, and paintings of his mistress. Rendered in a sweeping, curvilinear style, this painting of graceful repose is not so much a portrait of Marie-Thérèse the person as it is Picasso's abstract, poetic homage to his young muse.—N.S.

MAX BECKMANN

Paris Society is Max Beckmann's portrait of émigrés, aristocrats, businessmen, and intellectuals engaged in disjointed festivity on the eve of the Third Reich. Beckmann was invited to paint this work by the German embassy in Paris. A series of sketches shows that Beckmann had conceived of the composition as early as 1925. By 1931, when he completed it, accusations and slander against the freethinking artist had begun to mount in Germany, and the somber character of *Paris Society* seems to reflect his sense of foreboding. Beckmann spent much time in Paris, but financial hardship stemming from his persecution led him to give up his studio there.

Paris Society is rife with ambiguities. The event depicted is a black-tie party, although the socialites gathered there seem strangely depressed. Some of the figures in the composition were identified by the artist's widow, Mathilde Beckmann. They include the central figure, Beckmann's friend Prince Karl Anton Rohan; the Frankfurt banker Albert Hahn at the far right; the music historian Paul Hirsch seated at the left; the German ambassador Leopold von Hoesch at the lower right, with his head in his hands; and possibly Paul Poiret, the French couturier, standing at the left. But why they are together in this scene and what their peculiar postures denote remain a matter of speculation.

In café, hotel, and beach scenes, Beckmann had proven himself to be a mordant painter of modern life, and some German critics counted him among the artists of the Neue Sachlichkeit. The universalizing tendency of his moral allegories, however, diverged from the political satire of his colleagues. Beckmann's paintings do not succumb to precise interpretation. In spite of their period detail, they seem to represent a condition rather than a historical moment.—C.L.

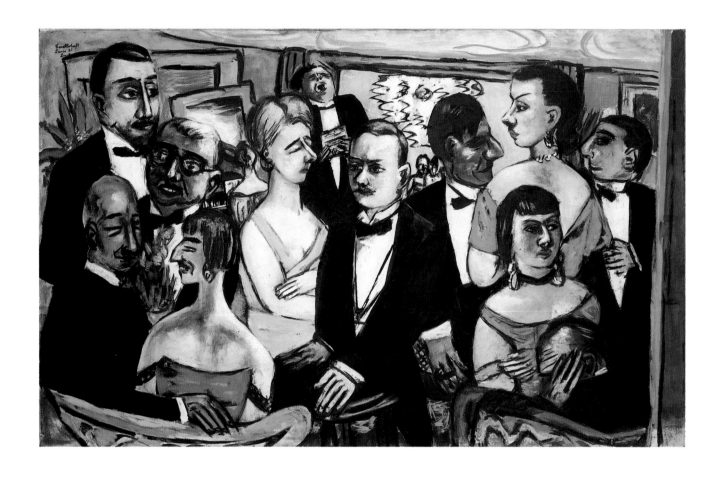

ROBERT DELAUNAY

In his treatise "Light," first published in the journal *Der Sturm* in 1913, Robert Delaunay expounded upon his preference for vision above all other senses: "Human sight is endowed with the greatest reality, since it comes to us directly from the contemplation of the universe. The eye is the most refined of our senses, the one which communicates most directly with our mind, our consciousness." Delaunay's *Eiffel Tower* (1909 – 12; e.g., p. 71) and *Windows* (1912 – 14) series present multiple views of the city of Paris, analyzing the simultaneous nature of sight, in which the mind registers an impression through successive movements of the eye. In his next group of paintings, *Circular Forms* (1913, and again in 1930 – 31), Delaunay dismissed representational objects altogether, striving instead to represent pure optical perception through investigations of color and light.

After studying Michel-Eugène Chevreul's nineteenth-century color theories, which also had great significance for the French Impressionists, Delaunay adopted Chevreul's hypothesis that, as a result of its placement next to other colors, a given color may have different effects—at times harmonious, sometimes dissonant—intensifying or diminishing adjoining hues. Delaunay explored the effect upon the eye of such juxtapositions: "Light in nature," he realized, "creates movement of colors." The pairing of complementary colors (such as red and green) produces slow vibrations perceptible to the eye, while dissonant juxtapositions (red next to blue) produce faster vibrations. Through such contrasts, he was able to represent real movement—"the vital movement of the world"—not simply the illusion of it; light and color alone became a means of expression. Delaunay's manipulations of vibrant hues in his *Windows* paintings inspired the poet Guillaume Apollinaire to describe their lyricism of color with the term "Orphism," after Orpheus, the poet and musician in Greek mythology.

In 1913, Delaunay completed *Circular Forms: Sun No. 1,* the first of the series. Comprised of concentrically placed zones of contrasting colors, this and similar compositions were inspired by observations of the sun and moon, as the works' titles indicate. As Delaunay exclaimed of the circle, "This is the cosmic, visible, truly real form!" Eschewing any reference to a subject, the Guggenheim's *Circular Forms* depicts the capacity of light to produce color independent of any object. The colors—pink to red, pale green, yellows and blue—which vary in intensity are released from any reference to particular things or emotions. Delaunay's composition resembles the endless number of luminous refractions that light creates when passing through a prism. The right side of the painting, a kaleidoscopic rendering of the left, simultaneously emanates inward and outward, conveying the limitless nature of light.—J.Y.

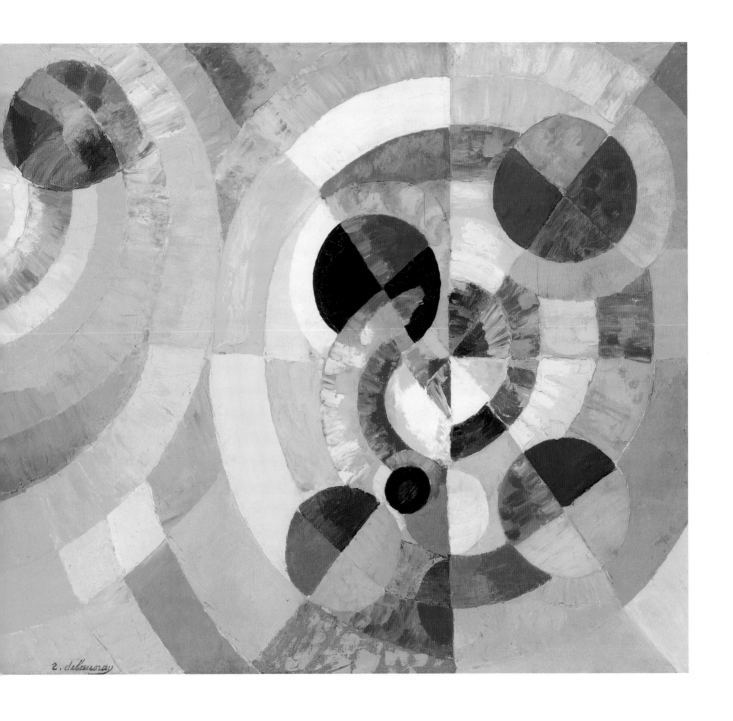

VASILY KANDINSKY

Increased censorship by the fascist government in Germany forced Vasily Kandinsky to leave his adopted homeland in 1933. After contemplating a move to the United States, he went instead to Paris, which he considered the artistic capital and where he believed a market for his paintings could be found. Rather than finding the acceptance he anticipated there, his work was not understood or embraced by French critics and curators, who had recently rediscovered Cubism, and Kandinsky found himself arguing that his work developed in tandem with, not out of, Cubism. Despite his unexpected struggle to establish the legitimacy of his expressionistic abstraction after his departure from the Bauhaus, Kandinsky's works from the Paris period share stylistic similarities with those of his contemporaries. He had connections with the Abstraction-Créationists, a loosely affiliated group of artists that included Piet Mondrian and Georges Vantongerloo, who were devoted to nonfigurative art. Although Kandinsky exhibited with them in Pairs in 1933, he felt that the importance they placed on abstract forms derived from geometry rather than nature was too limiting. The Surrealists also invited him to participate in their sixth Salon des Surindépendents, also in 1933.

In *Dominant Curve*, which both the artist and his critics viewed as one of the most important works in his oeuvre, Kandinsky synthesized the vibrancy and spirituality of his early canvases with Bauhaus geometry and Surrealist biomorphism based on scientific forms. The green rectangle that resembles a microscope slide overlaid with microorganisms in the upper left corner and the embryonic form in the upper right reveal Kandinsky's interest in biology, zoology, and embryology. The artist favored biomorphic forms for their association with the generative aspects of nature, and although he collected organic specimens and scientific encyclopedias during his Bauhaus years, he only introduced such images into his work in 1934. He combined these science-derived forms with primary geometric shapes, energetic lines, and a lively pastel palette with Surrealist motifs, harnessing the energy of Joan Miró's curving lines, for example, and using disjunctive imagery to disrupt conventional compositional strategies and create unexpected combinations resulting in free-associative meanings for the viewer.

Throughout the 1930s, Kandinsky reinvigorated his past pictorial vocabularies—*Dominant Curve* returns to the large-scale format of his expressionist canvases of the early 1910s, for example—while creating a new set of imagery based on a combination of his inner visions and observations of the physical world. Even when adopting Surrealist-inspired forms, Kandinsky's original belief that abstraction could be used to communicate spiritual ideas continued to pervade his work, whether it be in his paintings or in his written theories on art and abstraction. In *Dominant Curve*, spirituality is derived from an otherworldly combination of abstract imagery and vivid colors.—E.B.

FERNAND LÉGER

Unlike many of his School of Paris colleagues, Fernand Léger eschewed using collaged frag-
ments to represent everyday life, instead developing proletarian themes that he executed in ever
larger formats. *The Great Parade* is the summation of his lifelong attempt to devise an imagery
of the everyday within the realm of painting. It was preceded by hundreds of preparatory stud-
ies in which Léger methodically resolved every detail of the complex composition. The stately
procession of figures is couched in the rhetoric of monumental history painting with only the
integrity of its subject matter saving it from the pomposity of a modern allegory.

This subject matter reveals Léger's political sympathies and intentions. An ardent believer in
equality, and apparently in the equality of the sexes as well, Léger depicted men and women as
indistinguishable equals on a wide swath of blue. The composition further relates to the concept
of leisure and its indexation to class. The lower classes did not know leisure time until the late
nineteenth century, when labor-saving industrialization and transportation advances made vaca-
tions possible. The circus is a place where all people are equal, united in their enjoyment of the
spectacle. Its capacity to entertain became a metaphor for Léger's vision of art as a vehicle for
the transformation of society. His hope was to create a painting with universally appealing val-
ues. Seemingly timeless, Léger's work was didactically intended to remind people of their funda-
mental right to self-fulfillment.—C.L.

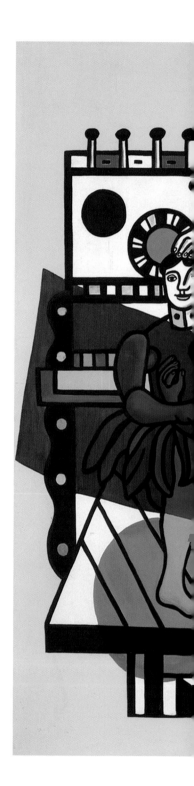

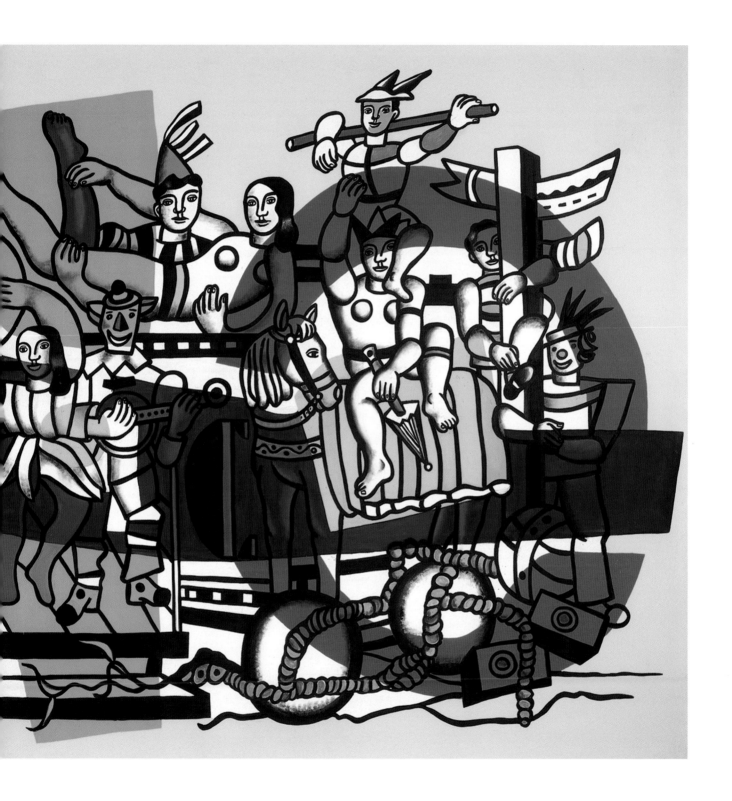

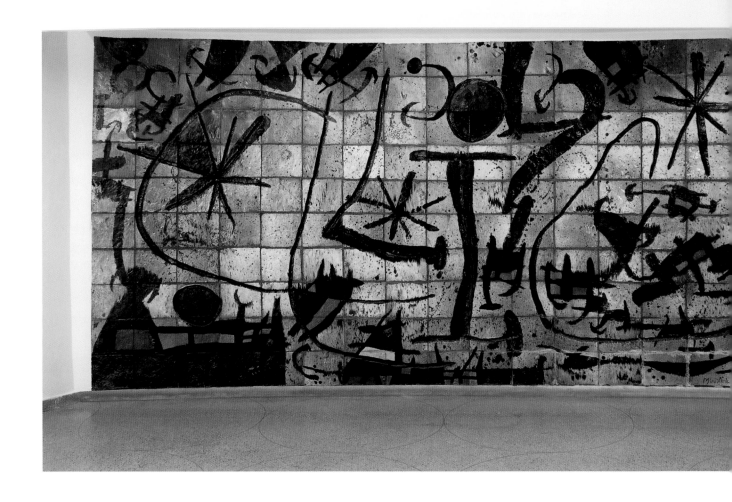

ALICIA, 1965–67
CERAMIC TILE
97⁷/₈ × 228¹/₂ INCHES
GIFT, HARRY F. GUGGENHEIM IN MEMORY OF HIS WIFE ALICIA PATTERSON GUGGENHEIM 67.1844

Joan Miró met ceramicist Josep Lloréns Artigas in 1912, while Miró was an art student in Barcelona. These longtime friends began to work together in 1944. Miró's initial experiments in the medium of ceramics were collaborative pieces in which he painted on the surfaces of Artigas's vase and plaque forms. Eventually Miró began to produce sculpture in the medium, making models out of found objects and natural materials that would then be translated into clay by Artigas or beginning in 1953, by his son Joan.

Alicia is Miró's second ceramic mural in the United States (the first was commissioned in 1950 for the Graduate Center at Harvard University and before its final installation, was exhibited at the Guggenheim in 1961). Executed at Artigas's atelier near Barcelona, *Alicia* is comprised of 190 separate ceramic tiles and is permanently installed in the rotunda of the Guggenheim's Frank Lloyd Wright building, occupying the first wall encountered as one ascends the museum's spiral ramp. Thomas M. Messer, the Guggenheim's Director from 1961 to 1988, contacted Miró in 1963 following the proposal of Harry F. Guggenheim, then President of the Solomon R. Guggenheim Foundation, to commission an appropriate memorial to his wife, Alicia Patterson Guggenheim, who died that year at the age of fifty-six.

The abstract composition, typical of Miró's characteristic style, palette, and vocabulary of motifs, includes the name "Alice" in reference to the commemorated Alicia Guggenheim. Although Messer valiantly and tactfully attempted to correct the misspelling Miró had included in his numerous letters, the artist mysteriously resisted. Amid his signature celestial forms, Miró perhaps playfully settled on a composition of letters that, as was suggested in a 1967 letter from his dealer Pierre Matisse, could be read either as "Alice" or "Alicia."

Miró undertook the project with enthusiasm, writing to Messer in August of 1966 and noting the significance he ascribes to the firing process in the completion of his ceramic works: "I am delighted to tell you that the great mural has already been started. I am very hopeful about the results of this first stage. Let's hope that our great friend Fire will also bring us his richness and his beauty for the next steps." Possibly it was the element of chance interaction, producing uncontrolled and unexpected results that drew the Surrealist Miró to the techniques for creating works in ceramics, a medium that remained significant in his oeuvre for over four decades.
—T.B.

JEAN DUBUFFET

Jean Dubuffet's *Corps de Dames* series (1950 – 51) of thirty-six works takes as its subject the nude female figure. With this group of iconoclastic canvases, which includes *Triumph and Glory*, Dubuffet ceaselessly reiterated his attack on the divine image, striking in this case at the natural embodiment of grace. In response to the accusations of ugliness commonly addressed to him at the time, he disputed the "accidental and highly specious convention" of beauty, claiming on the contrary that he proposed a "fervent celebration" of the real. Dubuffet insisted that he was protesting against certain traditional ideals of beauty—those "inherited from from the Greeks and cultivated by magazine covers."

Perhaps the outrageous character of the drawing in the *Corps de Dame*—echoed across the Atlantic by Willem de Kooning's *Women*—arose from an increasing need to underline the subject, even as the treatment became more abstract. In *Triumph and Glory*, the woman's body is transformed into a flattened textured surface, adapted to fit the large, rectilinear canvas. As in other works in the series, only essential physiological details have been scratched into its wet surface. The prevailing impression is of built-up layers of paint, applied like plaster to a wall, crudely and bluntly portraying an abstracted earthy female: an image of stalwart presence and fundamental solidity. Dubuffet's claim of celebratory imagery is bolstered here by the painting's title, *Triumph and Glory*, and by the figure's pose, with arms upraised.—SRGM/D.A.

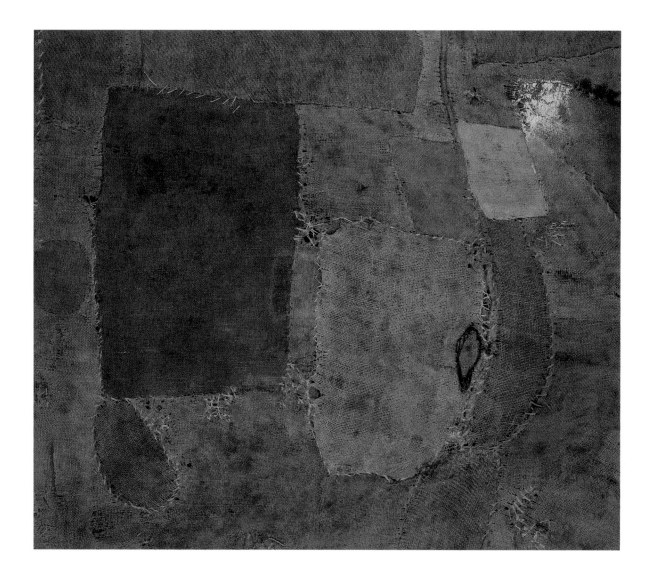

COMPOSITION (COMPOSIZIONE), 1953
OIL, GOLD PAINT, AND GLUE ON BURLAP AND CANVAS
33⅞ × 39½ INCHES
53.1364

Composition is one of Alberto Burri's *Sacchi* (sacks), a group of collage constructions made from burlap bags mounted on stretchers. One of Burri's first series employing nontraditional mediums, the *Sacchi* were initially considered assaults against the established aesthetic canon. His use of the humble bags may be seen as a declaration of the inherent beauty of natural, ephemeral materials, in contradistinction to traditional "high art" mediums, which are respected for their ostentation and permanence. Early commentators suggested that the patchwork surfaces of the *Sacchi* metaphorically signified living flesh violated during warfare; the stitching was linked to the artist's practice as a physician. Others suggested that the hardships of life in postwar Italy predicated the artist's redeployment of the sacks in which relief supplies were sent to the country.

Yet Burri maintained that his use of materials was determined purely by the formal demands of his constructions. "If I don't have one material, I use another. It is all the same," he said in 1976. "I choose to use poor materials to prove that they could still be useful. The poorness of a medium is not a symbol: it is a device for painting." The title *Composition* emphasizes the artist's professed concern with issues of construction, not metaphor. Underlying the work is a rigorous compositional structure that belies the mundane impermanence of his chosen mediums and points to art-historical influences. While the *Sacchi* rely on lessons learned from the Cubist- and Dada-inspired constructions of Paul Klee and Kurt Schwitters, they are primary examples of the expressionism widely practiced in postwar Europe.—J.B.

LUCIO FONTANA

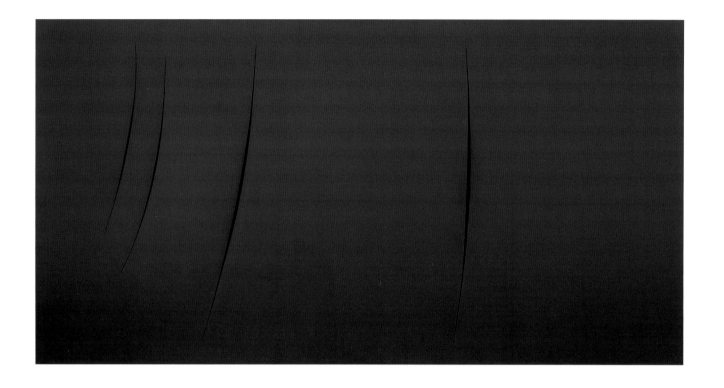

SPATIAL CONCEPT, EXPECTATIONS (CONCETTO SPAZIALE, ATTESE), 1959
WATER-BASED PAINT ON CANVAS
49⅝ × 98¾ INCHES
GIFT, MRS. TERESITA FONTANA, MILAN 77.2322

Lucio Fontana's respect for the advancements of science and technology during the twentieth century led him to approach his art as a series of investigations into a wide variety of mediums and methods. In his manifestos, Fontana announced his goals for a "spatialist" art, one that could engage technology to achieve an expression of the fourth dimension. He wanted to meld the categories of architecture, sculpture, and painting to create a groundbreaking new aesthetic idiom.

From 1947 on, Fontana's experiments were often entitled *Concetti spaziali*, among which a progression of categories unfolds. Beginning in 1958, Fontana purified his paintings by creating matte, monochrome surfaces, thus focusing the viewer's attention on the slices that rend the skin of the canvas. Paintings such as *Spatial Concept, Expectations* are among these *Cuts* (*Tagli*), whose violent jags enforce the idea that the painting is an object, not solely a surface.

Many of Fontana's proclamations echo Futurist declarations made before World War 1. The artist's wish that his materials be integrated with space, his need to express movement through gesture, and his interest in states of being (exemplified in his use of the word "expectations" in the title of this work), suggest the artist's familiarity with the work of Umberto Boccioni, a leading Futurist sculptor, painter, and theorist whom Fontana cited as an inspiration.—J.B.

ANTONI TÀPIES

In the years after World War II, both Europe and America saw the rise of predominantly abstract painting concerned with materials and the expression of gesture and marking. New Yorkers dubbed the development in the United States. Abstract Expressionism, while the French named the pan-European phenomenon of gestural painting Art Informel (literally "unformed art"). A variety of the latter was Tachisme, from the French word *tache*, meaning a stain or blot. Antoni Tàpies was among the artists to receive the label Tachiste because of the rich texture and pooled color that seemed to occur accidentally on his canvases.

Tàpies reevaluates humble materials, things of the earth such as sand—which he used in *Great Painting*—and the refuse of humanity: string, bits of fabric, and straw. By calling attention to this seemingly inconsequential matter, he suggests that beauty can be found in unlikely places. Tàpies sees his works as objects of meditation that every viewer will interpret according to personal experience. "What I do attempt," he maintains, "is to create images that will cause the observer to look upon reality in a more contemplative way."

Tàpies's images often resemble walls that have been scuffed and marred by human intervention and the passage of time. In *Great Painting*, an ocher skin appears to hang off the surface of the canvas; violence is suggested by the gouge and puncture marks in the dense stratum. These markings recall the scribbling of graffiti, perhaps referring to the public walls covered with slogans and images of protest that the artist saw as a youth in Catalonia—a region in Spain that experienced the harshest repression of the dictator Francisco Franco. Tàpies has called walls the "witnesses of the martyrdoms and inhuman sufferings inflicted on our people." *Great Painting* suggests the artist's poetic memorial to those who have perished and those who have endured.—J.B.

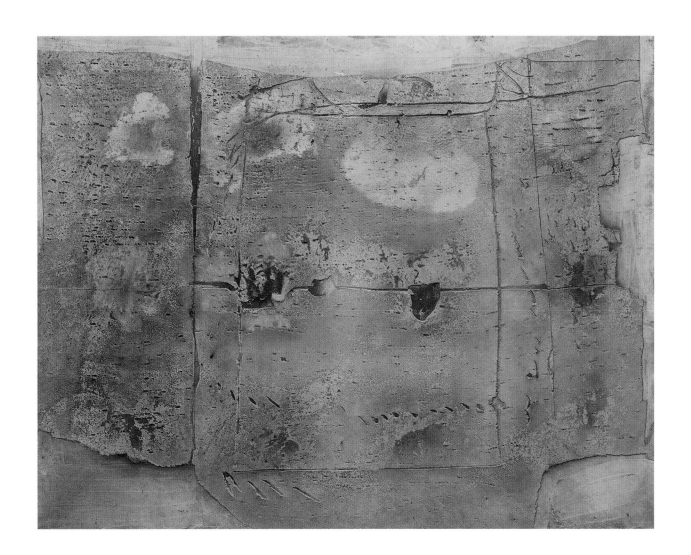

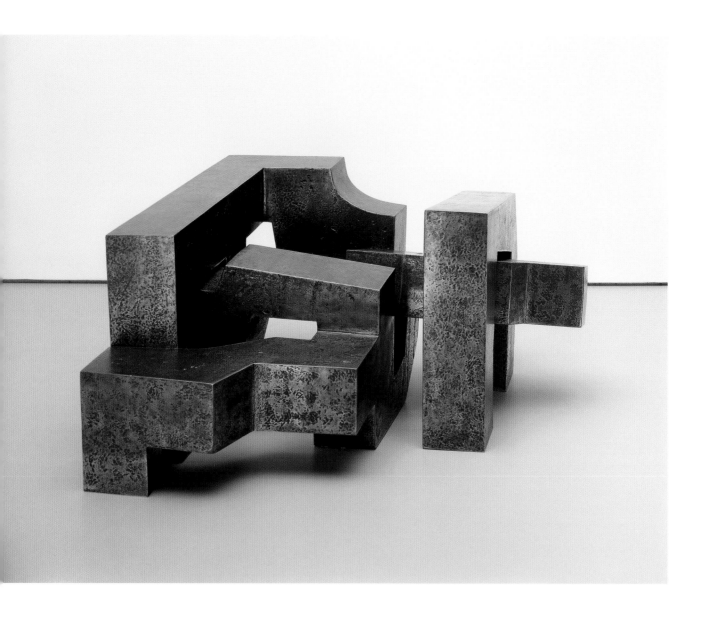

Prior to the twentieth century, artists did not work directly in metal as a sculptural medium. Rather, they carved plaster and molded clay originals that were subsequently cast at a foundry by expert craftsmen. Thus, the sculpture of Eduardo Chillida, comprised of abstract forms created through pounding and bending steel, represents a quintessentially modern approach. Chillida considers his materials not as a vehicle for representation but as an inherent part of the work's total conception and form. His way of working is characteristic of his native region, but it also has roots in the art of Julio González, who is generally regarded as having made the initial breakthrough to direct metal sculpture in the late 1920s.

Executed with a heroic sense of scale and a tremendous sensitivity for mass, space, and materials, Chillida's abstract sculpture is well in keeping with the Tachiste sensibility of late 1940s and 1950s art. Accentuating the work's physical properties, the surface of *Three Irons* is raw and pitted by acid. As the viewer considers the work from various angles, the interrelationships of the interlocking steel limbs in space seem to change. Chillida's interest in volumetric forms may stem, in part, from his early training in architecture. His first welded metal sculptures were relatively delicate and in keeping with a Cubist language of linear forms. But he soon developed a technique that seems to reference the Spanish tradition of forged ironwork, which had been particularly strong in the Basque provinces and Catalonia.

During the 1960s, Chillida boosted the scale of his work and executed a series of public commissions. This experience of working monumentally informs his works in all scales, so that even the relatively small *Three Irons* possesses a majestic sense of structure.—I.S.

MARK ROTHKO

Best known for his large-format paintings featuring rectangles of luminous color that seem to float on the surface of the picture plane, Mark Rothko explored a range of styles, including a kind of social realism and Surrealism, before arriving at his distinctive form of abstraction in the late 1940s. Paintings such as *Untitled (Violet, Black, Orange, Yellow on White and Red)* mark the transition to his mature style. Like the Abstract Expressionists and Color Field painters with whom he was associated, Rothko sought to elicit the expressive possibilities of color.

Rothko's paintings have often been interpreted metaphorically. The artist himself seemed to encourage such readings, denying that his works derived solely from an interest in the formal elements of painting. In the tradition of painters such as Vasily Kandinsky, Kazimir Malevich, Piet Mondrian, and, more contemporaneously, Adolph Gottlieb and Barnett Newman (with whom the artist worked), Rothko often spoke of abstraction's ability to invoke the truths of existence in the modern world. Thus critics have unearthed abstracted referents in Rothko's work, particularly those from Christian imagery. The horizontal orientation of the rectangular elements in combination with the atmospheric color in the artist's work from the late 1940s have also been thought to invoke Romantic landscape painting, physical or metaphysical depth, or absence. At the same time, however, Rothko acknowledged the materiality, or presence, of his paintings: "The difference between me and [Ad] Reinhardt is that he's a mystic. By that I mean that his paintings are immaterial. Mine are here. Materially. The surfaces, the work of the brush and so on. His are untouchable."

The tension between absence and presence in Rothko's painting has elicited still other metaphors for reading his work, namely architecture and urban space. According to Jeffrey Weiss, his paintings evoke both object and place. The vertical white bands at the edges of *Untitled* (vertical elements would disappear in Rothko's later work) combine with the horizontal slash of white at the top of the painting to comprise a framing device, within which the rectangles of red, orange, and yellow hover. This quasi-architectural space or grid, enhanced by the work's scale, suggests a door or threshold, a liminal space that encompasses not only the viewer's field of vision but his or her body as well, conflating real and pictorial space. Weiss traces Rothko's architectural and urban motifs to a series of works from the middle to late 1930s that depict interiors and subjects drawn from the subway and city streets. Yet he cautions that the metaphor of space is an encoded one, since Rothko's paintings are resolutely nonobjective. The work of interpretation remains a complex one, reducible to neither metaphor nor form.—J.M.

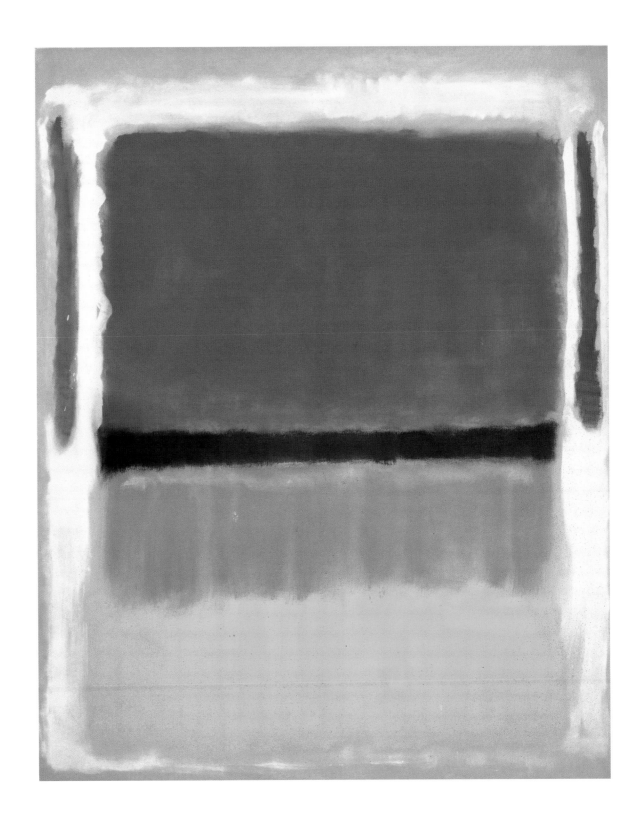

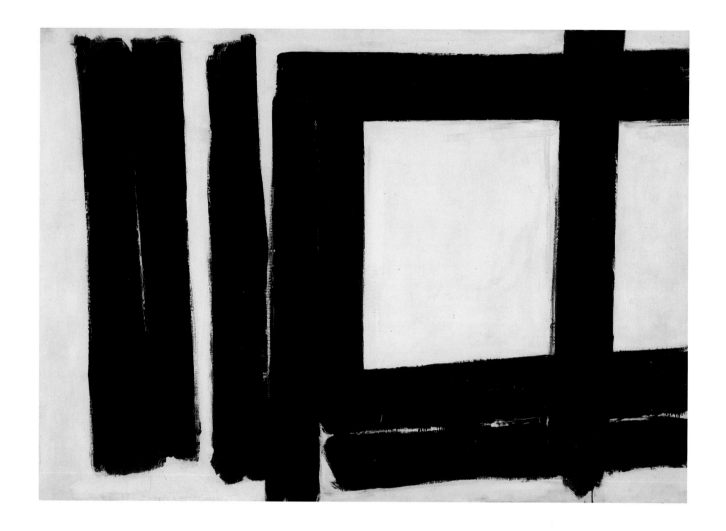

By the end of the 1940s, Franz Kline's work was already yielding to a looser application of paint and a more emphatic expressionistic technique, and in the early 1950s, he was applying black and white commercial paint with housepainter's brushes to large canvases. He became known as an Action painter because his work expressed movement and energy, emphasizing dynamic line. The characteristic black slashes of *Painting No. 7* suggest the full body movement of the artist as he spontaneously applied the paint, incorporating chance splatters and smearing. In fact, Kline's paintings were constructed only to look as if they were painted in a moment of inspiration—they usually resulted from the transfer of a sketch to the canvas.

Unlike Willem de Kooning and Jackson Pollock, Kline never flirted with figuration in his abstract paintings, and he avoided spatial ambiguity. *Painting No. 7* is among the artist's most straightforward statements; it also demonstrates his knowledge of art history. Kline's emphasis on the square in this and other works suggests his interest in Josef Albers and Kazimir Malevich. Art historian Harry Gaugh cites Piet Mondrian's 1930 *Composition No. 1* (p. 111) as an influence, and also contends that the compositional structure of *Painting No. 7* recalls James McNeill Whistler's *Arrangement in Black and Gray: The Artist's Mother* (1871). Though the similarity between the latter two paintings might appear incidental, Kline referred to Whistler in other paintings, and the austere geometry of Whistler's canvas would have appealed to him.—J.B.

WILLEM DE KOONING

In 1948, in response to Willem de Kooning's first solo exhibition, the art critic Clement Greenberg acclaimed him "an outright 'abstract' painter"; of the gestural black-and-white paintings on display, he noted that "there does not seem to be an identifiable image in any of the ten pictures in his show." However, in 1950 de Kooning began a series of gruesomely expressive paintings of women that, when they were exhibited in 1953, brought accusations of betrayal by advocates of pure abstraction and stirred a major controversy: in which style did de Kooning intend to paint, figurative or nonrepresentational? A fusion of the two, it seemed at the time, was untenable.

Composition exemplifies the issues at the heart of this controversy. In *Composition*—like his other contemporaneous works that blend aspects of figurative, landscape, and abstract painting—various components that characterized the *Women* can be detected, such as fragmented and scrambled references to female anatomy; a palette of florid reds, pinks, turquoise blue, and rancid yellow; and de Kooning's signature agitated brushstrokes. Although it shares these elements with the *Women* series, *Composition* is far more abstract. Its underlying structure is composed of side-by-side rectangles, obscured by a thick, active paint surface characterized by its slashing gestures, heavy, rasping textures, and a proliferation of suggestive images, such as the red-and-yellow bralike form at the upper right.

Ambiguities abound in *Composition*, brought about by its multiple focuses, visual rhythms, and abrupt breaks and discontinuities. The painting can be said to lack a final incisiveness, and that is its strength. In reference to the critical debate surrounding abstract and figurative painting—a debate that still surrounds Abstract Expressionism—de Kooning once remarked, "What's the problem? This is all about freedom."—J.A.

COMPOSITION, 1955
OIL, ENAMEL, AND CHARCOAL ON CANVAS
79⅛ × 69⅛ INCHES
55.1419

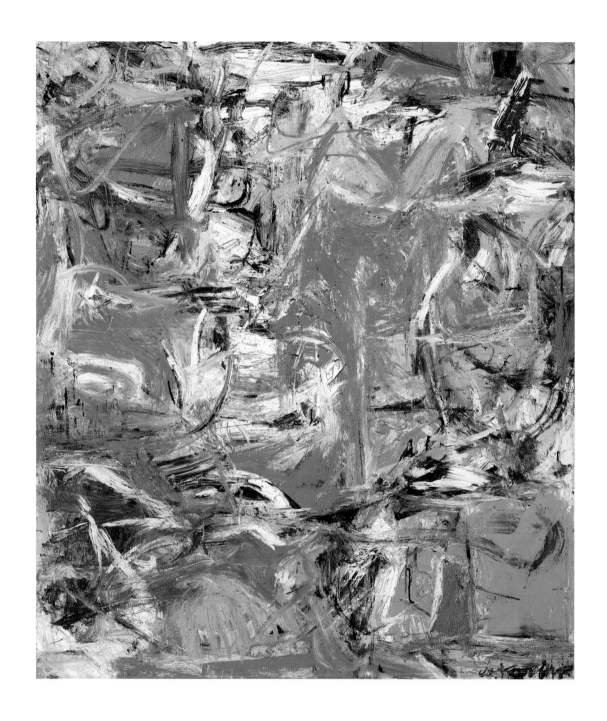

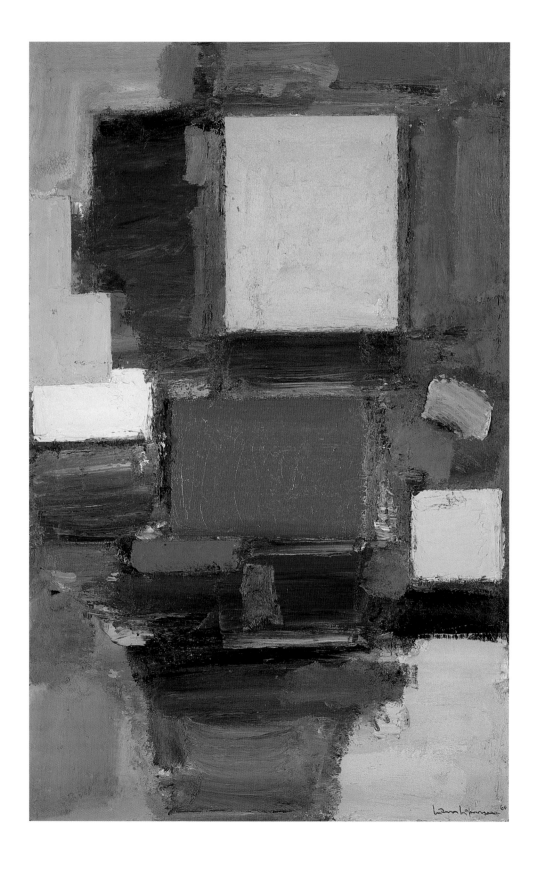

Hans Hofmann lived in Paris from 1904 to 1914, at a time when the leading avant-garde artists, many of whom he knew, were the pioneers of the Fauvist and Cubist movements. His earliest canvases were in a Cubist style. Throughout his career, Hofmann maintained his interest in the planar and compacted structure of Cubism, and at times, combined this concern with the exuberant color of French Fauvist and German Expressionist painters, the improvisational ideas of Kandinsky, the automatism of Surrealism, and the principles of De Stijl. From 1944 on, Hofmann obliterated specific images, though even in some of his most painterly abstract canvases, such as *The Gate*, he incorporated the planes of Synthetic Cubism into his non-objective style.

Made in 1959 and 1960, *The Gate* belongs to a series of works loosely devoted to architectonic volumes. Hofmann used contrasting rectangles of primary and secondary colors to reinforce the shape of his essentially unvarying easel-painting format. Art historian Irving Sandler suggests two possible sources for Hofmann's use of rectangular forms: either from one of his teaching techniques in which he attached pieces of construction paper to his students' canvases or, as curator Sam Hunter noted, from geometric diagrams Hoffman devised for his unpublished manual *The Painter and His Problems.*

Through Hofmann's role as a teacher in California, New York, and Provincetown, in addition to his writings and lectures, he became one of America's most influential exponents of abstraction. He believed that the act of painting yielded spiritual and psychological possibilities. He sought to create through color and balance in his canvases, a "push and pull" tension symbolic of the dynamic forces of nature. And while he upheld the concept of art for art's sake, Hofmann insisted that, even in abstraction, students should always work from some form of nature. He claimed, "The object should not take the importance. There are bigger things to be seen in nature than the object. To become [more] expressive, something must be suppressed. . . . But I have never given up the object."—SRGM

ROBERT MOTHERWELL

Robert Motherwell was only twenty-one-years old when the Spanish Civil War broke out in 1936, but its atrocities made an indelible impression on him, and he later devoted a series of more than 200 paintings to the theme. The tragic proportions of the three-year battle—more than 700,000 people were killed in combat and it occasioned the first air-raid bombings of civilians in history—roused many artists to respond. Most famously, Pablo Picasso created his monumental 1937 painting *Guernica* as an expression of outrage over the events. From Motherwell's retrospective view, the war became a metaphor for all injustice. He conceived of his *Elegies to the Spanish Republic* as majestic commemorations of human suffering and as abstract, poetic symbols for the inexorable cycle of life and death.

Motherwell's allusion to human mortality through a nonreferential visual language demonstrates his admiration for French Symbolism, an appreciation he shared with his fellow Abstract Expressionist painters. Motherwell was particularly inspired by the Symbolist poet Stéphane Mallarmé's belief that a poem should not represent some specific entity, idea, or event, but rather the emotive effect that it produces. The abstract motif common to most of the *Elegies*—an alternating pattern of bulbous shapes compressed between columnar forms—may be read as an indirect, open-ended reference to the experience of loss and the heroics of stoic resistance. The dialectical nature of life itself is expressed through the stark juxtaposition of black against white, which reverberates in the contrasting ovoid and rectilinear slab forms.

About the *Elegies*, Motherwell said, "After a period of painting them, I discovered Black as one of my subjects—and with black, the contrasting white, a sense of life and death which to me is quite Spanish. They are essentially the Spanish black of death contrasted with the dazzle of a Matisse-like sunlight." This and other remarks Motherwell made regarding the evolution of the *Elegies* indicate that form preceded iconography. Given that the *Elegies* date from an ink sketch made in 1948 to accompany a poem by Harold Rosenberg that was unrelated to the Spanish Civil War, and that their compositional syntax became increasingly intense, it seems all the more apparent that the "meaning" of each work in the series is subjective and evolves over time.—N.S.

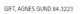

ELEGY TO THE SPANISH REPUBLIC NO. 110, EASTER DAY, 1971
ACRYLIC WITH PENCIL AND CHARCOAL ON CANVAS
82 × 114 INCHES
GIFT, AGNES GUND 84.3223

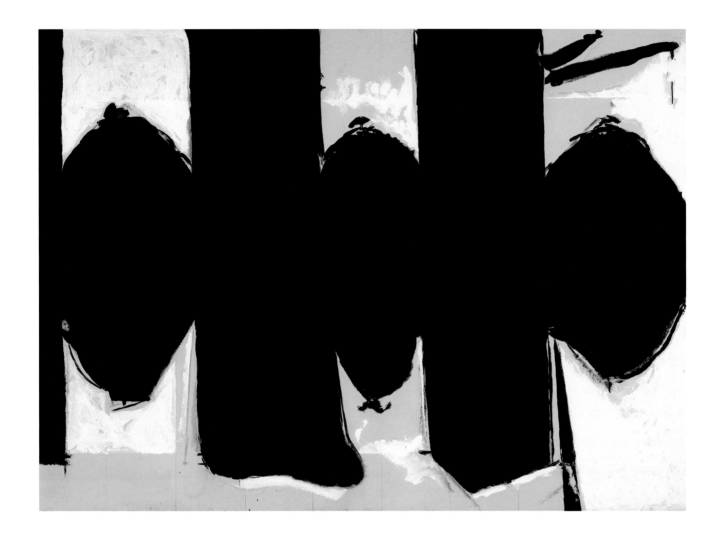

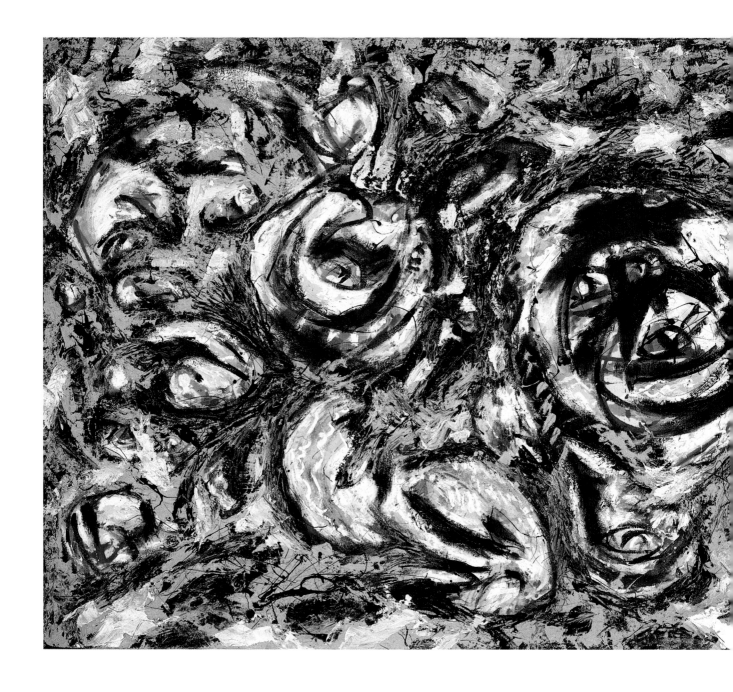

OCEAN GREYNESS, 1953
OIL ON CANVAS
57³/₄ × 90¹/₈ INCHES
54.1408

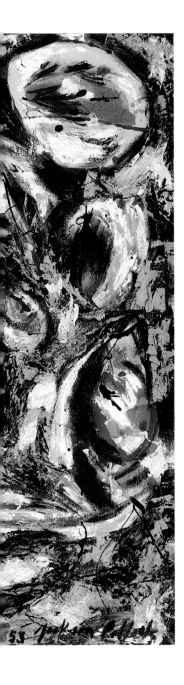

The critical debate that surrounded Abstract Expressionism during the late 1940s was embodied in the work of Jackson Pollock. Clement Greenberg, a leading critic and Pollock's champion, professed that each discrete art form should, above all else, aspire to a demonstration of its own intrinsic properties and not encroach on the domains of other art forms. A successful painting, he believed, affirmed its inherent two-dimensionality and aimed toward complete abstraction. At the same time, however, the critic Harold Rosenberg was extolling the subjective quality of art; fervent brushstrokes were construed as expressions of an artist's inner self, and the abstract canvas became a gestural theater of private passions. Pollock's art—from the early, Surrealist-inspired figurative canvases and those invoking "primitive" archetypes to the later labyrinthine webs of poured paint—elicited both readings. Pollock's reluctance to discuss his subject matter and his emphasis on the immediacy of the visual image contributed to shifting and, ultimately, dialectic views of his work.

In 1951, at the height of the artist's career, *Vogue* magazine published fashion photographs by Cecil Beaton of models posing in front of Pollock's drip paintings. Although this commercial recognition signaled public acceptance—and was symptomatic of mass culture's inevitable expropriation of the avant-garde—Pollock continuously questioned the direction and reception of his art. His ambivalence about abstract painting, marked by a fear of being considered merely a "decorative" artist, was exacerbated, and it was around this time that he reintroduced to his paintings the quasi-figurative elements that he had abandoned when concentrating on the poured canvases. *Ocean Greyness*, one of Pollock's last great works, depicts several disembodied eyes hidden within the swirling colored fragments that materialize from the dense, scumbled gray ground. "When you are painting out of your unconscious," he claimed, "figures are bound to emerge." Manifest in this painting is a dynamic tension between representation and abstraction that, finally, constitutes the core of Pollock's multileveled oeuvre.—N.S.

Selected Readings

Many of the artworks reproduced in this book have been fully documented in the following Guggenheim Museum publications. In some cases, the authors have used these books as primary sources. Entries not original to this publication have been reprinted and, in certain instances, revised from these publications. These books will also be of interest to the reader seeking additional information on the collection.

Art of this Century: The Guggenheim Museum and Its Collection, 1993; reprinted 2001.

Art Through the Ages: Masterpieces of Painting from Titian to Picasso, 2002

Barnett, Vivian Endicott. *The Guggenheim Museum: Justin K. Thannhauser Collection*, 1978.

_____. *Handbook: The Guggenheim Museum Collection 1900–1980*, 1984.

Drutt, Matthew, ed. *Thannhauser: The Thannhauser Collection of the Guggenheim Museum*, 2001.

Masterpieces and Master Collectors: Impressionist and Early Modern Paintings from the Hermitage and Guggenheim Museums, 2001.

Rendezvous: Masterpieces from the Centre Georges Pompidou and Guggenheim Museums, 1998.

Rudenstine, Angelica Zander. *The Guggenheim Museum Collection: Paintings 1880–1945.* 2 vols, 1976.

Spector, Nancy, ed. *A to Z: Guggenheim Museum Collection*, 2002

The following books and articles are suggested for those readers seeking additional information or viewpoints on the artists whose works are discussed in this catalogue.

Alexander Archipenko

Michaelsen, Katherine Jánszky, and Nehama Guralnik. *Alexander Archipenko: A Centennial Tribute* (exh. cat.). Washington D.C.: National Gallery of Art; Tel Aviv: Tel Aviv Museum, 1986.

Reff, Theodore. "Harlequins, Saltambiques, Clowns and Fools." *Artforum* (New York) 10, no. 2 (October 1971), pp. 30–43.

Max Beckmann

Buenger, Barbara C. "Max Beckmann's Ideologues: Some Forgotten Faces." *The Art Bulletin* (New York) 71, no. 3 (September 1989), pp. 453–79.

Phelan, Anthony, ed. *The Weimar Dilemma: Intellectuals in the Weimar Republic*. Manchester: Manchester University Press, 1985.

Stehlé-Akhtar, Barbara, Reinhard Spieler, et al. *Max Beckmann in Exile* (exh. cat.). New York: Guggenheim Museum, 1996.

Constantin Brancusi

Bach, Friedrich Teja, Margit Rowell, and Ann Temkin. *Constantin Brancusi: 1876–1957* (exh. cat.). Philadelphia: Philadelphia Museum of Art, 1995.

Balas, Edith. *Brancusi and Rumanian Folk Traditions*. Boulder, Colo.: East European Monographs, 1987.

Chave, Anna. *Constantin Brancusi: Shifting the Bases of Art*. New Haven: Yale University Press, 1993.

Hulten, Pontus, Natalia Dumitresco, and Alexandre Istrati. *Brancusi*. New York: Harry N. Abrams, 1987.

Georges Braque

Cooper, Douglas. *The Cubist Epoch*. London: Phaidon Press, 1970.

Golding, John. *Cubism: A History and an Analysis, 1907–1914*. London and Boston: Faber, 1988.

Golding, John, et al. *Braque: The Late Works* (exh. cat., Royal Academy of Arts, London). New Haven: Yale University Press, 1997.

Leymarie, Jean. *Georges Braque* (exh. cat.). New York: Guggenheim Museum, 1988.

Rubin, William. *Picasso and Braque: Pioneering Cubism* (exh. cat.). New York: The Museum of Modern Art, 1989.

Alberto Burri

Calvesi, Maurizio. *Alberto Burri*. Trans. Robert E. Wolf. New York: Harry N. Abrams, 1975.

Corà, Bruno. *Burri e Fontana* (exh. cat., Centro par l'Arte Contemporanea). Milan: Skira, 1996. In Italian and English.

Nordland, Gerald. *Alberto Burri: A Retrospective View 1948–77* (exh. cat.). Los Angeles: Frederick S. Wight Gallery, University of California, 1977.

Alexander Calder

Calder, Alexander, and Jean Davidson. *Calder: An Autobiography with Pictures*. New York: Pantheon, 1966.

Lipman, Jean. *Calder's Universe* (exh. cat.). New York: Whitney Museum of American Art, 1976.

Prather, Marla. *Alexander Calder 1898–1976* (exh. cat.). Washington D.C.: National Gallery of Art; New Haven: Yale University Press, 1998.

Marc Chagall

Chagall, Marc. *Marc Chagall: My Life, My Dream, Berlin and Paris, 1922–1940*. Trans. Elisabeth Abbott. New York: Prestel, 1960.

Compton, Susan. *Chagall* (exh. cat.). London: Royal Academy of Arts, 1985.

Kagan, Andrew. *Marc Chagall*. New York: Abbeville Press, 1989.

Rosensaft, Jean Bloch. *Chagall and the Bible* (exh. cat., Jewish Museum, New York) New York: Universe Books, 1987.

Eduardo Chillida

Chillida (exh. cat., Museum of Art, Carnegie Institute). Paris: Maeght, 1979.

De Barañano, Kosme, ed. *Chillida: 1948–1998* (exh. cat.) Madrid: Museo Nacional Centro de Arte Reina Sofía and Bilbao: Museo Guggenheim Bilbao, 1998.

Selz, Peter. *Chillida*. New York: Abrams in association with J. M. Tasende, 1986.

Wagner, Sandra. "An Interview with Eduardo Chillida." *Sculpture* (Washington, D.C.) 16, no. 9 (November 1997), pp. 22–27.

Willem de Kooning

Cummings, Paul, Jörn Merkert, and Clair Stoullis. *Willem de Kooning: Drawings, Paintings, Sculpture* (exh. cat.). New York: Whitney Museum of American Art, 1983.

Hess, Thomas B. *Willem de Kooning*. New York: George Braziller, 1959.

Prather, Marla, David Sylvester, and Richard Shiff. *Willem de Kooning: Paintings* (exh. cat.). Washington, D.C.: National Gallery of Art; New Haven: Yale University Press, 1994.

Rosenberg, Harold. *Willem de Kooning*. New York: Harry N. Abrams, 1974.

Yard, Sally. *Willem de Kooning*. New York: Rizzoli, 1997.

Robert Delaunay

Buckberrough, Sherry A. *Robert Delaunay: The Discovery of Simultaneity*. Ann Arbor, Mich.: UMI Research Press, 1978.

Delaunay, Robert, and Sonia Delaunay. *The New Art of Color: The Writings of Robert and Sonia Delaunay*. Ed. Arthur A. Cohen. Trans. David Shapiro and Arthur A. Cohen. New York: Crown, 1978.

Hoog, Michel R. *Delaunay*. Trans. Alice Sachs. New York: Crown Publishers, 1976.

Vriesen, Gustav, and Max Imdahl. *Robert Delaunay: Light and Color*. Trans. Maria Pelikan. New York: Harry N. Abrams, 1967.

Jean Dubuffet

Jean Dubuffet: Paintings (exh. cat., Tate Gallery, London). London: Arts Council of Great Britain, 1966.

Rowell, Margit. *Jean Dubuffet: A Retrospective* (exh. cat.). New York: Guggenheim Museum, 1973.

Selz, Peter Howard. *The Work of Jean Dubuffet* (exh. cat.). New York: The Museum of Modern Art, 1962.

Max Ernst

Camfield, William A. *Max Ernst: Dada and the Dawn of Surrealism*. (exh. cat., The Menil Collection, Houston). Munich: Prestel-Verlag, 1993.

Ernst, Max. *Beyond Painting and Other Writings by the Artist and his Friends*. New York: Wittenborn, Schultz, 1948.

Schneede, Uwe M. *Max Ernst*. Trans. by R. W. Last. New York: Praeger, 1973, 1972.

Spies, Werner, ed. *Max Ernst: A Retrospective* (exh. cat., Tate Gallery, London). Munich: Prestel-Verlag, 1991.

Waldman, Diane. *Max Ernst: A Retrospective*. (exh. cat.) New York: Guggenheim Museum, 1975.

Lucio Fontana

Ballo, Guido. *Lucio Fontana*. New York: Praeger, 1971.

Billeter, Erika. *Lucio Fontana, 1899–1968: A Retrospective* (exh. cat.). New York: Guggenheim Museum, 1977.

Cotter, Holland. "Fontana's Post-Dada Operatics." *Art in America* (New York) 75, no. 3 (March 1987), pp. 80–85.

Whitfield, Sarah. *Lucio Fontana* (exh. cat.). London: Hayward Gallery, 1999.

Naum Gabo

Gabo: Constructions, Sculpture, Paintings, Drawings, Engravings. With introductory essays by Herbert Read and Leslie Martin. Cambridge, Mass.: Harvard University Press, 1957.

Hammer, Martin and Christina Lodder. *Constructing Modernity: The Art and Career of Naum Gabo.* New Haven: Yale University Press, 2000.

Nash, Steven A. and Jörn Merkert, eds. *Naum Gabo: Sixty Years of Constructivism.* (exh. cat., Dallas Museum of Art). Munich: Prestel-Verlag, 1985.

Pevsner, Alexei. *A Biographical Sketch of My Brothers, Naum Gabo and Antoine Pevsner.* Amsterdam: Augustin & Schoonman, 1964.

Rickey, George. "Naum Gabo: 1890–1977." *Artforum* (New York) 16, no. 3 (Nov. 1977), pp. 22–27.

Juan Gris

Cooper, Douglas, ed. and trans. *Letters of Juan Gris (1913–1927): Collected by Daniel-Henry Kahnweiler.* London: Percy Lund, Humphries and Co. Ltd, 1956.

Gaya-Nuño, Juan Antonio. *Juan Gris.* Trans. Kenneth Lyons. Boston: New York Graphic Society, 1975.

Green, Christopher. *Juan Gris* (exh. cat.). London: Whitechapel Art Gallery, 1992.

Kahnweiler, Daniel-Henry. *Juan Gris: His Life and Work.* Trans. Douglas Cooper. New York: Harry N. Abrams, Inc., 1947.

Soby, James Thrall. *Juan Gris* (exh. cat.). New York: The Museum of Modern Art, 1958.

Hans Hofmann

Goodman, Cynthia. *Hans Hofmann.* New York: Abbeville Press, 1986.

Goodman, Cynthia, Irving Sandler, et al. *Hans Hofmann* (exh. cat.). New York: Whitney Museum of American Art, 1990.

Greenberg, Clement. *Hans Hofmann.* Paris: G. Fall, 1961.

Hofmann, Hans. *Search for the Real and Other Essays.* Eds. Sarah T. Weeks and Barlett Hays. Cambridge, Mass.: MIT Press, 1967.

Jaffe, Irma B. "A Conversation with Hans Hofmann." *Artforum* (New York) 9, no. 5 (January 1971), pp. 34–39.

Vasily Kandinsky

Barnett, Vivian Endicott. *Kandinsky at the Guggenheim.* New York: Guggenheim Museum, 1983.

Barnett, Vivian Endicott, Christian Derouet, et al. *Kandinsky in Paris: 1934–1944* (exh. cat.). New York: Guggenheim Museum, 1985.

Dabrowski, Magdalena. Kandinsky *Compositions* (exh. cat.). New York: The Museum of Modern Art, 1995.

Lindsay, Kenneth C., and Peter Vergo, eds. *Kandinsky: Complete Writings on Art.* 2 vols. New York: Da Capo Press, 1994.

Long, Rose-Carol Washton. *Kandinsky: The Development of an Abstract Style.* New York: Oxford University Press, 1980.

Ernst Ludwig Kirchner

Deutsche, Rosalyn. "Alienation in Berlin: Kirchner's Street Scenes." *Art in America* (New York) 71, no. 1 (January 1983), pp. 64–72.

Gordon, Donald E. *Ernst Ludwig Kirchner: A Retrospective Exhibition* (exh. cat.). Boston: Museum of Fine Arts, 1968.

_____. *Ernst Ludwig Kirchner.* Cambridge, Mass.: Harvard University Press, 1968.

Masheck, Joseph. "The Horror of Bearing Arms: Kirchner's Self-Portrait as a Soldier: The Military Mystique and the Crisis of World War I (With a Slip-of-the-Pen by Freud)." *Artforum* (New York) 19, no. 4 (December 1980), pp. 56–61.

Paul Klee

Aichele, K. Porter. "Paul Klee's Operatic Themes and Variations." *The Art Bulletin* (New York) 68, no. 3 (September 1986), pp. 450–66.

Dennison, Lisa, and Andrew Kagan. *Paul Klee at the Guggenheim Museum* (exh. cat.). New York: Guggenheim Museum, 1993.

Kagan, Andrew. *Paul Klee: Art and Music.* Ithaca, N.Y.: Cornell University Press, 1983.

Lanchner, Carolyn, ed. *Paul Klee* (exh. cat.). New York: The Museum of Modern Art, 1987.

Werckmeister, O. K. *The Making of Paul Klee's Career 1914–1920.* Chicago: University of Chicago Press, 1989.

Franz Kline

Anfam, David. *Franz Kline: Black & White, 1950–1961* (exh. cat.). Houston: Menil Collection in association with Fine Art Press, 1994.

Gaugh, Harry F. *Franz Kline: The Color Abstractions* (exh. cat.). Washington, D.C.: Phillips Collection, 1979.

———. *The Vital Gesture: Franz Kline* (exh. cat., Cincinnati Art Museum). New York: Abbeville Press, 1985.

Kingsley, April. "Franz Kline: Out of Sight, Out of Mind." *Arts Magazine* (New York) 60, no. 9 (May 1986), pp. 41–45.

Oskar Kokoschka

Calvocoressi, Richard, and Katharina Schulz. *Oskar Kokoschka* (exh. cat.). New York: Guggenheim Museum, 1986.

Kokoschka, Oskar. *My Life.* Trans. David Britt. New York: Macmillan, 1974.

Strobl, Alice, and Alfred Weidinger. *Oskar Kokoschka, Works on Paper: The Early Years, 1897–1917* (exh. cat.). New York: Guggenheim Museum, 1994.

František Kupka

Henderson, Linda Dalrymple. "An Alternative View Among the Cubists: The Theosophist Kupka." In *The Fourth Dimension and Non-Euclidean Geometry in Modern Art.* Princeton, N.J.: Princeton University Press, 1983, pp. 103–09.

———. "X Rays and the Quest for Invisible Reality in the Art of Kupka, Duchamp, and the Cubists." *Art Journal* (New York), no. 47 (winter 1988), pp. 323–40.

Kosinski, Dorothy, ed. *Painting the Universe: František Kupka, Pioneer in Abstraction* (exh. cat., Dallas Museum of Art). Ostfildern-Ruit, Germany: Hatje Cantz, 1997.

Mladek, Meda, and Margit Rowell. *František Kupka, 1871–1957: A Retrospective* (exh. cat.). New York: Guggenheim Museum, 1975.

Mikhail Larionov

Boissel, Jessica, ed. *Nathalie Gontcharova, Michel Larionov* (exh. cat.). Paris: Centre Georges Pompidou, 1995.

Kovtun, Yevgeny. *Mikhail Larionov: 1881–1964.* Trans. by Paul Williams. Bournemouth, England: Parkstone Press, 1998.

Parton, Anthony. *Mikhail Larionov and the Russian Avant-Garde.* Princeton, N.J.: Princeton University Press, 1993.

Waldemar, George. *Larionov.* Paris: La Bibliothèque des Arts, 1966.

Fernand Léger

Green, Christopher. *Léger and the Avant-Garde.* New Haven: Yale University Press, 1976.

Kosinski, Dorothy, ed. *Fernand Léger, 1911–1924: The Rhythm of Modern Life* (exh. cat., Kunstmuseum Wolfsburg). Munich and New York: Prestel, 1994.

Lanchner, Caroline, Jodi Hauptman, et al. *Fernand Léger* (exh. cat.). New York: The Museum of Modern Art, 1998.

Serota, Nicholas, ed. *Fernand Léger: The Later Years* (exh. cat., Whitechapel Art Gallery, London). Munich: Prestel-Verlag, 1987.

Kazimir Malevich

Andersen, Troels. *Malevich* (exh. cat.). Amsterdam: Stedelijk Museum, 1970.

D'Andrea, Jeanne, ed. *Kazimir Malevich 1878–1935* (exh. cat.). Los Angeles: Armand Hammer Museum of Art and Cultural Center; Seattle: University of Washington Press, 1990.

Douglas, Charlotte. *Kazimir Malevich*. New York: Harry N. Abrams, 1994.

Hilton, Alison. *Kazimir Malevich*. New York: Rizzoli, 1992.

Milner, John. *Kazimir Malevich and the Art of Geometry*. New Haven: Yale University Press, 1996.

Franz Marc

Levine, Frederick S. *The Apocalyptic Vision: The Art of Franz Marc as German Expressionism*. New York: Harper & Row, 1979.

Moffitt, J. F. "'Fighting Forms: The Fate of the Animals': The Occultist Origins of Franz Marc's 'Farbentheorie.'" *Artibus et Historiae* (Venice), no. 12 (1986), pp. 107–26. In English.

Rosenthal, Mark. *Franz Marc*. Munich: Prestel, 1989.

Selz, Peter. *German Expressionist Painting*. Berkeley and Los Angeles: University of California Press, 1957.

Henri Matisse

Cowart, Jack, and Dominique Fourcade. *Henri Matisse: The Early Years in Nice, 1916–1930* (exh. cat.). Washington, D.C.: National Gallery of Art, 1986.

Elderfield, John. *Henri Matisse: A Retrospective* (exh. cat.). New York: The Museum of Modern Art, 1992.

Flam, Jack. *Matisse: The Man and His Art, 1869–1918*. Ithaca, N.Y.: Cornell University Press, 1986.

Schneider, Pierre. *Matisse*. Trans. Michael Taylor and Bridget S. Romer. New York: Rizzoli, 1984.

Spurling, Hilary. *The Unknown Matisse: A Life of Henri Matisse, The Early Years, 1869–1908*. New York: Knopf, 1998.

Joan Miró

Dupin, Jacques. *Joan Miró: Life and Work*. Trans. Norbert Guterman. New York: Harry N. Abrams, 1962.

Dupin, Jacques, et al. *Joan Miró: A Retrospective* (exh. cat.). New York: Guggenheim Museum, 1987.

Rowell, Margit, and Rosalind E. Krauss. *Joan Miró: Magnetic Fields* (exh. cat.). New York: Guggenheim Museum, 1972.

Rowell, Margit, ed. *Joan Miró: Selected Writings and Interviews*. Trans. Paul Auster and Patricia Mathews. Boston: G. K. Hall, 1986.

Weelen, Guy. *Miró*. Trans. Robert Erich Wolf. New York: Harry N. Abrams, 1989.

Amedeo Modigliani

Hall, Douglas. *Modigliani*. London: Phaidon Press, 1998.

Hobhouse, Janet. "Amedeo Modigliani." In *The Bride Stripped Bare: The Artist and the Nude in the Twentieth Century*. New York: Weidenfeld & Nicolson, 1988, pp. 135–66.

Schmalenbach, Werner. *Amedeo Modigliani: Paintings, Sculptures, Drawings* (exh. cat., Kunstsammlung Nordrhein-Westfalen, Düsseldorf). Trans. David Britt, Caroline Beamish, et al. Munich: Prestel, 1990.

Sichel, Pierre. *Modigliani: A Biography of Amedeo Modigliani*. New York: Dutton, 1967.

László Moholy-Nagy

Caton, Joseph Harris. *The Utopian Vision of Moholy-Nagy*. Ann Arbor, Mich.: UMI Research Press, 1984.

Kostelanetz, Richard, ed. *Moholy-Nagy: An Anthology*. New York: Da Capo Press, 1991.

Moholy-Nagy, László. *Vision in Motion*. Chicago: P. Theobald, 1947.

Piet Mondrian

Blotkamp, Carel. *Mondrian: The Art of Destruction.* New York: Harry N. Abrams, 1995.

Bois, Yve-Alain, Joop Joosten, et al. *Piet Mondrian, 1872–1944* (exh. cat., National Gallery of Art, Washington, D.C.). Boston: Little, Brown and Company, 1994.

Carmean, E. A., Jr. *Mondrian: The Diamond Compositions* (exh. cat.). Washington, D.C.: National Gallery of Art, 1979.

Cheetham, Mark A. "The Mechanisms of Purity I: Mondrian" and "Purity as Aesthetic Ideology." In *The Rhetoric of Purity: Essentialist Theory and the Advent of Abstract Painting.* Cambridge and New York: Cambridge University Press, 1991, pp. 40–64, 102ff.

Krauss, Rosalind E. "Grids." In *The Originality of the Avant-Garde and Other Modernist Myths.* Cambridge, Mass.: MIT Press, 1985, pp. 8–22.

Mondrian, Piet. *The New Art—The New Life: The Collected Writings of Piet Mondrian.* Eds. and trans. Harry Holtzman and Martin S. James. Boston: G. K. Hall, 1986.

Welsh, Robert P., Joop Joosten, et al. *Piet Mondrian, 1872–1944: Centennial Exhibition* (exh. cat.). New York: Guggenheim Museum, 1971.

Robert Motherwell

Carmean, E. A., Jr. "Robert Motherwell's Spanish Elegies." *Arts Magazine* (New York) 50, no. 10 (June 1976), pp. 94–97.

Caws, Mary Ann. *Robert Motherwell: What Art Holds.* New York: Columbia University Press, 1996.

Flam, Jack. *Motherwell.* New York: Rizzoli, 1991.

Gaugh, Harry F. "Elegy for an Exhibition." *Art News* (New York) 85, no. 3 (March 1985), pp. 71–75.

Mattison, Robert Saltonstall. *Robert Motherwell: The Formative Years.* Ann Arbor, Mich.: UMI Research Press, 1987.

Francis Picabia

Borràs, Maria Lluisa. *Picabia.* New York: Rizzoli, 1985.

Camfield, William A. *Francis Picabia, His Art, Life and Times.* Princeton, N.J.: Princeton University Press, 1979.

Felix, Zdenek, ed. *Francis Picabia: The Late Works 1933–1953* (exh. cat., Deichtorhallen, Hamburg). Ostfildern-Ruit, Germany: Hatje Cantz, 1998.

Hultén, Pontus. *The Machine as Seen at the End of the Mechanical Age* (exh. cat.). New York: The Museum of Modern Art, 1968.

Pablo Picasso

Barr, Alfred H., Jr. *Picasso: Fifty Years of His Art.* New York: The Museum of Modern Art, 1946.

Daix, Pierre, and Joan Rosselet. *Picasso: The Cubist Years. A Catalogue Raisonné of the Paintings and Related Works.* Boston: New York Graphical Society, 1979.

Golding, John. *Cubism: A History and an Analysis, 1907–1914.* New York: G. Wittenborn, 1959.

Penrose, Roland, and John Golding, eds. *Picasso in Retrospect.* New York: Praeger, 1973.

Richardson, John. *A Life of Picasso: Volume I, 1881–1906; Volume II: 1907–1917, The Painter of Modern Life.* New York: Random House, 1991; 1996.

Schwarz, Herbert. *Picasso and Marie-Thérèse Walter, 1925–1927* (exh. cat.). Sillery, Quebec: Editions Isabeau, 1988.

Jackson Pollock

Clark, Timothy J. "Jackson Pollock's Abstraction." In *Reconstructing Modernism: Art in New York, Paris, and Montreal 1945–1964.* Ed. Serge Guilbaut. Cambridge, Mass.: MIT Press, 1990, pp. 172–238.

Landau, Ellen G. *Jackson Pollock.* New York: Harry N. Abrams, 1989.

O'Connor, Francis V., and Eugene Victor Thaw, eds. *Jackson Pollock: A Catalogue Raisonné of Paintings, Drawings and Other Works. 4 vols.* New Haven: Yale University Press, 1978.

Varnedoe, Kirk, and Pepe Karmel, eds. *Jackson Pollock: New Approaches* (exh. cat.). New York: The Museum of Modern Art, 1999.

Liubov Popova

Bowlt, John, Matthew Drutt, et al. *Amazons of the Avant-Garde* (exh. cat.). New York: Guggenheim Museum, 2000.

Dabrowski, Magdalena. *Liubov Popova* (exh. cat.). New York: The Museum of Modern Art, 1991.

Sarabianov, Dimitri, and Natalia Adaskina. *Liubov Popova*. Trans. Marian Schwartz. New York: Harry N. Abrams, 1990.

Mark Rothko

Anfam, David. *Mark Rothko: The Works on Canvas: Catalogue Raisonné*. New Haven: Yale University Press; Washington, D.C.: National Gallery of Art, 1999.

Ashton, Dore. *About Rothko*. New York: Da Capo Press, 1996.

Chave, Anna. *Mark Rothko: Subjects in Abstraction*. New Haven: Yale University Press, 1989.

Waldman, Diane. *Mark Rothko, 1903–1970: A Retrospective* (exh. cat., Guggenheim Museum). New York: Harry N. Abrams, 1978.

Weiss, Jeffrey S. *Mark Rothko* (exh. cat., National Gallery of Art, Washington, D.C.). New Haven: Yale University Press, 1998.

Egon Schiele

Comini, Alessandra. *Egon Schiele's Portraits*. Berkeley and Los Angeles: University of California Press, 1974.

Dabrowski, Magdalena and Rudolf Leopold. *Egon Schiele: The Leopold Collection, Vienna* (exh. cat.). New York: The Museum of Modern Art, 1997.

Kallir, Jane. *Egon Schiele: The Complete Works*. New York: Harry N. Abrams, 1998.

——. *Egon Schiele* (exh. cat., National Gallery of Art, Washington, D.C.). New York: Harry N. Abrams, 1994.

Gino Severini

Apollonio, Umbro, ed. *Futurist Manifestos*. Trans. Robert Brain, et al. New York: Thames and Hudson, 1973.

Fraquelli, Simonetta, and Christopher Green. *Gino Severini: From Futurism to Classicism* (exh. cat.). London: Hayward Gallery, 1999.

Hanson, Anne Coffin. *Severini Futurista, 1912–1917* (exh. cat.). New Haven: Yale University Art Gallery, 1995.

Perloff, Marjorie. *The Futurist Moment: Avant-Garde, Avant Guerre, and the Language of Rupture*. Chicago: University of Chicago Press, 1986.

Severini, Gino. *The Life of a Painter: The Autobiography of Gino Severini*. Trans. Jennifer Franchina. Princeton, N.J.: Princeton University Press, 1995.

Antoni Tàpies

Agustí, Anna. *Tàpies: The Complete Works, Volume 1: 1943–1960, Volume 2: 1961–1968*. Barcelona: Fundacio Antoni Tàpies and Edicions Polígrafa, 1989; 1990.

Barrio-Garay, José Luis. *Antoni Tàpies: Thirty-Three Years of His Work* (exh. cat.). Buffalo, N.Y.: Albright-Knox Art Gallery, 1977.

Cembalest, Robin. "Master of Matter." *Art News* (New York) 89, no. 6 (summer 1990), pp. 142–47.

Giménez, Carmen, ed. *Antoni Tàpies* (exh. cat.). New York: Guggenheim Museum, 1995.

Photographic Credits